Must-Visit
Design
Destinations
in TOKYO

トーキョーデザイン探訪

デザインがよくわかる美術館・
ギャラリー・ショップガイド ［東京版］

JN111954

アイデア編

はじめに

日本のビジュアルカルチャーを「デザイン」という切り口からテーマごとに地図にまとめ紹介するバイリンガルのガイドブックシリーズ、TRIP TO JAPAN GRAPHICS。第一弾となる本書では、1953年創刊のデザイン誌『アイデア』の編集部が推薦する東京都内のデザインミュージアムやギャラリー、デザインスポット・ショップなどの施設を、8つのエリアに分けてご紹介します。
各施設には、国内外で活躍するグラフィックデザイナー、デザイン関係者の方々によるおすすめポイントも掲載しました。名作デザインや最新のデザインに触れることができるデザインギャラリーやショップはもちろん、美術館や博物館の展示作品や展示空間、建築物などをデザイン的な視点から楽しむためのポイントも収録しています。
また、カバーの裏面には、全掲載施設を一望できるMAPもご用意しました。地図を広げ、旅行や散策のルートを考えてみるのも良いかもしれません。本書を片手に、東京の街のあらたな一面を探しに出かけてみてはいかがでしょうか。

Introduction

TRIP TO JAPAN GRAPHIC is a series of bilingual guidebooks that allows readers to explore Japan's visual culture with the help of art and design professionals. Destinations are organized onto maps that focus on different areas of Tokyo, and within each area, they are organized by theme. In this first volume, the editors of IDEA, a design magazine founded in 1953, recommend design museums, galleries, design spots, and stores in Tokyo. These destinations are divided into eight areas.
For each destination, we have included recommendations from graphic designers, and design professionals from Japan and abroad. In addition to our list of recommended design galleries and stores where you can discover the latest designs and masterpieces, the book also includes tips on how to enjoy the artwork, exhibition spaces, and museum architecture from a design-oriented perspective.
We also included a map inside the cover that allows you to browse the listed facilities at once. Unfold the map and consider a new trip, or a new route to explore the city in your own way. We invite you to go out, with this book in your hand, and discover a new side of Tokyo.

目次

CONTENTS

065 表参道・青山　OMOTESANDO / AOYAMA

083 新宿・四谷　SHINJUKU / YOTSUYA

目次

CONTENTS

エリア一覧
Area Index

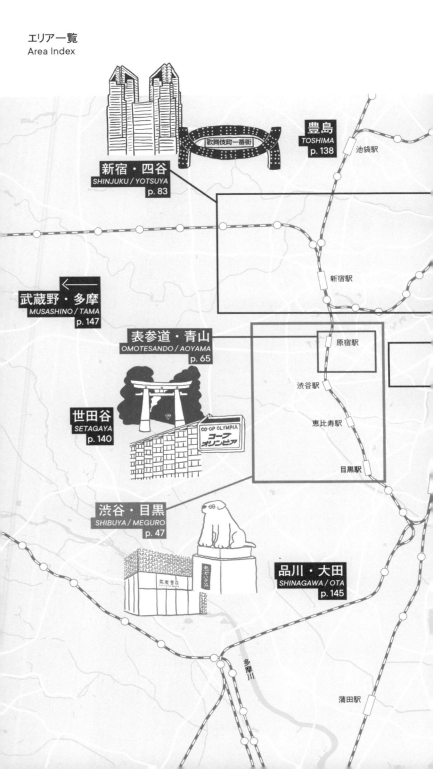

新宿・四谷
SHINJUKU / YOTSUYA
p. 83

歌舞伎町一番街

豊島
TOSHIMA
p. 138

池袋駅

新宿駅

武蔵野・多摩
MUSASHINO / TAMA
p. 147

表参道・青山
OMOTESANDO / AOYAMA
p. 65

原宿駅

渋谷駅

恵比寿駅

世田谷
SETAGAYA
p. 140

CO-OP OLYMPIA
コープ
オリンピア

目黒駅

渋谷・目黒
SHIBUYA / MEGURO
p. 47

品川・大田
SHINAGAWA / OTA
p. 145

多摩川

蒲田駅

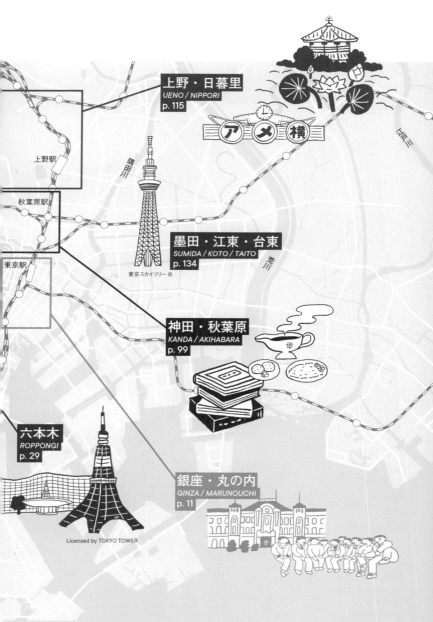

上野・日暮里
UENO / NIPPORI
p. 115

上野駅

秋葉原駅

東京駅

墨田・江東・台東
SUMIDA / KOTO / TAITO
p. 134

東京スカイツリー ®

神田・秋葉原
KANDA / AKIHABARA
p. 99

六本木
ROPPONGI
p. 29

Licensed by TOKYO TOWER

銀座・丸の内
GINZA / MARUNOUCHI
p. 11

東京湾

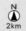

N
2km

本書の使い方
How to use this book

アイコンの見方
Legend

時 営業時間
休 休館日
¥ 利用料※1
住 住所
電 電話※2
交 交通アクセス

※1 ★印のある施設は、障害者手帳をお持ちの方および
その付添の方の利用料が無料です。
※2 ◎印のある電話番号はハローダイヤルです。

H Hours of Operation
C Closed Days
¥ Admission Fee※1
A Address
Ph Telephone Number※2
Ac Access

※1 Facilities marked with an ★ offer free entrance
for those with a physical disability certificate and
their attendant.
※2 Telephone Number marked with an ◎ is Hello
Dial.

凡例
Notes

・本書の情報は2020年12月現在のものです。本書の発
行後に予告なく変更される場合がありますので、利用時
には各施設の公式情報もご確認ください。
・新型コロナウイルス感染症拡大防止対策により、一部の
施設の営業時間や休館日、イベントや各種プログラムの
開催日程等に変更がございます。詳細は各施設にお問
い合わせください。
・交通アクセスに記載の所要時間は、交通状況により異な
ります。お時間に余裕をもってお出かけください。

・ Information listed in this book is current
as of December 2020 and subject to
change without notice after publication.
Please check with each facility for the most
current information at the time of use.
・ Due to measures to prevent the spread
of the new coronavirus, facility operating
hours and schedules for events and
programs are subject to change. Please
contact the specific facility for details.
・ Travel time to these venues may vary
according to traffic conditions. Please allow
your-self plenty of time when visiting them.

銀座・丸の内
GINZA / MARUNOUCHI

① ギンザ・グラフィック・ギャラリー（ggg）
ginza graphic gallery

**日本のグラフィックデザインの
過去・現在・未来をアーカイブする
専門ギャラリー**

1986年に大日本印刷の文化事業の一
環として、東京・銀座に設立されたグ
ラフィックデザイン専門のギャラリー。銀
座は同社の創業の地であり、「ギンザ・
グラフィック・ギャラリー（ginza graphic
gallery）」と名づけられ、3つの「g」の
頭文字から「スリー・ジー（ggg）」の愛
称で親しまれている。2008年に公財
DNP文化振興財団が設立され、その活
動を継承し一層の充実をはかっている。
年間8本程度開催される企画展は、グ
ラフィックデザイナーの個展や国際コン
ペティションの受賞作品の展覧など、国
内外のグラフィックデザインの過去・現
在・未来を紹介する内容。そのほかにも
グラフィックデザイナーの仕事をまとめ
たコンパクト版のビジュアルブック『ggg
Books（世界のグラフィックデザイン）』など
の出版活動も続けられている。
ギャラリー階上2Fの「グラフィック・アー
カイブ・ライブラリ」内では、gggの刊行
物のほか、電子図書館サービスも実施
されており、これまでの展覧会のポス
ター画像や会場の記録映像・写真など
がタブレット端末や持参のスマートフォン
でも閲覧できる。

**A gallery dedicated to archiving
the past, present and future of
Japanese graphic design**

This gallery specializes in graphic
design and was established by Dai
Nippon Printing in 1986. Founded in
Ginza, a mecca for art galleries in Tokyo,
the gallery was named ginza graphic
gallery, also referred to as "three g" or
"ggg." The gallery introduces the past,
present, and future of domestic and
international graphic design through
various activities, from solo exhibitions
of designers to shows featuring award-
winning works from international
competitions. The gallery is also active
in publishing projects.

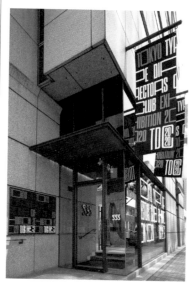

Photo by Mitsumasa Fujitsuka

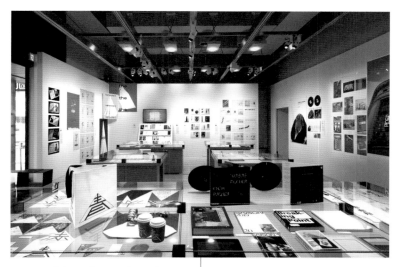

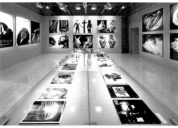

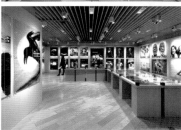

RECOMMENDATION

原研哉
Kenya Hara

ここで個展をやりませんか、とお誘いがあったら、グラフィックデザイナーとして世に認められた証。そんな風にクリエイターたちのあいだでは思われているのではないでしょうか。上下二層にわかれた空間を生かし切るには結構な量の展示コンテンツが必要なのと、観客がクリエイティブな人々なので、生半可な展示だと満足させられない。コンセプトも、作品も、その見せ方も……。会場では常にグラフィックデザイナーの全力投球が見られます。

Being invited to hold a solo exhibition at this gallery is a sign that you have been recognized by the industry as a successful graphic designer. I suspect this is how many creators think of this gallery. To make the most of the upper and lower floors of the gallery, you need a lot of content to exhibit. Since the audience consists of people who are creative themselves, a half-hearted exhibition will not suffice in terms of concept, work, or presentation. This is where you can see graphic designers giving their all.

時 11:00 − 19:00 (イベント開催時は変更あり)
休 日曜・祝日 ¥ 無料
住 東京都中央区銀座 7-7-2 DNP 銀座ビル1F ／ B1F
電 03-3571-5206 交 地下鉄銀座線,日比谷線,丸ノ内線「銀座」駅より徒歩5分
H 11:00-19:00 (hours subject to change for special events) C Sundays and holidays
¥ Free Ad DNP Ginza Building 1F / B1F, 7-7-2 Ginza, Chuo-ku, Tokyo Ph 03-3571-5206
Ac 5 min walk from Ginza Station on the Ginza, Hibiya, and Marunouchi lines
–
www.dnpfcp.jp/gallery/ggg

② クリエイションギャラリー G8 ／ ガーディアン・ガーデン
Creation Gallery G8 / Guardian Garden

**ビジュアル表現を発信する
ふたつのギャラリー**

情報提供ビジネスを展開する株式会社リクルートホールディングスが運営するふたつのギャラリー。もとは1985年に同社の銀座7丁目社屋ビルに「G7ギャラリー」として開館。その後、場所を現在の銀座8丁目ビル1階に移転し、1989年に「クリエイションギャラリーG8」（以下、G8）が誕生。1年後の1990年には渋谷スペイン坂に「ガーディアン・ガーデン」（以下、GG）が誕生した。

G8ではグラフィックデザインやイラストレーション分野で活躍し、日本を代表するクリエイターや優れたデザインを紹介、GGではグラフィックと写真の2部門の公募展の主催および展示を通して若いクリエイターの活動支援を行なっている。G8の「クリエイションギャラリー」という名称は同社の経営全般のアドバイザーでもあったグラフィックデザイナーの亀倉雄策（1915-1997）が1989年に創刊したデザイン誌『CREATION』に由来する。日本のグラフィックデザインを牽引した亀倉は、20世紀の優れた作家たちの仕事を残す活動にも取り組んだ。そうした亀倉の思想を受け継ぎながら、デザインを通じて豊かな生活の提案や、様々な出会いをつくる場所を目指して運営される空間だ。

Two galleries dedicated to supporting visual expression

Two galleries run by Recruit Holdings, an information provider. Both galleries organize exhibitions to introduce graphic design, illustration, and photography. G8 focuses on introducing Japan's leading creators and outstanding design work. Guardian Garden supports young creators by organizing public exhibitions for graphic design and photography. G8 is managed under the philosophy of Yusaku Kamekura, one of Japan's leading graphic designers, who worked to preserve the work of the best designers of the 20th century through a design magazine, "CREATION."

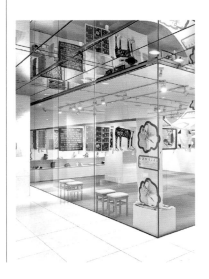

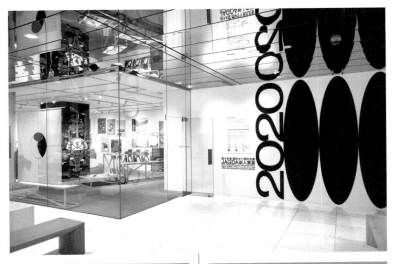

時 11:00–19:00　休 日曜・祝日　¥ 無料

住 [G8]東京都中央区銀座8-4-17 リクルートGINZA8ビル1F　[GG]東京都中央区銀座7-3-5 ヒューリック銀座7丁目ビルB1F

電 [G8]03-6835-2260　[GG]03-5568-8818

交 [G8]JR,地下鉄銀座線「新橋駅」より徒歩3分 [GG]JR,地下鉄銀座線「新橋駅」より徒歩5分

H 11:00-19:00　C Sundays and holidays ¥ Free　Ad [G8] 1F Recruit Ginza 8 Building, 8-4-17 Ginza, Chuo-ku, Tokyo　[GG] 1F Recruit Ginza 8 Building, 8-4-17 Ginza, Chuo-ku, Tokyo Ph [G8] 03-6835-2260　[GG] 03-5568-8818 Ac [G8] 3 min walk from Shinbashi Station on the JR and Ginza lines　[GG] 5 min walk from Shinbashi Station on the JR and Ginza lines

–

[G8] rcc.recruit.co.jp/g8
[GG] rcc.recruit.co.jp/gg

RECOMMENDATION

アイデア編集部
IDEA

毎年グラフィックと写真の2部門にわけて、GGで開催されるコンペティション「1_WALL」は、デザイン界における若手の登竜門的存在。一次・二次の審査を通過したファイナリスト6名によるグループ展が開催され、期間中行われる各自のプレゼンテーションにより最終的なグランプリが決まるというシステムで、グランプリ受賞者は個展の機会を得られる。審査員を務める現役グラフィックデザイナー、イラストレーターの顔ぶれも豪華。

The annual competition *1_WALL*, which is divided into two categories for graphics and photography, is a gateway to success for young artists in the design world. The six finalists who pass the first and second rounds are invited to participate in a group exhibition. The grand prize is awarded based on the artists' presentations during the exhibition, with the winner receiving an opportunity to hold a solo exhibition. An impressive lineup of graphic designers and illustrators serve as judges for the competition.

③ 東京ステーションギャラリー
Tokyo Station Gallery

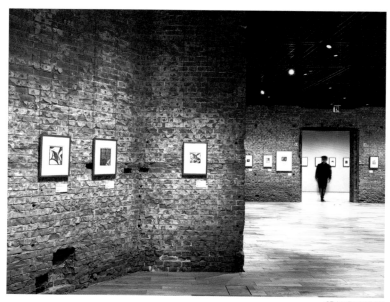

©Tokyo Tender Table

近代日本の玄関口を
新たな文化拠点に

1988年、重要文化財である東京駅丸の
内駅舎内に開館した美術館。東京駅の
歴史を体現する煉瓦壁の展示室をもつ
美術館として親しまれ、東京駅舎の復
原工事を経て2012年に現在のかたちに
リニューアルオープン。日本の近代化を
象徴する鉄道駅舎として時代時代をみ
つめてきた建造物は、新たな文化拠点
として多くの来場者を迎えている。建造
物はもちろん、近代美術を中心に、鉄道、
建築、デザインまで幅広いテーマで開催
される企画展も見応えあり。

A new cultural hub at the gateway to modern Japan

This museum opened in 1988 inside the Marunouchi Station Building, recognized as an Important Cultural Asset. Known for its brick-walled exhibition space that embodies the history and identity of the Tokyo Station, the museum reopened in 2012 following the restoration of the station building. The building, which has witnessed years of history and serves as a symbol of Japan's modernization, now welcomes visitors as a new cultural center. The museum is worth a visit not only for its architectural value but for the special exhibitions with themes ranging from modern art, railways, architecture, and design.

名建築を味わう
東京ステーションホテル

同じ丸の内駅舎にある東京ステーションホテルは,国内外の賓客や訪日外国人を迎えるための名門ホテルとして駅舎の開業から1年後の1915(大正4)年に誕生。川端康成や松本清張ら文豪たちにも愛され,沢山のエピソードが知られている。2012年の駅舎リニューアルでは,戦時中に焼失した3階建てドーム屋根が復元され,ホテル内は内装を一新した。ホテルの一室からも眺められるドーム天井内の美しいレリーフは必見。誕生当初の姿に甦った赤レンガの建築物は,駅内のショップなどを含む複合施設「Tokyo Station City」の顔として丸の内の新たな名所となっている。

🕐 10:00 — 18:00,
(金曜)10:00 — 20:00 (入館は閉館30分前まで)
🈺 月曜(祝日の場合は翌平日),年末年始,展示替期間
💴 展覧会により異なる
🏠 東京都千代田区丸の内1-9-1
☎ 03-3212-2485
🚉 JR「東京駅」丸の内北口改札前より徒歩0分
🕐 10:00-18:00, Fridays 10:00-20:00 (Admission
until 30 min before closing)
🈺 Mondays (or following weekday if Monday
is a holiday), New Year holidays, and between
exhibitions
💴 Fees vary by exhibition
🏠 1-9-1 Marunouchi, Chiyoda-ku, Tokyo
☎ 03-3212-2485
🚉 In front of Marunouchi North Exit of JR Tokyo
Station
–
www.ejrcf.or.jp/gallery/

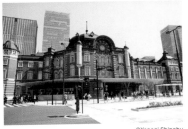

©Yanagi Shinobu

RECOMMENDATION

佐藤亜沙美
Asami Sato

街に貼られた同館のポスターが印象的で、それをきっかけに度々足を運んでいる。特に「メスキータ」展は印象的で、数種類作成された告知広告はこの作家をよくあらわしていた。図録も手が込んでおり、「コデックス装」と呼ばれる開きの良い本体に対して、上から黒の寒冷紗が巻かれ製本されている。わたしが以前、製本会社に相談した際にはどこもお手上げだったのだが、見事にそれが施されていて、素晴らしいアプローチだと思った。

I visit the museum often, having been attracted by the posters of the museum I saw around the city. *The Mesquita exhibition* left a particularly strong impression, and I thought the several different advertisements for the show did a good job of capturing the essence of the artist. The catalogue was elaborately designed, with black cheese cloth wrapped around the Codex binding. In the past, when I had consulted with the book binders to use this technique myself, they had given up on me, but this catalog was beautifully made, and I thought it was an excellent approach.

④ JPタワー学術文化総合ミュージアム 「インターメディアテク」
JP Tower Museum INTERMEDIATEQUE

**リ・デザインの視点から歴史資料を
未来につなげる博物館**

**A museum that connects
historical resources with
cutting-edge technology**

東京大学が1877年の創設以来収集してきた学術資料を整理、保管、研究、公開する博物館活動を行う東京大学総合研究博物館（UMUT）は、現在、同大学の本郷キャンパス内に位置する本館とあわせて、小石川分館、インターメディアテク、宇宙ミュージアムTeNQの合計4館によって組織されている。KITTE丸の内にあるインターメディアテクは、同ビルを運営する日本郵便（株）との協働運営による公共施設で、博物館学の視点から保管・陳列されてきた歴史的な学術標本を、多様な表現メディアと関連付け、先端的なテクノロジーと伝統的なものづくり技術の融合を試みる実験的な展示施設。昭和モダニズムの名建築である旧東京中央郵便局舎の姿を残した展示室内には、東京大学で戦前から使われてきた展示什器も設置されており、歴史の流れを感じながら貴重資料の数々に出会える鑑賞体験を演出する空間づくりは、2013年のグッドデザイン賞にも輝いている。東京駅から地下道直結というアクセスでありながら、入館料無料というのも魅力のひとつ。博物館をより身近な場所として感じ、未来のものづくりにつなげるための新しいミュージアムだ。

The University Museum, the University of Tokyo (UMUT) organizes, stores, researches, and displays the academic heritage collected by the University of Tokyo since its founding in 1877. The institution currently consists of the main building located on the university's Hongo campus, the Koishikawa annex, the INTERMEDIATEQUE, and the TeNQ Space Museum. The INTERMEDIATEQUE inside the KITTE Marunouchi building is a public facility jointly operated with the owner of the building, Japan Post Co., Ltd. It is an experimental exhibition facility that combines historical specimens, stored and displayed from a museological perspective, with a variety of expressive media in an attempt to fuse cutting-edge technology with traditional manufacturing techniques.

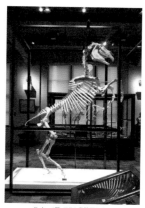

インターメディアテク常設展示内ウマ骨格標本
© インターメディアテク

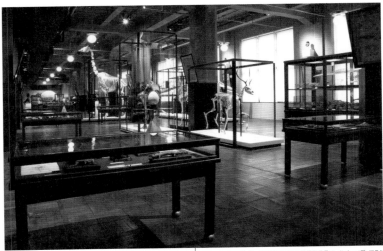

インターメディアテク2階常設展示風景 © インターメディアテク

インターメディアテク内ギメ・ルーム開設記念展「驚異の小部屋」展示風景
© インターメディアテク

空間・展示デザイン © UMUT works

時 11:00－18:00（金曜・土曜は20時まで開館）
休 月曜日（祝日の場合は翌平日）、年末年始、その他館
が定める日　￥ 無料
住 東京都千代田区丸の内2-7-2 KITTE2・3F
電 050-5541-8600◎
交 JR「東京駅　丸の内南口」より徒歩1分
H 11:00 - 18:00 (Open until 20:00 on Fridays
and Saturdays)　C Mondays (or the following
Tuesday if Monday is a National Holiday) and
Year-end holidays, May close irregularly.
￥ Free　Ad KITTE 2-3F, 2-7-2 Marunouchi,
Chiyoda-ku, Tokyo　Ph 050-5541-8600◎
Ac 1 min walk from Marunouchi South Exit of JR
Tokyo Station
-
www.intermediatheque.jp

7

アイデア編集部
IDEA

KITTE丸の内の地下1階から地上6階まで7
つのフロアには、全国各地のご当地の味や日
本のものづくりをテーマにしたショップやデザ
イン商品を扱うショップが充実しており、お土
産や贈り物を探すのにもおすすめ。ビジュア
ルアイデンティはクリエイティブディレクション
を原研哉、アートディレクションとデザインを三
澤遥のふたりが手がけている。

The seven floors of KITTE Marunouchi,
from the basement to the sixth floor, are
filled with stores featuring local flavors,
Japanese craftsmanship from across the
country, and design products, making it
a great place to shop for souvenirs and
gifts. As the creative director, Kenya
Hara oversaw the visual identity, and
Haruka Misawa was in charge of the art
direction and design.

⑤ 銀座ソニーパーク
Ginza Sony Park

Ginza Sony Park

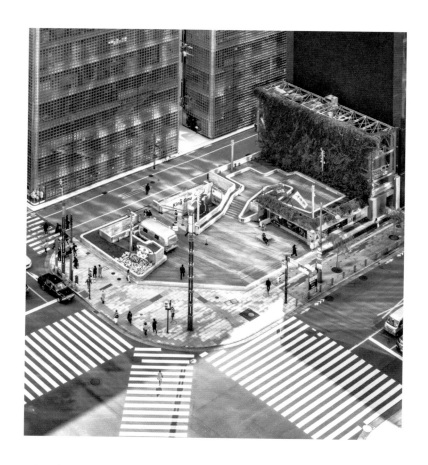

**これからの銀座を俯瞰する
オープンスペース**

ソニーの創業70周年を機に、2018年に旧ソニービルが「Ginza Sony Park」としてリニューアル。再開発が乱立する銀座の街で、建物を解体した後の空間を一時的に公園として活用し、銀座の地に根付いた新しい空間づくりを検討するためのプロジェクトが進行中。地下4層の「ローワーパーク」で構成されたオープンスペースでは、年間を通して驚きや遊び心が感じられる体験型イベントやライブなどが実施されている。2025年には地上部に新ソニービルが「Ginza Sony Park」最終形として開業予定。

数寄屋橋から生まれる
新しいコミュニケーション

地下4層のローワーパークでは、過去に
トラヤカフェの期間限定店舗が出店する
など、人気カフェや飲食店のポップアッ
プストアが営業中で、期間により様々
な銀座の旬を味わうことができる。ま
た、2019年には、TOKYO ART BOOK
FAIRが1ヶ月にわたり開催されるなど、文
化発信プログラムも充実しており、各界
の著名人や専門家を講師に招いたオー
プンカレッジや、アーティストとのコラボ
レーションイベントなども開催されている。
常に変化する空間のなかでたくさんの刺
激に出会えるユニークな施設だ。

An open space with a bird's-eye view of the future of Ginza

On Sony's 70th anniversary, the former
Sony Building reopened as the new
Ginza Sony Park in 2018. In Ginza, where
redevelopment is rampant, a project
is underway to temporarily transform
the area from the demolition of the old
building into a public park, creating
a new space that will become part of
the neighborhood. Underneath it will
be a four-story underground structure
called the Lower Park, which will host
a variety of fun events and exciting
live performances to entertain visitors
throughout the year. Sony's final form of
their new building "Ginza Sony Park" is
planned to open in 2025.

🕐 11:00－19:00,地上部は5:00－24:30の間出入り
自由　🏠 12月30日－1月3日　💴 無料
🚃 東京都中央区銀座5-3-1　🚇 地下鉄丸の内線,銀
座線,日比谷線「銀座駅」B9番出口直結
🕐 11:00-19:00 (Above-ground floor is open from
5:00 - 24:30)
🏠 New Year holidays　💴 Free
📍 5-3-1 Ginza, Chuo-ku, Tokyo
🚶 1 min walk from Ginza Station on the
Marunouchi, Ginza, and Hibiya lines
－
www.ginzasonypark.jp

RECOMMENDATION

7

アイデア編集部
IDEA

「変わり続ける公園」がコンセプトとなった同
ビルのリニューアル計画は、ソニービル時代
にソニー創業者のひとり盛田昭夫と設計者
の芦原義信が残した「銀座の庭」の発想を
継承し、拡張したもの。大都市東京におけ
るあたらしい公園を体験できるプロジェクト
は、2019年度のグッドデザイン金賞（経済産業大
臣賞）を受賞している。
The renovation plan for the building,
based on the concept of it being
an ever-changing park, inherits and
expands on the idea of the Ginza
Garden from the era of the former
Sony Building. This idea was originally
conceived by one of the founders
of Sony, Akio Morita, and architect
Yoshinobu Ashihara. The project, which
allows visitors to experience a new kind
of park in the Tokyo metropolis, won the
2019 Good Design Gold Award.

⑥ 無印良品 銀座
MUJI Ginza

**銀座から世界へ、
ライフスタイルを提案する店舗**

東京・銀座の並木通りに2019年にオープンした無印良品の世界旗艦店。銀座の地に世界中から訪れる人や、銀座界隈で働き生活を営む人、生産者などとつながり、生活者の視点から本当に暮らしに必要な商品とサービスを提供することを目指している。なかでも、地下1階と地上1階に展開される「食」関連の商品・サービスには力が注がれ、関東近県の農家を中心とした全国との繋がりによる産地直送の青果の販売や、「素の食」をテーマとするレストラン「MUJI Diner」の展開など、食べ物と人との関係を再度見つめなおす空間が提供されている。

A store that proposes a lifestyle from Ginza to the world

This is MUJI's global flagship store, which opened in 2019. The concept aims to provide truly essential products and services by cnnecting everyday people, including visitors from around the world, with producers and farmers, and people who work and live in the Ginza area. The store focuses on food-related products and services, which are offered on the basement floor and first floor. There are displays of fresh fruit and vegetables delivered directly from local mostly farms in the neighboring Kanto prefectures. The MUJI Diner, a restaurant focusing on the concept of "simple food," provides a space to re-examine the relationship between food and people.

高層階に広がる新感覚の
都市型ホテル

店舗の6〜10階には、日本初の無印良
品のホテル「MUJI HOTEL GINZA」
もオープンし、79部屋の客室を提供す
る。フロント階には、複合的なデザイン文
化の発信基地である「ATELIER MUJI
GINZA」が展開され、飲食やイベントを
楽しむサロンやラウンジのほか、ものづ
くりやデザインにまつわる展示を行うふ
たつのギャラリースペースと、デザインや
アートの書籍を揃えたライブラリースペー
スが併設されている。また、内装には、
木・石・土を中心に、路面電車の敷石や
船の廃材が再利用されるなど、時間がつ
くり出す風合いを空間に取り入れている。

時 公式情報をご確認ください
住 東京都中央区銀座3-3-5　電 03-3538-1311
交 地下鉄丸の内線、銀座線、日比谷線「銀座駅」より
徒歩3分
H See website for official information
Ad 3-3-5 Ginza, Chuo-ku, Tokyo
Ph 03-3538-1311　Ac 3 min walk from Ginza
Station on the Marunouchi, Ginza, and Hibiya
lines
–
shop.muji.com/jp/ginza

RECOMMENDATION

中島祐介
Yusuke Nakajima

6FのMUJI HOTELフロントに併設したライ
ブラリーには、MUJIの世界観で選ばれたA-Z
のキーワードに紐づくビジュアルブックが並ん
でいる。設定されたキーワードが興味深いの
に加え、滅多に手にとって見ることができない
貴重な本も多く取り揃えていて、一般公開され
ているライブラリーとしてはなかなか類を見な
い充実ぶり。
The library is attached to the MUJI
HOTEL lobby on the 6th floor and
contains visual books associated with
keywords, arranged in alphabetical
order from A-Z, that were selected
based on MUJI's philosophy. The
keywords themselves are interesting,
and the selection includes many rare
and valuable books, making this one of
the more unique libraries that is open to
the public.

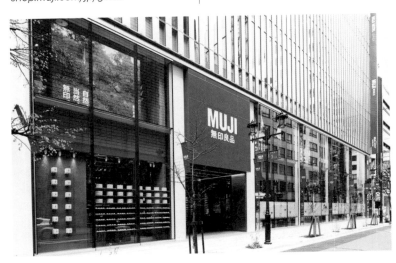

7 CLASKA Gallery & Shop "DO" 丸の内店
CLASKA Gallery & Shop "DO" Marunouchi

ほしいものが見つかる空間

建物の老朽化にともない2020年をもって閉店となった東京・目黒のデザインホテルCLASKA。そのなかのショップとして始まったCLASKA Gallery & Shop "DO"（クラスカ ギャラリー&ショップ ドー）では、現代の日本の暮らしに映える工芸品やプロダクト製品などを取り扱う。都内には丸の内店を含め7店舗を展開。各都市にも店舗を構えるほか、オンラインショップでも購入可能。オリジナルデザインの商品や様々なつくり手と協同で開発した商品なども販売し、日用品からギフトや東京土産まで、心地良い品々に出会える空間。

A store with everything from daily necessities to gifts

Originally a part of the CLASKA hotel in Meguro, Tokyo, which closed its doors in 2020, the store sells a wide range of items, from craftwork to products that complement modern Japanese lifestyle. They also carry items under their own brand and some developed in collaboration with others. With seven stores across Tokyo, including the KITTE Marunouchi store, you'll find a wide range of products from everyday necessities to gifts and Tokyo souvenirs.

11:00－21:00（日曜・祝日は20時まで）
無料　東京都千代田区丸の内2-7-2 KITTE 4F
03-6256-0835
JR,地下鉄丸ノ内線「東京駅」より徒歩1分
11:00-21:00, Sundays and Holidays 11:00-20:00　Free　KITTE 4F, 2-7-2 Marunouchi, Chiyoda-ku, Tokyo
03-6256-0835　1 min walk from Tokyo Station on the JR and Marunouchi lines
–
do.claska.com/shop/marunouchi

RECOMMENDATION

渡部千春
Chiharu Watabe

"DO"の重要性を実感したのは40代になった頃。生活雑貨も少し良いものが欲しい、かつ必要になってきたけれど、デザイン名作や純民芸はまだちょっと重い。お箸から紙モノから普通に使えるものを扱っている店って意外にない。こういう悩みをもった「中年生活雑貨難民」向けにはうってつけなお店がここに！と感動しました。ディレクターを務める大熊健郎氏とは20年余りの知己ですが、大熊さんの選ぶものは間違いない、と断言できます。
I realized the value of DO when I was in my 40s. I wanted and needed a few good household items, but design masterpieces and pure folk art still felt a bit too heavy. Surprisingly, there were no stores that offered simple, everyday items you could use with ease, from chopsticks to paper goods. I thought, this is the perfect place for middle-aged refugees deprived of good, everyday stuff! I've known the director of the store, Takeo Okuma, for more than 20 years, and I can tell you that his choices are solid.

8 デザインギャラリー1953
Design Gallery 1953

鑑賞だけでなく、購入も可。
グッドデザインの歴史を語り継ぐスペース

1964年に銀座を代表する百貨店、松屋銀座の7Fに開設されたデザインのためのギャラリー。「デザインの啓蒙」を旗印に1953年に発足した「日本デザインコミッティー」の拠点的な立ち位置でオープンし、企画から運営までをメンバーが手がける展覧会は毎回バラエティに富んでいる。隣接する「デザインコレクション」では、メンバーによってセレクトされた世界中の優れたデザイングッズ・コレクションも販売。日常生活にもより良いデザインを浸透させようとするコミッティーの活動を象徴するスペースだ。

Design items for display and for sale while showcasing the history of good design

This gallery opened in 1964 inside Matsuya Ginza, one of the area's most respected department stores. It was established as the hub of the Japan Design Committee, which was founded in 1953 under the banner of "design enlightenment." The gallery hosts a wide variety of exhibitions and sells a collection of well-designed items selected from around the world by the committee members.

時 10:00−20:00 休 松屋銀座の営業時間に準ずる
¥ 無料 住 東京都中央区銀座3-6-1 松屋銀座7階
電 03-3567-1211（10:00-20:00、7階デザインコレクションまで） 交 地下鉄銀座線,丸ノ内線,日比谷線「銀座駅」より徒歩3分

H 10:00-20:00 C Same as Matsuya Ginza business hours ¥ Free Ad 3-6-1 Ginza, Chuo-ku, Tokyo, located on the 7th floor of Matsuya Ginza Ph 03-3567-1211 (from 10:00-20:00, please call Design Collection on the 7th floor) Ad 3 min walk from Ginza Station on the Ginza, Marunouchi, and Hibiya lines

–
designcommittee.jp/gallery

RECOMMENDATION

原研哉
Kenya Hara

僕は銀座で働くようになって37年になりますが、一番身近なデザインギャラリーであり、まさに近所の出来事として親しみ続けてきました。小さなギャラリーですが、毎回、空間を生かす展示の着想が違っていて飽きません。そういえば、生まれて初めて個展を開いたのはここでした。ギャラリーの外壁には、これまで開催されてきた展覧会名がきちんと記録されていて、今後開催される展覧会名が記されるべき広大な余白も残されています。

I have been working at Ginza for 37 years now, and this is the design gallery I am most familiar with. I have continued to enjoy it as a neighborhood affair. It's a small gallery, but they continue to come up with new ideas for making the most of the space, and I never get tired of it. Come to think of it, it was here that I had my very first solo exhibition. The names of past exhibitions are neatly recorded on the outside wall, which still has ample room available for upcoming shows.

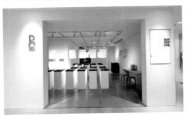

Nacása & Partners Inc.

銀座・丸の内の行きたいショップ・見たい建築
Shops and architecture in Ginza / Marunouchi

パナソニック汐留美術館
Panasonic Shiodome Museum of Art

ジョルジュ・ルオー（1871−1958）の絵画や版画作品など約240点を収蔵する美術館。その一部を常設展示するほか、パナソニック社と関わりの深い、建築や工芸デザインをテーマとした企画展も年間を通じて開催される。

The museum houses approximately 240 paintings and prints by Georges Rouault (1871-1958). Some of these works are on permanent display, and the museum also holds special exhibitions throughout the year that focus on architecture and craft design works that have close ties to Panasonic.

🏠 東京都港区東新橋1-5-1 パナソニック東京汐留ビル4F
📧 050-5541-8600 ◎　Ad Panasonic Tokyo Shiodome Building 4F, 1-5-1 Higashi-Shimbashi, Minato-ku, Tokyo
Ph 050-5541-8600 ◎

アドミュージアム東京
The Ad Museum Tokyo

世界でも珍しい広告専門のミュージアム。江戸時代から現代まで約32万点の資料を収集・公開しており、広告の社会的・文化的価値への理解を深める活動を行っている。

A one-of-a-kind museum that is specialized for advertising. The museum collects and displays approximately 320,000 resources on advertising and marketing, from the range of the Edo period to the present day. The facility is engaged in activities that help deepen the public's understanding of the social and cultural value of advertising.

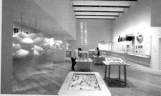

🏠 東京都港区東新橋 1-8-2 カレッタ汐留　📧 03-6218-2500
Ad Caretta Shiodome, 1-8-2 Higashi-Shimbashi, Minato-ku, Tokyo　Ph 03-6218-2500

資生堂ギャラリー
Shiseido Gallery

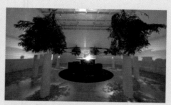

1919年に資生堂社内に開設された陳列場にはじまる日本最古の画廊。90年代からは現代美術を軸に同時代の表現を積極的に紹介しており、現在地にリニューアルオープンして以降は空間的にも充実した展示を実現している。

This is Japan's oldest art gallery, which began as an exhibition hall on Shiseido's company premises in 1919. Since the 90s, the gallery has been actively introducing contemporary art and other contemporary works of the time. The exhibition space has been enhanced since it reopened at its current location.

8/25−9/26「記憶の珍味　諏訪綾子展　Taste of Reminiscence
Delicacies from Nature」撮影：加藤健

🏠 東京都中央区銀座 8-8-3 東京銀座資生堂ビルB1F
📧 03-3572-3901　Ad Tokyo Ginza Shiseido B1F, 8-8-3 Ginza Chuo-ku, Tokyo　Ph 03-3572-3901

銀座メゾンエルメス
GINZA MAISON HERMÈS

エルメス銀座店のほかギャラリーと予約制のミニシアターが併設された「メゾン（家）」。隣接するビルの建て壊しによりガラスブロック造の美しいファサードが見えるようになった。設計はレンゾ・ピアノ。

In addition to the Hermes Ginza store, the Maison (House) has a gallery and an appointment-only mini-theater. The recent demolition of the adjacent building revealed a beautiful side of the glass block structure. The building was designed by Renzo Piano.

🏠 東京都中央区銀座 5-4-1　📧 03-3569-3300
Ad 5-4-1 Ginza, Chuo-ku, Tokyo　Ph 03-3569-3300

©Nacása & Partners

ポーラ ミュージアム アネックス
POLA MUSEUM ANNEX
POLA MUSEUM ANNEX

美容、美術、美食をコンセプトとするポーラ銀座ビルで、年間を通じ無料の企画展を開催。箱根の本館で収蔵される名作の数々から現代アートまで、気軽にアートを楽しみ、美意識を磨ける機会を提供している。

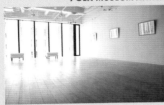

Free special exhibitions are held throughout the year in the POLA Ginza, a building based on the concepts of beauty, art, and gastronomy. Displaying selected works from the collection of masterpieces housed in the main building in Hakone, the gallery offers visitors an opportunity to enjoy art and inspire their aesthetic sensibilities in a casual setting.

住 東京都中央区銀座1-7-7 ポーラ銀座ビル 3階
電 050-5541-8600 ◎ Ad Pola Ginza Bldg 3F, 1-7-7 Ginza, Chuo-ku, Tokyo Ph 050-5541-8600

銀座 蔦屋書店　銀座 蔦屋書店
GINZA TSUTAYA BOOKS

本を介してアートと日本文化と暮らしをつなぎ「アートのある暮らし」を提案する総合書店。店内には書籍フロアのほか、カフェやギャラリー、雑貨コーナーもあり、本やアートを眺めながら思い思いの時間を過ごせる。

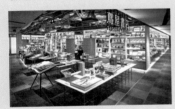

A large bookstore that uses the theme of "life with art" to connect art, Japanese culture, and lifestyle through books. In addition to the books section, the store also has a café, gallery, and retail corner, allowing visitors to enjoy time among books and art.

住 東京都中央区銀座6丁目10-1 GINZA SIX 6F
電 03-3575-7755
Ad 6-10-1 Ginza, Chuo-ku, Tokyo Ph 03-3575-7755

森岡書店
Morioka Shoten

MORIOKA SHOTEN & CO., LTD.
A SINGLE ROOM WITH A SINGLE BOOK.
SUZUKI BUILDING, 1-28-15 GINZA,
CHUO-KU, TOKYO, JAPAN
◆

銀座の中心街から離れた一角にある書店兼ギャラリー。通常の書店のような在庫はもたず、その時々で一冊を取り上げ、本からインスパイアされた展覧会を開催している。本との対話を楽しめる贅沢な空間。

This bookstore and gallery is located in a remote corner a few minutes away from the center of Ginza. Rather than carrying an inventory of mainstream titles, the store occasionally holds exhibitions that are inspired by a single book. It is a luxurious space where visitors can delve deeply into a dialogue with books.

住 東京都中央区銀座1-28-15 鈴木ビル1階
電 03-3535-5020 Ad Suzuki Building 1F, 1-28-15 Ginza, Chuo-ku, Tokyo Ph 03-3535-5020

UNIQLO TOKYO
UNIQLO TOKYO

2020年に完成したユニクロのグローバル旗艦店。ユニクロのLifeWearを体現する店舗として、1階から4階までを貫く大きな吹き抜けが特徴。1階にある「LifeWear Square」ではシーズン毎に異なる展示があり、生活を彩るアイテムのひとつとして生花も販売している。

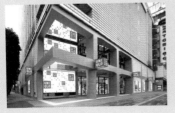

UNIQLO's global flagship store completed in 2020. The building has a large open ceiling from the 1st floor to the 4th floor, to represent UNIQLO's concept of LifeWear. "LifeWear Square" on the 1st floor of the store shows different exhibits every season and also sells flesh flower arrangement as one of the items to color customers's lives.

住 東京都中央区銀座三丁目2番1号 マロニエゲート銀座2 地上1-4階 電 03-5159-3931 Ad Marronnier Gate Ginza 2 1-4F, 3-2-1 Ginza, Chuo-ku, Tokyo Ph 03-5159-3931

王子ペーパーライブラリー
OJI PAPER LIBRARY

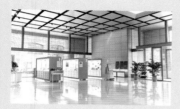

総合製紙メーカーの王子グループが運営するギャラリー。約200種類の紙サンプルの無償配布や、紙はもちろん、森づくりや環境対応などの取り組みを切り口としたテーマ展の開催など、様々な情報を配信している。

A gallery that is run by the Oji Group, a general paper manufacturer. The gallery has exhibited about 200 paper samples, such as forest planting, environmental response based themed, and held various exhibitions to share knowledge and information about paper.

🏠 東京都中央区銀座4-7-5 王子ホールディングス本館1階
☎ 03-3563-4523　Ad Oji Holdings Main Building 1F, 4-7-5 Ginza, Chuo-ku, Tokyo　Ph 03-3563-4523

松竹大谷図書館
Shochiku Otani Library

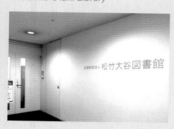

松竹大谷図書館

歌舞伎座近くの演劇・映画の専門図書館。貸し出しサービスは行っていないが、歌舞伎からアニメまで幅広いジャンルの演劇・映画の台本やプログラム、写真などの貴重資料を49万点以上所蔵し、無料で一般公開している。
（日本語資料のみ）

Special Library of theatre and movie near Kabuki-za Theatre. Although materials are not available for loan, visitors may gain access to approximately 490,000 pieces of the collection of valuable resources, such as theatre and movie's script, program, and photos of the wide genre from Kabuki to anime. (Only Japanese resources)

🏠 東京都中央区築地1-13-1 銀座松竹スクエア3階
☎ 03-5550-1694　Ad Ginza Shochiku Square, 3F, 1-13-1 Tsukiji, Chuo-ku, Tokyo　Ph 03-5550-1694

三菱一号館美術館
Mitsubishi Ichigokan Museum, Tokyo

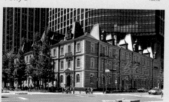

1894年に竣工した赤煉瓦造の建物を復元し2010年美術館として開館。近代美術を中心に企画展が年3回開催。19世紀末西洋美術を中心としたコレクションも魅力のひとつであり、ミュージアムカフェやショップなども充実。

A red-brick building constructed in 1894 has been reborn as a museum, offering exhibitions centered on modern art three times a year. The museum's collection of late 19th-century Western art is one of its main fascinating, and it also has a museum café and store.

🏠 東京都千代田区丸の内2-6-2　☎ 050-5541-8600◎
Ad 2-6-2 Marunouchi, Chiyoda-ku, Tokyo
Ph 047-316-2772 (Foreign language support)◎

ハーマンミラーストア丸の内
HermanMiller Store Marunouchi

HermanMiller

アーロンチェアやチャールズ&レイ・イームズのデザイン家具など取り扱う家具メーカーの日本直営店舗。同社の取り扱い製品の一部を直に体験できるほか、展示やワークショップなどのイベントも行われている。

Herman Miller, a furniture manufacturer, owns and operates this store that carries the Aeron Chair and furniture designed by Charles & Ray Eames. The store offers visitors the opportunity to experience products firsthand and attend exhibitions and workshops.

🏠 東京都千代田区丸の内2-1-1　☎ 03-3201-1820
Ad 2-1-1 Marunouchi, Chiyoda-ku, Tokyo
Ph 03-3201-1820

Daici Ano

六本木
ROPPONGI

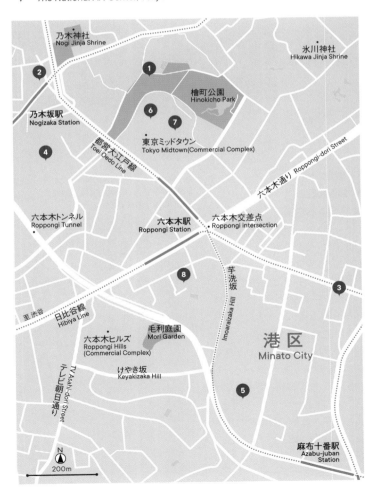

1 21_21 DESIGN SIGHT
21_21 DESIGN SIGHT

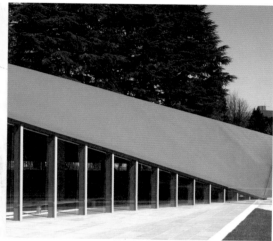

Photo: Masaya Yoshimura

デザインの視点から
社会との関係を探る、
デザイン専門の展示施設

デザインの発信・普及の場として、2007年に東京ミッドタウンの敷地内につくられた施設。デザイナーの三宅一生、グラフィックデザイナーの佐藤卓、プロダクトデザイナーの深澤直人、デザインジャーナリストの川上典李子を中心に、展覧会のテーマや内容などについて検討を行っている。一枚の鉄板からつくられているシンボルマークの住居表示板のようなデザインは、本館がデザインの「場」であることを示し、日常に潜む可能性をデザインによって引き出すというコンセプトを表現。ロゴの21と21の間は人間の目の幅になるよう、制作された。

A facility dedicated to exploring the relationship between society and design

This facility was constructed on the grounds of Tokyo Midtown in 2007 as a venue dedicated to the promotion and dissemination of design. Designer Issey Miyake, graphic designer Taku Satoh, product designer Naoto Fukasawa, and design journalist Noriko Kawakami are at the center of discussions regarding the facility's exhibitions and content. The facility's logo symbolizes the concept of using design to open our eyes to the possibilities of everyday life. The distance between the numbers 21 and 21 is meant to be the space between the human eyes.

「一枚の鉄板」からつくられた
地下に広がる建築デザイン

三宅一生の服づくりのコンセプトである「一枚の布」に着想を得た本館の建築は、安藤忠雄によるもの。地面に向かって傾斜する、一枚の鉄板を折り曲げたような屋根が独創的で、全体のボリュームの約8割が地下に埋設されている。ショップがある地上階を降りると、地下階はふたつのギャラリーから構成されているが、日本最長の複層ガラスと高い天井から自然光が差し込む設計により、地下であることを意識させない。開館10周年を迎えた2017年には、デザインのプレゼンテーション・スペースとして、別棟にギャラリー3が開設された。

🕐 10:00－19:00（入館は閉館30分前まで）
🈚 火曜,年末年始,展示替期間
💰 一般1200円,大学生800円,高校生500円,中学生以下無料
🏠 東京都港区赤坂9-7-6 東京ミッドタウン ミッドタウン・ガーデン内　📞 03-3475-2121
🚇 地下鉄大江戸線,日比谷線「六本木駅」,千代田線「乃木坂駅」より徒歩5分

🕐 10:00-19:00 (Admission until 30 min before closing)　🅒 Tuesdays, New Year holidays, and between exhibitions
💰 General ¥1,200, university students ¥800, high school students ¥500, free for junior high school students and younger
🏠 Midtown Garden, Tokyo Midtown, 9-7-6 Akasaka, Minato-ku, Tokyo　📞 03-3475-2121
🚇 5 min walk from Roppongi Station on the Oedo and Hibiya lines, 5 min walk from Nogizaka Station on the Chiyoda line

–
www.2121designsight.jp

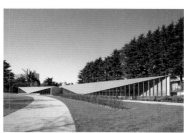

RECOMMENDATION

7

アイデア編集部
IDEA

エントランス部分には展覧会ごとの関連書籍やデザイングッズを取り扱うショップも併設されており、立ち寄りたいポイント。「デザインの視点」をもち帰ることのできるアイテムが揃えられており、なかでも鮮やかな青と白の「21_21」のシンボルマークをモチーフにした佐藤卓デザインのオリジナルグッズが目を引く。At the entrance of the museum, there is a store selling books and design-related items that are relevant to each exhibition, making it a must-stop for visitors. There are a variety of items that allow visitors to take home and be inspired by a new design perspective. Items featuring the blue and white 21_21 logo, by Taku Satoh, are also eye-catching.

❷ TOTOギャラリー・間／ Bookshop TOTO
TOTO GALLERY・MA / Bookshop TOTO

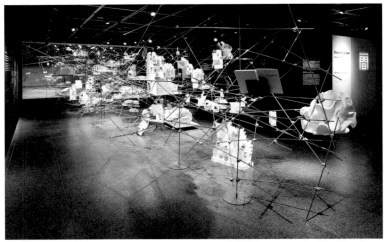

平田晃久展 Discovering New（2018年）© Nacása & Partners

出展者による空間のつくり込みも見所な建築の専門ギャラリー「TOTOギャラリー・間」

住宅設備機器メーカーであるTOTOが社会貢献の一環として運営する、建築の専門ギャラリー。1985年の開設以来、運営委員による企画のもと、国内外の建築家の個展を開催してきた。発足時のメンバーには、グラフィックデザイナーの田中一光も名を連ねる。展示デザインを出展者に委ねることで、展示空間そのものも作品として紹介。GALLERY 1から外部の中庭を抜けてGALLERY 2に至るという、全体で240平方メートルほどの小さなギャラリー空間に、出展者の思想や価値観の凝縮したメッセージ性の高い展覧会を発信している。

An architecture gallery featuring exhibitions with incredible spatial presentations, TOTO GALLERY・MA

This gallery specializes in architecture and is run by the housing equipment manufacturer TOTO as part of its philanthropic efforts. The venue has hosted solo exhibitions of domestic and international architects since its establishment in 1985. Graphic designer Ikko Tanaka was one of the members who managed the gallery at the time of its founding. Exhibitors are entrusted with the design of the exhibitions, which results in shows where the space itself becomes part of the artwork. The small gallery, which is about 240 square meters in total, extends from GALLERY 1 to GALLERY 2 and through an outside courtyard. During an exhibition, it becomes a condensed expression of the exhibitors' ideas and values.

独自のセレクトが並ぶ建築・デザインの専門書店「Bookshop TOTO」

1995年に、TOTOギャラリー・間のミュージアムショップとして、また、建築・デザイン・生活文化をテーマに書籍の発行を行うTOTO出版の直営書店として設立された。ギャラリーでの出展者や展覧会企画テーマの関連書籍のほか、日本の伝統的な建築や日本庭園に関する本を集めたコーナーや、スタッフによる独自の切り口でセレクトしたフェア棚などを通して、国内外の建築・デザインを中心とした書籍や雑誌を紹介。TOTO出版書籍のサイン本コーナーも人気。TOTOギャラリー・間休館中も土曜・日曜・月曜・祝日を除いて営業。

[TOTOギャラリー・間]
🕐 11:00－18:00　🚫 月曜・祝日, 夏期休暇・年末年始・展示替期間　¥ 無料　🏠 東京都港区南青山1-24-3 TOTO乃木坂ビル3F　☎ 03-3402-1010

[Bookshop TOTO]
🕐 11:00－18:00　🚫 月曜・祝日, TOTOギャラリー・間休館中の土曜・日曜　🏠 東京都港区南青山1-24-3 TOTO乃木坂ビル2F　☎ 03-3402-1525

[TOTOギャラリー・間／Bookshop TOTO]
🚇 地下鉄千代田線「乃木坂駅」より徒歩1分／地下鉄大江戸線「六本木駅」より徒歩6分

[TOTO GALLERY・MA]
🕐 11:00-18:00 🚫 Mondays, holidays, summer holidays, New Year holidays, and between exhibitions ¥ Free 🏠 TOTO Nogizaka Building 3F, 1-24-3 Minami-Aoyama, Minato-ku, Tokyo ☎ 03-3402-1010

[Bookshop TOTO]
🕐 11:00-18:00 🚫 Mondays, holidays, summer holidays, New Year holidays, and Saturdays and Sundays between exhibitions 🏠 TOTO Nogizaka Building 2F, 1-24-3 Minami-Aoyama, Minato-ku, Tokyo ☎ 03-3402-1525

[TOTO GALLERY・MA／Bookshop TOTO]
🚇 1 min from Nogizaka Station on the Chiyoda line, 6 min from Roppongi Station on the Oedo line

[TOTOギャラリー・間] jp.toto.com/gallerma
[Bookshop TOTO] jp.toto.com/bookshoptoto

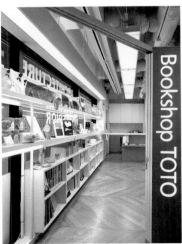

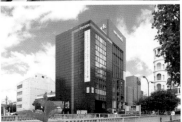

RECOMMENDATION

7

アイデア編集部
IDEA

展示空間の世界観が展覧会の広報物や関連書籍にも反映されているのも同ギャラリーの魅力。TOTO出版では、建築や生活文化に関わるシリーズ書籍も刊行しているが、山口信博や中島英樹、秋田寛といった個性豊かなブックデザイナーたちが装丁を手がけた書籍の数々にも注目したい。

The design and concept of the exhibition often extend to the design of the promotional materials and exhibition-related books, a feature that makes this gallery unique. TOTO Publishing has a series of books on architecture, culture, and lifestyle. Many of their notable books are made by designers, including Nobuhiro Yamaguchi, Hideki Nakajima, and Kan Akita.

③ アクシスギャラリー
AXIS GALLERY

AXIS GALLERY

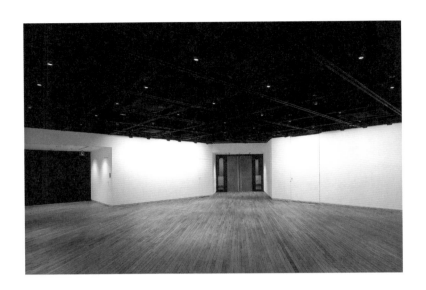

**多様な用途に対応したデザインを
発信し続けるギャラリー**

デザイン誌『AXIS』を発行するアクシス
が運営するデザインギャラリー。1981年
の開設以来、優れたデザインとその思想
を紹介する独自の企画展やフォーラム
などを通じ、デザイン情報の発信を行っ
てきた。レンタルスペースとしても利用
が可能で、企業の新製品発表会、パー
ティやワークショップなど多目的な空間
として活用されている。同じビル内には、
「デザインのある生活」を提案するライ
フスタイルショップ「リビング・モティーフ」
や、デザインを中心とした洋書を取り扱う
「ビブリオファイル」などの店舗やギャラ
リーも入っている。

**A gallery that continues to be
a source of design information
by providing a variety of
services**

This gallery is owned and operated
by Axis, the publisher of the design
magazine AXIS. Since its opening in
1981, the gallery has presented design
information through unique exhibitions
and forums where outstanding designs
and design philosophies are introduced.
The gallery can also be rented for other
purposes. The building also houses
galleries and stores, such as LIVING
MOTIF, a lifestyle shop that uses the
theme "life with design," and Bibliophile,
a bookstore featuring Western design
books.

創刊以来40年続く、デザインの専門誌

AXISビルと同時に創刊した同誌は、デザインの視点で、人間の可能性や創造性を伝えるメディアとして、誌面とウェブの双方で情報を発信。1986年にはバイリンガル化、87年には日本国内におけるDTPの先駆的導入など、積極的な試みを図り、クオリティの高いレイアウトで一般誌とは異なる誌面を展開してきた。2001年には、創刊20周年を記念して、TypeProjectによる開発、鈴木功のデザインのもと、エディトリアルデザイン専用の日本語書体となる「AXIS Font」を発表した。

時 展覧会により異なる　休 展覧会により異なる
¥ 展覧会により異なる
住 東京都港区六本木 5-17-1 AXISビル 4F
電 03-5575-8655　交 地下鉄日比谷線、大江戸線「六本木駅」、南北線「六本木一丁目駅」、大江戸線「麻布十番駅」より徒歩8分

H Hours vary by exhibition
C Closed days vary by exhibition
¥ Fees vary by exhibition
Ad AXIS Building 4F, 5-17-1 Roppongi, Minato-ku, Tokyo　Ph 03-5575-8655
Ac 8 min walk from Roppongi Station on the Hibiya and Oedo lines, Roppongi-itchome Station on the Namboku line, and Azabu-juban Station on the Oedo line
–
www.axisinc.co.jp/building/rentalspace

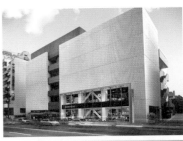

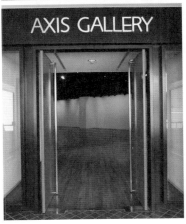

RECOMMENDATION

永原康史
Yasuhito Nagahara

六本木飯倉片町のAXISビルはデザイン好きの人なら一度は行ったことがあるはず。森美、新国立、21_21などを擁する六本木アート＆デザインエリアのなかで老舗を誇る（81年開館）も、開館展の「ソットサス」展、91年の「ワーマン」展、10年の「世界を変えるデザイン」展など、常に問題提起を孕む一歩先の企画を展開してきた。展示を観たあとに直営ショップのリビング・モティーフを覗くのも楽しみのひとつ。
The AXIS building in Roppongi in Iikura-Katamachi is an essential stop for any design lover. The building, which opened in 1981, is one of the oldest in the art and design district of Roppongi, which includes the Mori Art Museum, the National Art Center, and 21_21. Axis has remained one step ahead of the curve by tackling current issues in their critical exhibitions, such as the building's opening exhibition on Sottsass, the 1991 Worman exhibition, and the 2010 *Design that Changes the World*. Stopping by their store, LIVING MOTIF, is one of the joys of visiting the shows.

4 国立新美術館
The National Art Center, Tokyo

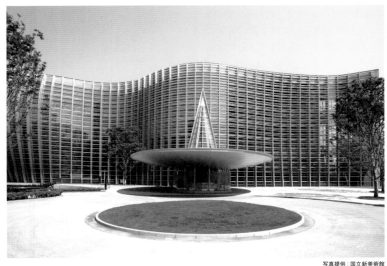

コレクションをもたない
「新しい」美術館

2007年に開館した国立美術館は、コレクションをもたずに、国内最大級の展示スペース（14,000㎡）を生かした多彩な展覧会の開催、美術に関する情報や資料の収集、公開など、アートセンターとしての役割を果たしている。建築家の黒川紀章が手がけた建物は、波のようにうねるガラスカーテンウォールが特徴。クリエイティブディレクターの佐藤可士和によるシンボルマーク・ロゴタイプは、日本の伝統色である緋色と消し炭色を基本色に採用。「新」の漢字を直線と曲線で組み合わせたシンボルマークは、開かれた美術の場を表現している。

An art center with expansive exhibition space for new art

This national art museum, opened in 2007, doesn't hold its own art collection but serves as an art center that uses its expansive exhibition space, one of the largest in the country at 14,000 square meters, to host various exhibitions and gather and display art-related resources. The building was designed by architect Kisho Kurokawa and is characterized by its transparent, undulating glass curtain walls. The logo was designed by creative director Kashiwa Sato and uses the traditional Japanese scarlet and charcoal as principal colors. It redesigns the Chinese character for "new" with straight and curved lines, expressing the openness of this new art space.

東京の今の空気感が圧縮された、
雑貨と本の混在する場

知名度やジャンルにとらわれることなく、東京的な視点で新しいデザインやアートを提供するミュージアムショップ・スーベニアフロムトーキョー。木質系の什器が柔らかい空間を演出している1階のスペースは、TORAFU ARCHITECTSによるもの。地下1階店内の空間デザインはインテリアデザイナーの形見一郎が、店舗開発と運営はライフスタイルショップ「CIBONE」などを運営する株式会社ウェルカム。併設されたSFTギャラリーでは、年間約6組の展示を開催し、紹介している若手デザイナーやアーティストの作品はその場で購入することも可能だ。

🕐 10:00－18:00（入場は閉館の30分前まで）
🚫 火曜（祝日の場合は翌平日）、年末年始
¥ 展覧会により異なる　🏠 東京都港区六本木7-22-2
📞 050-5541-8600◎　🚇 地下鉄千代田線「乃木坂駅」直結／大江戸線「六本木駅」より徒歩4分／日比谷線「六本木駅」より徒歩5分
🕐 10:00-18:00
(Admission until 30 min before closing)
🅲 Tuesdays (or following weekday if Tuesday is a holiday), New Year holidays
¥ Fees vary by exhibition
Ad 7-22-2 Roppongi, Minato-ku, Tokyo
Ph 047-316-2772◎
Ac Direct access from Nogizaka Station on the Chiyoda line, 4 min walk from Roppongi Station on the Oedo line, 5 min walk from Roppongi Station on the Hibiya line
–
www.nact.jp

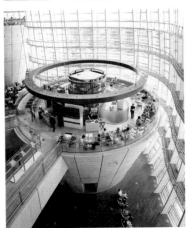

5 国際文化会館
International House of Japan

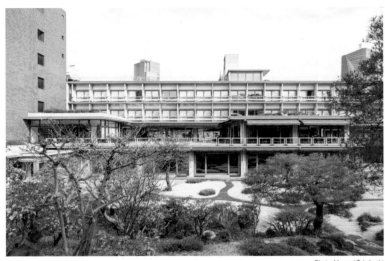

Photo: Manami Takahashi

日本近代建築界の
巨匠たちによる共作

都会の一角にありながら、自然のなかで人々が出会い対話する、国際交流のための場としてつくられた施設。建物は旧館と新館に別れており、1955年に完成した旧館の設計は、近代建築界の巨匠、ル・コルビュジエの弟子として知られる前川國男、坂倉準三と、吉村順三の3人によるもの。鉄筋コンクzリート造でありながら、平安時代の釣殿風様式を取り入れるなど、名造園師・七代目小川治兵衛による回遊式日本庭園との調和が図られている。1976年には前川國男により旧館の改修と新館の増築が竣工された。

A collaboration by the masters of modern Japanese architecture.

Located in a corner of the city, this facility was created to foster international exchange, a place where people could meet and talk with each other in the midst of nature. The building is divided into the old wing and the new wing. The old wing, completed in 1955, was designed by Junzo Yoshimura with Junzo Sakakura and Kunio Maekawa who was a student of Le Corbusier one of the masters of modern architecture. Although the building is made of reinforced concrete, it was designed to harmonize with the strolling Japanese garden by Ogawa Jibei VII, a master landscape gardener, by incorporating elements like the tsuridono style of the Heian period. In 1976, Maekawa Kunio renovated the old wing and expanded the new wing.

庭園を見渡せる自慢のティーラウンジ

会館内には、多くの国際会議の舞台となってきた会議室や宴会場のほか、レストランや、披露宴会場、宿泊施設も備えられており、会員だけでなく一般の利用も可能。なかでも、モダンな建築空間を楽しみながら美しい庭園を一望できるティーラウンジ「ザ・ガーデン」は、都会の喧騒を忘れられる場所。モーニングからディナーまで営業しており、季節や時間帯によって様々に移りかわる庭園の景色を味わえる贅沢な空間。

🕐 各施設により異なる
🈳 無休
¥ 各施設により異なる
🏠 東京都港区六本木 5-11-16　☎ 03-3470-4611
🚇 地下鉄大江戸線「麻布十番駅」より徒歩5分／地下鉄南北線「麻布十番駅」より徒歩8分
🅷 Hours vary by each facilities　🅲 Open daily
¥ Fees vary by each facilities
🅰d 5-11-16 Roppongi, Minato-ku, Tokyo
🅰c 5 min walk from Azabu-juban Station on the Oedio line, 8 min walk from Azabu-juban Station on the Namboku line
–
www.i-house.or.jp/index.html

RECOMMENDATION

アイデア編集部
IDEA

六本木ヒルズから麻布方面に向かう途中という、まさに都会の真ん中に位置するにもかかわらず、江戸時代は武家屋敷として、明治には候爵邸として、時代とともに変遷しながら今も緑豊かな空間を残す場所。完成から半世紀以上経ちながら現役で利用される新旧館は、2006年に文化庁が指定する「登録有形文化財」にも登録された。美術館めぐりに疲れたら立ち寄りたい穴場スポット。
Standing right in the city center between Azabu and Roppongi Hills, this house has retained its lush greenery even though it has evolved over time, serving as a samurai residence during the Edo period and as a nobleman's residence in the Meiji period. The new and old buildings, which are still in use more than half a century after their completion, were registered as a Tangible Cultural Property by the Agency for Cultural Affairs in 2006. If you get tired of visiting museums, this is a great place to stop by.

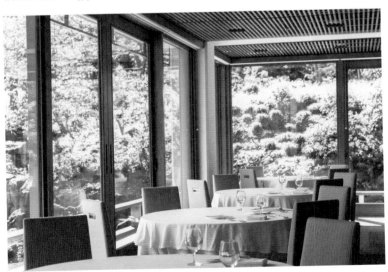

6 サントリー美術館
Suntory Museum of Art

都市の居間を演出した空間で感じる生活のなかの美

総合飲料メーカーのサントリーが1961年に開館した美術館。2007年に現在の東京ミッドタウン内へ移転し、建築家の隈研吾が設計を手がけた。絵画や陶磁、漆工、染織など日本の古美術を中心に、約3,000件もの美術品を収蔵。常設展は設けず企画展がメインで、時代や国や民族といった枠組みに縛られない自由な展示が特徴的。2021年に開館60周年を控える同館は、改修工事や隈によるエントランスやショップ・カフェのデザイン、館内スタッフの制服デザインを刷新した上で、2020年7月にリニューアル・オープンした。

「都市の居間」としての居心地の良い空間を目指した館内は、木と和紙を意匠に用いて、自然の温もりと柔かい光を表現。展示室は3階と4階の2層からなり、天井高9.3mの吹き抜けや、2枚の格子をスライドさせて光を調節する「無双格子」を巨大なガラス面に設置することで、様々な演出が可能となっている。葛西薫とナガクラトモヒコが手がけたシンボルマークは、漢字の「美」から生まれた平仮名の「み」の一文字に美への思いを凝縮。同館が所蔵する「浄瑠璃物語絵巻」の詞書を出典に、書家の石川九楊が監修した。

Experience art inside an urban living room

Opened in 1961 by beverage manufacturer Suntory, the museum relocated to its current location in Tokyo Midtown in 2007, with a new facility designed by architect Kengo Kuma. The museum has a collection of around 3,000 works of art, mainly Japanese antiques, such as paintings, ceramics, laquerware, and textiles. The museum has no permanent exhibitions but hosts special exhibitions that are not bound by the frameworks of time, country, or ethnicity. The interior of the museum, which was designed as an urban living room, uses wood and Japanese paper to create a relaxing atmosphere filled with gentle wooden textures and soft light. The logo was designed by Kaoru Kasai and Tomohiko Nagakura.

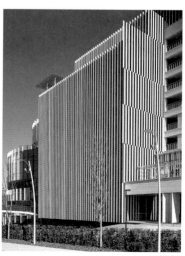

© 木奥恵三

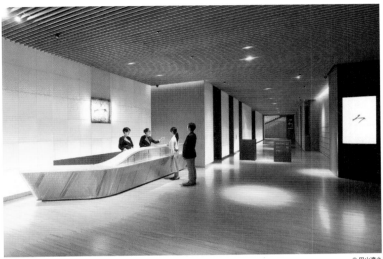

© 田山達之

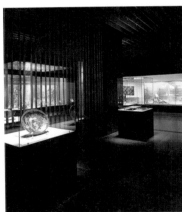

© 木奥惠三

7

アイデア編集部
IDEA

併設の「shop x cafe」では、和モダンをテーマとした品々や、150年余の伝統を誇る老舗「加賀麩 不室屋」プロデュースのランチやスイーツを味うことができる。同館は国立新美術館、森美術館と地図上で三角形を描くことから「六本木アート・トライアングル（略称あとろ）」として連携しており、あわせて回ると割引なども受けられてお得なため、各館をハシゴする合間に併設のカフェを楽しむのも◎。The museum store and cafe offer modern Japanese items as well as lunch and sweets made by Fumuroya, a long-established Kaga fu (traditional food made of wheat flour gluten) producer with 150 years of tradition. The museum is part of the "Art Triangle Roppongi (ATRo)"along with the National Art Center and the Mori Art Museum, and there is a special discount for people who visit all three venues on the same trip. The cafe provides a good respite while visiting the three venues.

🕐 10:00－18:00／（金曜・土曜）10:00－20:00（入館は閉館30分前まで）
🚫 火曜、年末年始、展示替期間
¥ 展覧会により異なる　🏠 東京都港区赤坂 9-7-4 東京ミッドタウン ガレリア 3 階　☎ 03-3479-8600
🚇 地下鉄大江戸線、日比谷線「六本木駅」直結
🕐 10:00-18:00, Fridays and Saturdays 10:00-20:00 (Admission until 30 min before closing)
🚫 Tuesdays, New Year holidays, and between exhibitions　¥ Fees vary by exhibition
📍 Tokyo Midtown Galleria 3F, 9-7-4 Akasaka, Minato-ku, Tokyo　☎ 03-3479-8600
🚇 Direct access from Roppongi Station on the Oedo and Hibiya lines

–
suntory.jp/SMA

⑦ 東京ミッドタウン・デザインハブ
Tokyo Midtown Design Hub

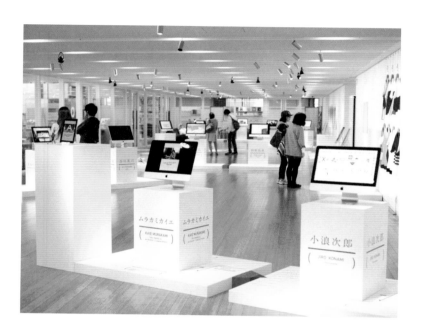

**デザインにより、人・ビジネス・知識を
つなげて、広げて、育てる場**

2007年に東京ミッドタウン内に開設さ
れたデザインネットワークの拠点。デザイ
ンのプロモーション・職能・研究教育と
いう3つの異なる役割を担う機関が運営
し、社会的な課題の解決、若手デザイ
ナーや海外のデザイン活動の紹介といっ
た展覧会やセミナーなどの開催を通して、
今日のデザインの姿と可能性をわかりや
すく提示。また、デザイナーやアーティスト
らによる子ども向けのワークショップの実
施など、次世代のデザイン人材育成も
積極的にサポート。

**Using design to connect and
nurture people, business, and
knowledge**

Established in 2007, this institution is
run by an organization that plays an
important role in the design industry in
the areas of design promotion, research,
and education. The gallery presents
modern design and its possibilities in
an easy-to-understand manner through
exhibitions and seminars that address
social issues, introduce young designers,
and explore overseas design activities. It
also actively supports the development
of the next generation of designers
through workshops for children.

インターナショナル・デザイン・リエゾンセンター

国際的なデザインの情報発信拠点・人材育成拠点・産学連携拠点として、デザインを中心とした様々な研究教育機関と連携し次世代デザインの振興を図ることを目的に、世界各国の18の教育機関、23のデザイン関連機関が加盟。加盟機関以外でも施設の主旨に合致する活動であれば利用が可能。センター内で不定期に開催するライブラリーでは、公益財団法人日本デザイン振興会の蔵書である過去から現在までのデザイン関連書籍、資料、日本のデザイン関連団体の年鑑などが無料で閲覧できる。

🕐 展覧会により異なる
🚫 展覧会により異なる
¥ 無料
🏠 東京都港区赤坂9-7-1 ミッドタウン・タワー 5F
📞 03-6743-3776
🚇 地下鉄大江戸線、日比谷線「六本木駅」直結／千代田線「乃木坂駅」より徒歩8分

H Hours vary by exhibition
C Closed days vary by exhibition　**Y** Free
Ad Midtown Tower 5F, 9-7-1 Akasaka, Minato-ku, Tokyo　**Ph** 03-6743-3776
Ac Direct access from Roppongi Station on the Oedo and Hibiya lines, 8 min walk from Nozaka Station on the Chiyoda line
—
designhub.jp

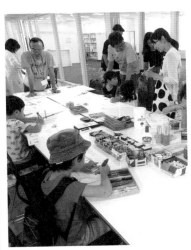

永原康史
Yasuhito Nagahara

六本木、東京ミッドタウンにあり、カンファレンスやワークショップが開催されるリエゾンセンターや、JDP（日本デザイン振興会）、JAGDA（日本グラフィックデザイナー協会）、多摩美術大学のサテライトオフィス（2021年4月開所予定）といったデザイン関連機関のオフィスに面している。ギャラリーでもホールでもなく、あえていうと広場のような展示空間が魅力。

Located in Tokyo Midtown, Roppongi, the Design Hub faces the liaison center, where conferences and workshops are held and offices of notable design-related organizations are located, including JDP (Japan Institute of Design Promotion), and JAGDA (Japan Graphic Designers Association), and a satellite office of Tama Art University (scheduled to be open on April 2021). It is neither a gallery nor a hall, but rather an attractive exhibition space that resembles a plaza.

⑧ complex665／ピラミデビル
complex665 / Piramide Building

東京を代表するギャラリーが集う、現代アートの一大発信地

complex665は、2016年にオープンした地上3階からなるギャラリー拠点で、各フロアには1990年代より日本の現代美術を牽引してきた3つのギャラリーが入る。小山登美夫ギャラリーはムトカ建築事務所、シュウゴアーツは青木淳建築計画事務所、タカ・イシイギャラリーと1Fビューイングスペースのタカ・イシイギャラリーオフィスは、ブロードビーンが設計するなど、スペース毎に別々の建築家が内装を手がけている。ロゴマークは、グラフィックデザイナーであり、自らもアートユニット「Nerhol」としても活動する田中義久によるもの。

ガラスのピラミッドによる外観が特徴的なピラミデビルは、建物自体は1990年の竣工だが、2011年以降、現代美術のギャラリーが集うようになり、六本木エリアの主要なアートスポットとなっている。17年にはペロタン東京がオープンし、19年にはTARO NASUが移転。現在ではワコウ・ワークス・オブ・アート、オオタファインアーツ、古美術を取り扱うロンドンギャラリーなど8つのギャラリーと、老舗オークション会社「フィリップス・オークショニアズ」の東京オフィスなどが入っている。

A center for contemporary art and a hub for Tokyo's leading galleries

The Piramide Building, with its distinctive glass pyramid exterior, has become a major art spot in the Roppongi area since 2011 and is now home to several contemporary art galleries. Perrotin Tokyo opened here in 2017, and TARO NASU relocated into the complex in 2019. Today, the building includes eight galleries and offices, such as Wako Works of Art and Ota Fine Arts. Nearby is complex 665, which opened in 2016. The three-story commercial facility is now home to three art galleries that have been leading the Japanese contemporary art scene since the 1990s.

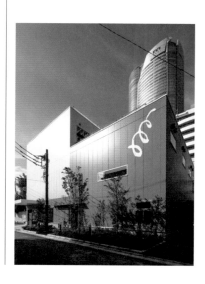

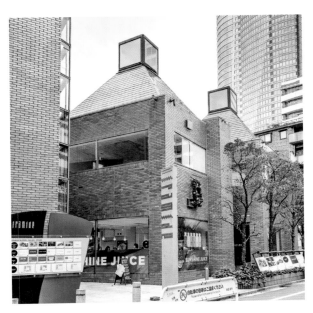

時 [complex665] 11:00−19:00（各ギャラリーごとで変動あり）, [ピラミデビル] ギャラリーにより異なる
休 ギャラリーにより異なる　料 無料
住 [complex665] 東京都港区六本木 6-5-24
[ピラミデビル] 東京都港区六本木 6-6-9
交 地下鉄大江戸線,日比谷線「六本木駅」より徒歩4分
H [complex665] 11:00-19:00 (hours vary by gallery)　[Piramide Building] hours vary by gallery　C Closed days vary by gallery

料 Free　Ad [complex665] 6-5-24 Roppongi, Minato-ku, Tokyo　[Piramide Building] 6-6-9 Roppongi, Minato-ku, Tokyo
Ac 4 min walk from Roppongi Station on the Oedo and Hibiya lines

―
各ギャラリーの公式サイト参照
See each gallery's website for official information

イエン・ライナム
Ian Lynam

六本木の中心部に位置するピラミデビルは、かつて警杖を手にした隙のない警官たちがいた警察署跡地の裏手に位置する。現在は複数のアートギャラリーと、ミュージシャンで映画監督のジム・オルークがよく利用するブリトー・スタンドが入居している。ワコー・ワークス・オブ・アートは10年前からこのビルに落ち着いており、ゲルハルト・リヒター、ヴォルフガング・ティルマンス、リュック・タイマンス、マイク・ケリーなどの展覧会を始めとする西洋の現代アートを提供。ピラミデにはほかにもオオタファインアーツ、ロンドンギャラリー、GALLERY-SIGN TOKYO などがある。

Nestled in the heart of Roppongi, a mere block behind the site of the former main police station with its ever-vigilant cops with bō-in-hand, lies the Piramide building, home to a complex of art galleries and a burrito stand frequented by musician and filmmaker Jim O'Rourke. Wako Works of Art has been ensconced in this building for nearly a decade, serving up the finest Western contemporary art including exhibitions by Gerhard Richter, Wolfgang Tillmans, Luc Tuymans and Mike Kelley. The Piramide is home to a number of other galleries including Ota Fine Arts, London Gallery, and Gallery – Sign Tokyo.

六本木の行きたいショップ・見たい建築
Shops and architectures in Roppongi

designshop + gallery
designshop + gallery

麻布にある、流行に左右されない、何十年ものあいだ使い続けられる家具や雑貨を扱うセレクトショップ。食、農業、建築など日本の生活文化やものづくりを、デザインをキーワードに様々な角度から紹介している。

A lifestyle boutique in Azabu that sells furniture and other items that can be used over decades. It introduces Japanese lifestyle and craftsmanship through different perspectives using food, agriculture, and architecture, with design as the central theme.

🏠 東京都港区南麻布 2-1-17 白ビル　☎ 03-5791-9790
Ad Shiro Building, 2-1-17 Minami-azabu, Minato-ku, Tokyo
Ph 03-5791-9790

六本木 蔦屋書店　　六本木 蔦屋書店
ROPPONGI TSUTAYA BOOKS

クライン ダイサム アーキテクツが手がけた店内には、3万冊の洋書・洋雑誌を揃えるマガジンコーナー、バーラウンジ、アートスペースなどがある。「日本・再発見」をコンセプトにした工芸品や文具も展開。

This store, designed by Klein Dytham Architecture, features 30,000 books and magazines on its shelves, a bar lounge, and an art gallery. The store also offers Japanese crafts and stationery, which are selected based on the concept of "Rediscovering Japan."

🏠 東京都港区六本木 6-11-1 六本木ヒルズ 六本木けやき坂通り
☎ 03-5775-1515　Ad ROPPONGI HILLS Roppongi Keyakizaka Street, 6-11-1 Roppongi, Minato-ku, Tokyo
Ph 03-5775-1515

文喫　　文喫
BUNKITSU

老舗書店跡地に2018年にオープンした有料書店。100坪の店内に90ある椅子やソファで、飲食もしながら約3万冊の蔵書を閲覧することができる。エントランスでは、定期的に本にまつわる企画展も開催。

This store, which opened in 2018 on the site of a former secondhand bookstore, requires an entrance fee. Customers can browse the store's 30,000 books and are welcome to eat and drink while lounging on 90 chairs and sofas spread across this 330-square-meter space. Special book-related exhibitions are held at the entrance on a regular basis.

🏠 東京都港区六本木 6-1-20 六本木電気ビル 1F
☎ 03-6438-9120　Ad Roppongi Electric Building 1F, 6-1-20 Roppongi, Minato-ku, Tokyo　Ph 03-6438-9120

六本木トンネル
Roppongi Tunnel

現代アーティストの北川純による「ジッパー」など、東京都のストリートペインティング事業の一環で制作された5つの壁画が楽しめるスポット。国立新美術館と東京ミッドタウンを回る際に立ち寄るのがおすすめ。

This spot features five murals created as part of the city government's street painting project, including a zipper by contemporary artist Jun Kitagawa. It's a great place to stop between a visit to the National Art Center and Tokyo Midtown.

🏠 東京都港区六本木 7
Ad 7 Roppongi, Minato-ku, Tokyo

渋谷・目黒
SHIBUYA / MEGURO

1 目黒区美術館
Meguro Museum of Art, Tokyo

2 東京都庭園美術館
Tokyo Metropolitan Teien Art Museum

3 東京都写真美術館
Tokyo Photographic Art Museum

4 MIYASHITA PARK
MIYASHITA PARK

5 日本民藝館
The Japan Folk Crafts Museum

6 POST
POST

7 東塔堂
Totodo

8 NEWPORT
NEWPORT

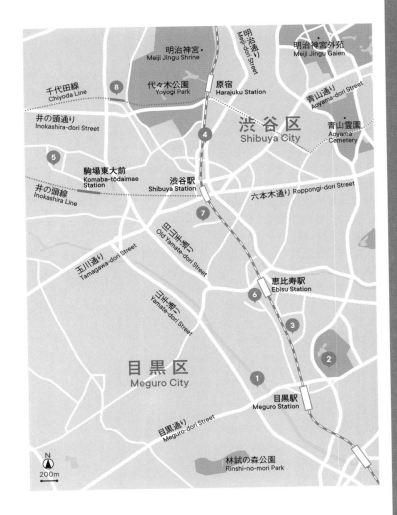

① 目黒区美術館
Meguro Museum of Art, Tokyo

Meguro
Museum of
Art,Tokyo
目黒区美術館

**作家の制作プロセスにも着目して
収集を行う、地域に根ざした美術館**

**A community-based art
museum that focuses on the
artist's creative process**

1987年に目黒区民センターの一角に開館した美術館。近代から現代にいたる日本の美術の流れを体系的に理解できるコレクションを目指して、「日本人作家が戦前に滞欧・滞米の時期に制作した作品」「戦後、国際的に活躍する作家の作品や海外展で発表された作品」「目黒区にゆかりの深い作品」「作品制作の過程を理解できる作品・資料」を4つの柱として収集を行っている。それらを所蔵作品展として公開するほか、多様な美術の動向をとらえた独創的な企画展を展開。また、美術の枠にとらわれず、「村野藤吾の建築」展といった建築やデザインなどの展示も行い、現代の動向も積極的に取り上げている。
作品のなりたちや画材として使われる素材・技法を追求する、幅広い年齢層を対象にしたワークショップも同館の大きな特徴のひとつ。地上3階、地下1階の4階層からなる館内は、住宅的な雰囲気を取り入れながら、鑑賞者の視覚的なリズムを演出した機能的な設計となっている。開館当初からデザイナーの矢萩喜従郎がロゴマークを担当。開館30周年となる2017年度には、新たに矢萩によるロゴマークのリニューアルを行った。

The museum was opened in 1987. It aims to systematically present the history of Japanese art, from modern times to the present day, by collecting works that fall under four pillars: works created by Japanese artists during their stays in Europe and the United States before World War II, works by international artists combined with works shown in overseas exhibitions, works with a strong connection to Meguro City, and works and resources that allow viewers to understand the process of making art. In addition to exhibiting these works as part of its collection, the museum holds creative exhibitions that capture diverse art trends. The museum also actively exhibits design and architectural pieces.

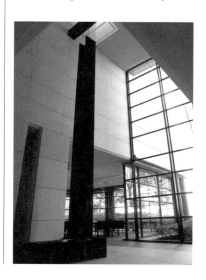

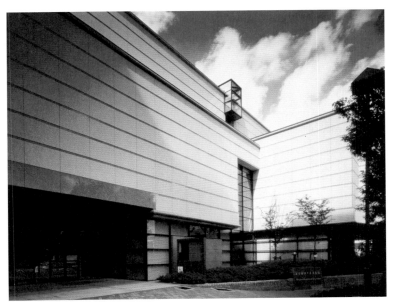

🕐 10:00−18:00（入館は閉館30分前まで）
🈺 月曜（祝日の場合は翌平日）,年末年始,展示替期間
💴 展覧会により異なる
🏠 東京都目黒区目黒2-4-36　📞 03-3714-1201
🚃 JR,地下鉄南北線,三田線,東急目黒線「目黒」駅より徒歩10分

🕐 10:00-18:00 (Admission until 30 min before closing)　🅒 Mondays (or following weekday if Monday is a holiday), New Year holidays, and between exhibitions
💴 Fees vary by exhibition
🏠 2-4-36 Meguro, Meguro-ku, Tokyo
📞 03-3714-1201　🚃 10 min walk from Meguro Station on the JR, Namboku, Mita, and Tokyu Meguro lines

–
mmat.jp

中野豪雄
Takeo Nakano

主に近代以降の美術・デザイン資料を収蔵し、企画展や区内の名作建築ツアー、ワークショップを開催するなど地域性に根ざした活動を行う。震災の年に開催された「DOMA秋岡芳夫 ─モノへの思想と関係のデザイン」は印象的で、近代がつくり上げてきた日本の社会的な構造に警鐘を鳴らす秋岡の活動と至言が多くの反響を呼んだ。地域性と収蔵方針、時代状況をクロスさせながら社会に問いかける優れた企画展を数多く開催している。

The museum primarily collects art and design resources from the post-modern era and engages in local activities, including special exhibitions, neighborhood architectural tours, and workshops. Held in 2011, the year of the Tohoku earthquake and tsunami, *DOMA Akioka Yoshio* was an impressive exhibition; Akioka's work and words of wisdom, which warned against the modern social structure of recent Japan, generated a lot of public interest. The museum has held several excellent exhibitions that question society by combining its own collection policies with regional characteristics and historical circumstances.

2 東京都庭園美術館
Tokyo Metropolitan Teien Art Museum

TOKYO METROPOLITAN TEIEN ART MUSEUM

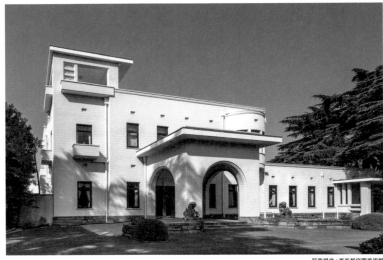

写真提供：東京都庭園美術館

**緑溢れる広大な庭園のなかで
建築と美術作品を味わう**

1933年に建設された旧朝香宮邸とその庭園を活用して、1983年に開館した美術館。建設当時フランスで全盛だったアール・デコ様式を日本で本格的に取り入れた建物が大きな見所で、国の重要文化財にも指定されている。2014年には、ホワイトキューブのギャラリーを備えた新館がオープンし、それぞれの展示空間を効果的に組み合わせた、展覧会や様々なプログラムを開催。デザイナー・建築家の矢萩喜從郎によるロゴマークは、和文・英文、タテ型・ヨコ型、カラータイプなど、バリエーション豊かな仕上がりである。

Savor art and architecture in a sprawling green garden

This museum opened in 1983 in the former Asaka Palace and garden, which was originally constructed in 1933. One of its main attractions is the building itself, an Important Cultural Property that is an authentic Japanese adaptation of the Art Deco style. In 2014, a new building and gallery with white walls opened, and the museum effectively uses the different exhibition spaces to hold exhibitions and other programs. The logo by designer and architect Kijuro Yahagi is available in a variety of languages and styles, including Japanese, English, vertical, horizontal, monotone, and colored.

時代を代表するデザイナーらの創作と
当時の技術が結集した
アール・デコ様式の建築

貴重な歴史建造物である本館は、当時
のアール・デコ様式の意匠がほぼそのま
ま現存する。大広間や大客室、書斎な
どの主要部分は室内装飾家のアンリ・
ラパンが、正面玄関のガラスレリーフ扉
などはガラス工芸家のルネ・ラリックが手
がけ、実際の建築にあたっては、宮内省
内匠寮の緻密な設計と日本古来の高
度な職人技が随所に発揮される。新館
は現代美術家・杉本博司の監修のもと、
ガラスを基調とした開放的な空間が広
がる。建物を取り囲む広大な庭園も、四
季折々に美しい花色を見せる見どころ
のひとつ。

🕐 10:00−18:00（入館は閉館30分前まで）
🚫 第2・第4水曜（祝日の場合は翌平日）,年末年始
¥ 展覧会により異なる
🏠 東京都港区白金台5-21-9
☎ 050-5541-8600 ◎
🚉 JR,東急目黒線「目黒駅」より徒歩7分
🅷 10:00-18:00 (Admission until 30 min before
closing) 🅒 Second and fourth Wednesdays
(or following weekday if Wednesday is a holiday),
New Year holidays
¥ Fees vary by exhibition
🄰🄳 5-21-9 Shirokanedai, Minato-ku, Tokyo
🄿🄷 050-5541-8600 ◎
🄰🄲 7 min walk from Meguro Station on the JR
and Tokyu Meguro lines
–
www.teien-art-museum.ne.jp

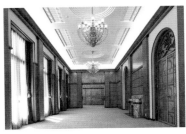

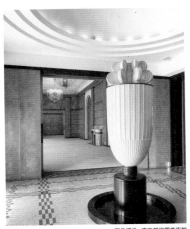

画像提供：東京都庭園美術館

RECOMMENDATION

野見山桜
Sakura Nomiyama

入り口からルネ・ラリックのガラスレリーフ扉
が出迎え、室内装飾家アンリ・ラパンがデザ
インした書斎など、アール・デコのスターデザ
イナーの共演が見もの。内装のあらゆる部
分に創意工夫が凝らされていて、市松模様や
コンクリートに漆塗装など日本の伝統的な意
匠や素材が多く見られるのも面白い。日本に
おける西洋文化受容を体感できる空間です。
建物に焦点をあてた建物公開が年に一度開
催され、そのときには普段入ることのできない
ウィンターガーデンが公開されます。
Starting with a glass relief door by
René Lalique that greets you at the
entrance, followed by a study designed
by Henri Rapin, the museum is filled
with works of star designers of the Art
Deco style. Every part of the interior
is carefully designed, and there are
many traditional Japanese designs and
materials used throughout the building,
such as checkerboard patterns and
lacquer paint on concrete. This is a
space where you can experience how
Western culture has been embraced
in Japan. Exhibition focusing on the
museum's architecture is held once
a year, and you can visit the Winter
Garden that are normally closed to the
public during this time.

③ 東京都写真美術館
Tokyo Photographic Art Museum

TOP MUSEUM

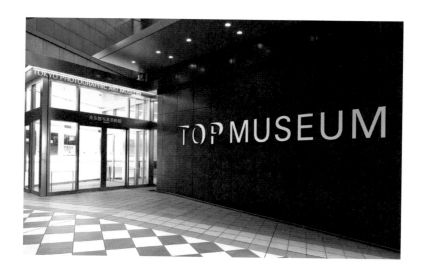

世界的にも珍しい写真と映像専門の公立美術館

国内唯一の写真と映像の専門美術館として1995年に総合開館。写真と映像の文化や歴史を理解する上で必要な国内外の作品や資料などを幅広く体系的に収集している。3つの展示室で収蔵展や作家の個展、映像とアートの祭典「恵比寿映像祭」など、年間約20本の展覧会を開催。1階のホールでは、新進気鋭監督の映画作品からドキュメンタリー、プレミアム作品まで幅広い上映も行う。ほかにも図書約5万冊と約1,800タイトル（2020年3月末日時点）の雑誌が揃う図書室、アートショップ「NADiff」が手がけるミュージアム・ショップなど充実した設備が揃う。

A rare public museum dedicated to photography and video

Opened in 1995 as Japan's only museum specializing in photography and film, this museum collects a variety of domestic and international works and resources that are essential to understanding the history and culture of photography and film. The museum holds about 20 exhibitions each year, including the Yebisu International Festival for Art & Alternative Visions, solo artist exhibitions, and shows featuring the museum's own collection. The first-floor hall hosts a wide range of screenings, from documentaries to major productions.

総合開館20周年を記して発表された
新しいシンボルマークとロゴタイプ

同館は、総合開館20周年となる2016年にリニューアル・オープンした。合わせて、英語館名の頭文字から命名した「TOP MUSEUM（トップミュージアム）」を愛称に決定し、シンボルマークとロゴタイプも刷新。シンボルマークは、グラフィックデザイナーの田中義久が担当し、光によって「TOP」の文字をうつし出し、新しい表現の扉をひらき、来館者を迎える決意をイメージしたデザインを制作。ロゴタイプは、書体デザインを中心に文字に関わる字游工房が手がけ、線の抑揚をおさえたシンプルな構成に仕上がった。

🕙 10:00－18:00／（木曜・金曜）10:00－20:00 ［夜間開館は現在休止中］（入館は閉館30分前まで）
🚫 月曜（祝日の場合は翌平日）、年末年始および臨時休館　📽 展覧会・上映により異なる
🏠 東京都目黒区三田1-13-3 恵比寿ガーデンプレイス内
☎ 03-3280-0099　🚃 JR「恵比寿駅」より徒歩7分／地下鉄日比谷線「恵比寿駅」より徒歩10分
🕙 10:00-18:00, Thursdays and Fridays 10:00-20:00 [Opening at night is currently suspended] (Admission until 30 min before closing)
🚫 Mondays (or following weekday if Monday is a holiday), New Year holidays and temporarily closure
📽 Fees vary by exhibition and screening
🏠 Yebisu Garden Place, 1-13-3 Mita, Meguro-ku, Tokyo　☎ 03-3280-0099
🚃 7 min walk from Ebisu Station on the JR line, 10 min walk from Ebisu Station on the Hibiya line
–
topmuseum.jp

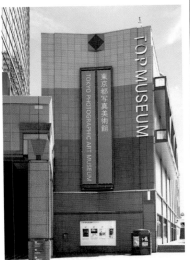

RECOMMENDATION

7

アイデア編集部
IDEA

写真に関連した展示企画だけでなく、同館では写真と映像の保存条件や展示環境に関する研究など、写真表現の今後を見据えた取り組みを行う。また、写真や映像の世界に興味をもつ人たちに向けたワークショップや体験プログラムを定期的に開催しており、様々な角度から写真・映像に触れられる美術館。

In addition to organizing exhibitions, the museum conducts research on image and photo conservation and the exhibition environment, with a focus on the future of photographic expression. The museum also regularly hosts workshops and hands-on programs for people interested in the worlds of photography and video, allowing them to experience these mediums from a variety of perspectives.

4 MIYASHITA PARK
MIYASHITA PARK

公園を起点にさまざまなカルチャーに出会える渋谷の新名所

渋谷駅と原宿駅を結ぶ山手線の線路脇にあった宮下公園が2020年にリニューアル。もともとスケート場などが設置されていたことから、スケートボードの練習に訪れる若者が集うなど、渋谷のストリートカルチャーを育ててきた場所だったが、開設当時からおよそ67年の時を経て、バリアフリーや耐震性などの観点から大規模改修が決定した。

最上階にはかつての宮下公園の面影がのこるスケート場、ボルダリングウォールの他、バレーやフットサルが楽しめる多目的運動施設（サンドコート使用）を設置。公園と一体となった地上4階建ての商業施設「RAYARD MIYASHITA PARK」には、約90のショップや飲食店が軒を連ねており、公園との親和性の高いストリートブランドから、横丁やミュージックバー、シェアオフィスなど、渋谷のあらたなカルチャーを生み出すストリートが誕生した。また、施設の一角にはホテルも完備され、公園にむかって開かれたロビースペースやレストランは宿泊客以外も利用可能で、様々なシーンで活用できるのも魅力のひとつ。東京観光のあたらしい拠点としてもおすすめ。

A new place of note to encounter a variety of culture from the park

The Miyashita park beside the Yamanote Line railway tracks was renovated in 2020. Originally equipped with a skateboard park, this public playground was known to attract young skateboarders, creating a place that fostered Shibuya's street culture. Recently, a decision was made to renovate the building to make it more accessible and earthquake resistant. On the top level, a multi-purpose sports facility was installed, including a skating rink that is reminiscent of the old Miyashita Park. The lower levels are lined with 90 stores and restaurants, creating a street designed to inspire the new Shibuya culture.

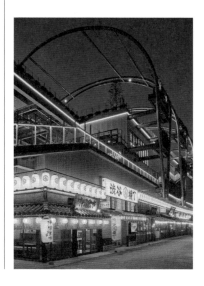

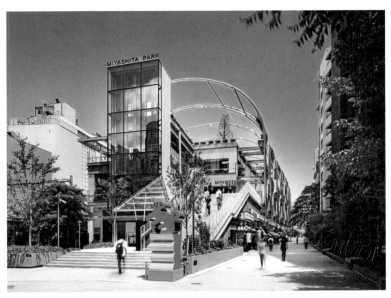

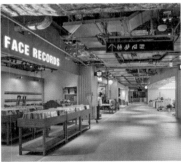

RECOMMENDATION

7

アイデア編集部
IDEA

ここ数年で駅周辺の再開発が進み、新しい高層ビルが立ち並ぶ渋谷の街で、ヒューマンスケールの渋谷を楽しめる空間。商業施設部分には話題の店舗も多いので、隅々まで楽しもうとすると1日では足りないかもしれない。公園で遊び、ショッピングや食事を楽しみ、最後はホテルにお泊まり……そんな新しい渋谷の楽しみ方を提案する施設。

Tucked in the middle of the new Shibuya skyscrapers, which were constructed as part of the grand redevelopment around the station over the past few years, this is a space where you can enjoy the experience of Shibuya on a personal level. With numerous trendy stores opening in the commercial part of the facility, visitors might want more than a day to explore. This facility provides a new way to enjoy Shibuya: play at the park, enjoy shopping and dining, and end with a stay at a hotel.

[時] [渋谷区立宮下公園] 8:00－23:00
[ショップ] 11:00－21:00 ※店舗により異なる
[レストラン・フードホール] 11:00－23:00
[￥] 各施設により異なる
[住] 東京都渋谷区神宮前 6-20-10
[電] 03-6712-5630
[交] JR, 地下鉄半蔵門線, 銀座線, 副都心線, 東急東横線, 田園都市線, 京王井の頭線「渋谷駅」より徒歩3分

[H] [MIYASHITA PARK] 8:00-23:00
[Shops] 11:00-21:00 *Hours vary by shop
[Restaurant / food hall] 11:00-23:00
[￥] Fees vary by each facilities
[Ad] 6-20-10 Jingumae, Shibuya-ku, Tokyo
[Ph] 03-6712-5630
[Ac] 3 min walk from Shibuya Station on the JR, Keio, Ginza, Hanzomon, Fukutoshin, Tokyu Toyoko, Denentoshi, Keio Inokashira lines

–
www.miyashita-park.tokyo

5 日本民藝館
The Japan Folk Crafts Museum

**民衆の日常品に美を見出した
民藝運動の本拠地**

初代館長で思想家の柳宗悦が、「民藝」という新しい美の概念の普及や、美の基準を提示する場として1936年に開館。主に江戸後期以降の民衆生活で使用された陶磁器や染織・木漆工などを中心に、古今東西の工芸品約17,000点が収蔵されている。また、柳とともに日本の近代工芸界に大きな流れをつくったバーナード・リーチ、濱田庄司、河井寛次郎、芹沢銈介、棟方志功など個人作家の作品も所蔵。年に4,5回の陳列替えを行いながら、常時約500点を展示する。年に一度開かれる新作工芸品の公募展「日本民藝館展」では、毎年200人以上の作り手から募られた様々な分野の工芸品が展示・販売される。外観・展示室ともに、和風意匠を基調としながら随所に洋風を取り入れた本館は、柳を中心に設計され、陳列物が美しく見えるように細やかな工夫が施されている。二代目館長には陶芸家の濱田庄司、三代目は宗悦の長男でインダストリアルデザイナーの柳宗理、四代目は実業家の小林陽太郎が就任。現在はプロダクトデザイナーの深澤直人が館長職を務め、日常生活に存在する美に目を向けた民藝と同様、人間の生活や道具のなかに存在する美を抽出することがデザインであると語っている。

Beauty is found in everyday objects at the home of the Mingei movement

Philosopher Yanagi Soetsu opened this museum in 1936. It houses approximately 17,000 artifacts from all over the world, with a focus on ceramics, textiles, and wood-lacquerware used in everyday life from the late Edo era to the present. The collection also includes works by individual artists, such as Bernard Leach, Hamada Shoji, Kawai Kanjiro, Serizawa Keisuke, and Munakata Shiko. These artists, together with Yanagi, created a major trend in modern Japanese craftsmanship. Approximately 500 works are on display at any given time, with the exhibit changing four or five times a year. The main building of the museum is a must-see; it was designed primarily by Yanagi and is based on a Japanese-style design with Western influences throughout.

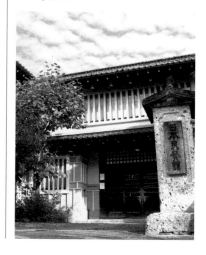

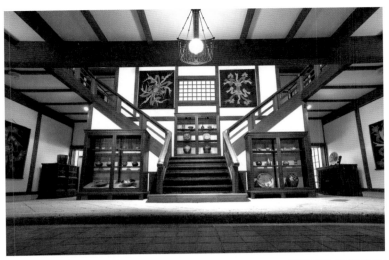

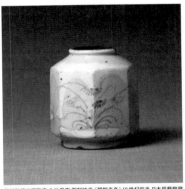

染付秋草文面取壺 金沙里窯 朝鮮時代〔朝鮮半島〕18世紀前半 日本民藝館蔵

時 10:00－17:00（入館は閉館30分前まで）
休 月曜（祝日の場合は翌平日）,年末年始,展示替期間
¥ 大人1,100円,高校・大学生600円,小中学生
200円★
住 東京都目黒区駒場4-3-33　電 03-3467-4527
交 京王井の頭線「駒場東大前駅」より徒歩7分
H 10:00-17:00 (Admission until 30 min before
closing)　C Mondays (or following weekday if
Monday is a holiday), New Year holidays, and
between exhibitions
¥ Adults ¥1,100, high school and university
students ¥600, junior high and elementary
school students ¥200★
Ad 4-3-33 Komaba, Meguro-ku, Tokyo
Ph 03-3467-4527
Ac 7 min walk from Komaba Todai-mae Station
on the Keio Inokashira line
–
www.mingeikan.or.jp

RECOMMENDATION

7

アイデア編集部
IDEA

民藝館の裏手には旧加賀藩主の前田家の
邸宅跡地が公園として残されており、その華
麗な暮らしを伝える館が保管されている。ま
た、敷地内には明治以降の近代文学に関連
する120万点あまりの資料が所蔵する日本
近代文学館もありあわせて訪れたい。文学館
「BUNDAN COFFEE & BEER」では店内
に並んだ書籍を閲覧しながら文豪たちにちな
んだオリジナル培煎のコーヒーやアルコール
類も楽しめる。

Behind the Mingeikan, the former
residence of the Maeda family—lords
of the Kaga clan—and remnants of
their sumptuous lifestyle is preserved
as a park. Also on the premises is the
Museum of Modern Japanese Literature,
which houses more than 1.2 million
documents related to modern Japanese
literature dating back to the Meiji era. At
BUNDAN COFFEE & BEER, visitors can
browse books while enjoying the cafe's
custom-roasted coffee and alcoholic
beverages that reflect some of Japan's
greatest literary figures.

6 POST
POST

POST

ひとつの出版社に焦点を当てて本を紹介するブックショップ

「出版社」をテーマに、定期的に扱う本が全て入れ替わるブックショップ。元々は古書と古家具を取り扱うテンポラリーショップ「limArt」から始まり、2010年に新刊をメインに取り扱う「POST」をオープン。2013年には古書と新刊の双方を取り扱う店舗として屋号をPOSTに統一した。アートディレクションはグラフィックデザイナーの田中義久が担当。ウェブサイトでは、そのときに特集している出版社の世界観が一目で見て取れるようにラインナップが並び、クリックすることで表紙と裏表紙、中見せのページが切り替わるなどインタラクティブなデザインが施されている。

店内に併設されたギャラリースペースでは、ブックデザインの背景にあるコンセプトや、デザイナーと作家間の協働作業を紹介し、本づくりにおけるデザイナーの役割やブックデザインについて伝える展覧会「SPOT」などを開催。また、ドイツのアート系出版社「Steidl」のオフィシャルブックショップでもある。オーナーの中島佑介は、田中らとともに、2015年から「TOKYO ART BOOK FAIR」のディレクターも務め、他店舗のブックコーディネートなども手がけている。

A bookstore that focuses on publishing companies

This store regularly rearranges its inventory to focus on a single publisher. In the attached gallery, the store introduces the concepts of book design and the collaborative process between designers and authors. It also hosts a show called SPOT, where they discuss the role of designers and book design in the book-making process. Graphic designer Yoshihisa Tanaka oversees the art direction. The store's interactive website is also worth a visit.

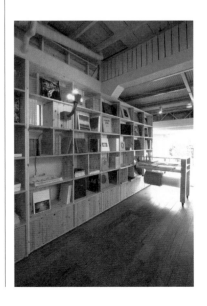

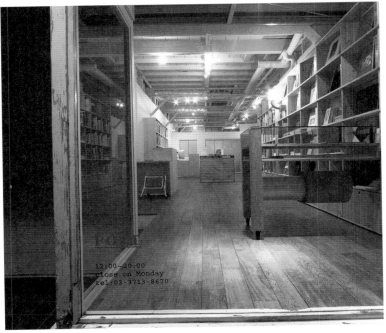

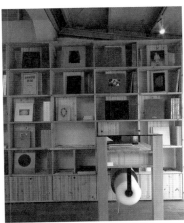

RECOMMENDATION

中島佑介
Yusuke Nakajima

本を選ぶときには注目されることが少ない「出版社」の単位で本を紹介し、作り手である「出版社」の掲げる哲学や思想も感じてもらうことで、新しい本との出会いを提供することを試みているアートブックショップ。書店の奥にはギャラリースペースも併設し、ここでは書籍刊行にあわせた展覧会や、本を主題にした企画展を開催している。

The store introduces books by focusing on an often-overlooked detail: the publisher. It offers visitors a new and unique approach to discovering books by sharing the publisher's philosophy and thoughts. They also have a gallery in the back, where book-related shows and exhibitions coinciding with book publications are held.

時 11:00 — 19:00　休 月曜日　¥ 無料
住 東京都渋谷区恵比寿南 2-10-3
電 03-3713-8670
交 JR、地下鉄日比谷線「恵比寿駅」より徒歩6分
H 11:00-19:00　C Mondays　¥ Free
Ad 2-10-3 Ebisu Minami, Shibuya-ku, Tokyo
Ph 03-3713-8670
Ac 6 min walk from Ebisu Station on the JR and Hibiya lines

–
post-books.info

7 東塔堂
Totodo

Totodo

「新しいクラシック」を
基準に厳選された本が並ぶ古書店

美術、写真、デザイン、建築関連書を扱う古書店。近現代の図書を中心に、内容だけではなく装幀や質感なども含めて、オーナーの大和田悠樹によって総合的に評価しながらセレクトされた本が並ぶ。書籍や写真集のほかにも、ビンテージのデザイン雑誌やプリント、ポスターなども販売。店内に併設されたギャラリースペースでは、年に数回、写真やイラスト、ペインティング、ポスターなどの企画展を開催している。同店は通信販売やイベント出店などをベースに、2006年4月に虎ノ門で開業し、麻布台に移転した後、2009年5月に現在の場所に実店舗を開いた。屋号は虎ノ門時代の部屋の窓から東京タワーが見えたことが由来となっており、「この仕事を始めた場所の風景」と「漢字表記から連想される、東塔のある境内の景色」、「アルファベット表記にしたときの文字のイメージ」が重ねられている。ロゴも建物と本の形態を組み合わせたデザインとなっている。中目黒にある「dessin」は姉妹店であり、写真集や美術書、絵本を中心にしたセレクトが人気である。どちらも温かいウッドテイストの棚による清潔感のある店内が特徴的で、空間をつくり上げたのは、家具屋のスタンダードトレードによるもの。

An antique bookstore where
a new generation of classic
books are curated

This is an antique and secondhand bookstore, specializing in books on art, photography, design, and architecture. Focusing on modern and contemporary publications, the store features books that are carefully selected by the owner, Yuki Owada, based on their content as well as the binding techniques and textures. Vintage design magazines, prints, and posters are available for purchase, and the gallery space hosts exhibitions of photographs, illustrations, paintings, and posters. The sister store, dessin, in Nakameguro is popular for its selection of photography books, art books, and children's picture books.

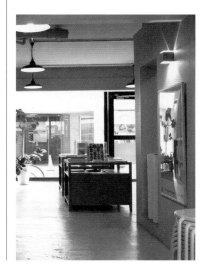

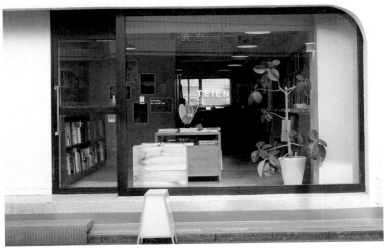

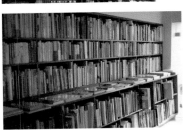

RECOMMENDATION

室賀清徳
Kiyonori Muroga

近年、戦後の日本が写真集をはじめ独自のビジュアル本の文化を発展させてきたことが海外から注目されていますが、同様のことはデザインの本についても言えます。職能的な内容を中心としていた欧米のデザイン書に比べると「デザイナーの作品集」というジャンルが早い時期から数多く刊行され、デザイナーによるエッセイも数多く刊行されてきました。造本も興味深い日本ならではの書物文化に触れられる空間です。

The unique visual culture of postwar Japan, as seen in photo books and other media, has received a great deal of international attention in recent years. This is also true of design books, which often focus on occupational content, the designer-book genre has a long and prolific history in Japan. Many designers have also published essays. Visitors to this bookshop can experience Japan's publishing culture as well as the country's attractive style of bookbinding.

時 13:00 ─ 19:00　休 日曜　￥ 無料
住 東京都渋谷区鶯谷町 5-7 第 2 ヴィラ青山 1F
電 03-3770-7387　交 JR,京王線,地下鉄銀座線,半蔵門線,副都心線「渋谷駅」より徒歩 9 分
H 13:00-19:00　C Sundays　¥ Free
Ad Dai-ni Villa Aoyama 1F, 5-7 Uguisudanicho, Shibuya-ku, Tokyo　Ph 03-3770-7387
Ac 9 min walk from Shibuya Station on the JR, Keio, Ginza, Hanzomon, Fukutoshin lines

–
totodo.jp

8 NEWPORT
NEWPORT

NEWPORT

良質な料理と音楽が迎える、展示も行うレストラン

季節に応じた野菜料理と自然派ワイン、良質な音楽が味わえる代々木公園近くのレストラン。ベジタリアン・ヴィーガン対応のメニューも豊富。店主の鶴谷聡平は元々音楽業界で働いていた経歴があり、毎週土曜日の夜には、常設しているDJブースにゲストDJを招いてのイベントも開催。エントランス横の壁はギャラリースペースとなっており、様々なアーティストの絵や写真作品も紹介している。

A restaurant with good food, music, and exhibitions

This restaurant near Yoyogi Park serves up seasonal vegetable dishes, natural wines, and good music. Vegetarian and vegan meal options are available. The manager, Sohei Tsurutani, used to work in the music industry and is a member of the three-person music group "Soundtrack Brothers," whose repertoire is comprised solely of music from movie soundtracks. Every Saturday night, guest DJs are invited to the restaurant's DJ booth. The wall next to the entrance functions as a small gallery, showcasing paintings and photographs by various artists.

時 11:00－14:30 [L.O.], （月曜・木曜・金曜）17:00－21:00 [L.O.], （土曜・日曜）11:00－21:00 [L.O.]
休 火曜・水曜
住 東京都渋谷区富ケ谷1-6-8
電 03-5738-5564
交 小田急線「代々木八幡駅」, 地下鉄千代田線「代々木公園駅」から徒歩1分
H 11:00-14:30 [L.O.], Mondays, Thursdays and Fridays 17:00-21:00 [L.O.], Saturdays and Sundays 11:00-21:00 [L.O.]
C Tuesdays and Wednesdays
Ad 1-6-8 Tomigaya, Shibuya-ku, Tokyo
Ph 03-5738-5564
Ac 1 min walk from Yoyogi-Hachiman Station on the Odakyu line, and Yoyogi-Koen Station on the Chiyoda line

-
nwpt.jp

RECOMMENDATION

加藤賢策（LABORATORIES）
Kensaku Kato (LABORATORIES)

オフィス近くにある小さなお店。ランチは基本的に毎日ここ。毎回悩んだ振りをして選ぶファラフェルプレート¥1,180。食事中は音楽認識アプリを立ち上げっぱなしにしておく。この界隈にオフィスを構えて良かったと思える理由のひとつ。
This is a small cafe near my office, my go-to lunch place. After pretending to consider other contenders, I order the falafel plate, which is ¥1,180. As I enjoy my lunch, I keep my song-recognition app running in the background. The experience here is one of the reasons I'm glad to have an office in this area.

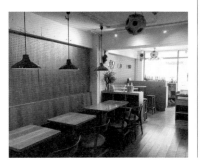

渋谷・目黒の行きたいショップ・見たい建築
Shops and architectures in Shibuya / Meguro

渋谷区立松濤美術館
The Shoto Museum of Art

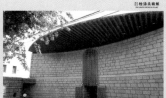

哲人と呼ばれる建築家、白井晟一の設計による、1981年に開館した美術館。絵画・彫刻・工芸など幅広い分野と時代を扱う特別展を年5回程度開催。会期中にはコンサートや建築ツアーなど多彩なイベントも行われる。

This museum opened in 1981 and was designed by architect Seiichi Shirai, who is known as a philosopher and poet. The museum holds special exhibitions five times a year, covering a wide range of periods and art types, including painting, sculpture, and crafts. Concerts and architectural tours are also held during the exhibition period.

住 東京都渋谷区松濤2-14-14　電 03-3465-9421
Ad 2-14-14 Shoto, Shibuya-ku, Tokyo　Ph 03-3465-9421

d47 MUSEUM
d47 MUSEUM

日本の伝統工芸から地元のデザインレーベルまで、都道府県をめぐる多彩な企画を開催するデザイン物産美術館。同じフロアには、リースギャラリー「CUBE 1,2,3」もあり様々な展覧会が行われている。

A museum of design and regional products that offers programs relating to the prefectures of Japan, including traditional crafts and design-focused travel guides. The facility also houses "CUBE 1, 2, 3," where various exhibitions are held.

住 東京都渋谷区渋谷2-21-1 渋谷ヒカリエ8F
電 [d47]03-6418-4718　[CUBE]03-6418-4718
Ad Shibuya Hikarie 8F, 2-21-1 Shibuya, Shibuya-ku, Tokyo
Ph [d47] 03-6427-2301　[CUBE]03-6418-4718

CAGE GALLERY
CAGE GALLERY

Photo by Yuki Harada

恵比寿と広尾のあいだに位置し、奥行24cmのふたつの枠（フレーム）からなるウィンドウ・ギャラリー。2017年のオープン以来、ジャンルや領域にとらわれない表現者の展示を企画。24時間作品を見ることができる。

Located between Ebisu and Hiroo, this facility uses two street-facing windows, measuring 24 cm deep, as a 24-hour gallery. Since opening in 2017, these windows have featured a variety of artists and artworks, focusing mainly on young and emerging artists.

住 東京都渋谷区恵比寿2-16-8 1F
Ad 2-16-8 1F Ebisu, Shibuya-ku, Tokyo

NADiff a/p/a/r/t
NADiff a/p/a/r/t

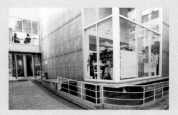

複数のギャラリーが入居する複合型アートスペース。「NADiff（ナディッフ）」が運営する1階のブックストアでは書籍の販売のみならず、インストアで行うイベントや併設するギャラリーでの企画展なども開催。

An art complex housing multiple galleries. The first-floor bookstore hosts in-store events and special exhibitions in its adjoining gallery, run by the art store NADiff.

住 東京都渋谷区恵比寿1-18-4 NADiff A/P/A/R/T 1F
電 03-3446-4977
Ad NADiff A/P/A/R/T 1F 1-18-4 Ebisu, Shibuya-ku, Tokyo
Ph 03-3446-4977

代官山 蔦屋書店
DAIKANYAMA TSUTAYA BOOKS

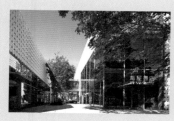

クライン ダイサム アーキテクツによる建築が国内外で話題を呼ぶライフスタイル提案型書店。近隣には複合建築の「ヒルサイドテラス」や、国内外の現代アートを扱う「アートフロントギャラリー」がある。

The architecture of this lifestyle bookstore was designed by Klein Dytham Architecture, and it has become a topic of conversation in Japan and around the world. The neighborhood is home to the Hillside Terrace architectural complex and the Art Front Gallery, which features contemporary art from Japan and abroad.

住 東京都渋谷区猿楽町 17-5　　電 03-3770-2525
Ad 17-5 Sarugakucho, Shibuya-ku, Tokyo
Ph 03-3770-2525

SO books
SO books

代々木八幡駅近くの美術専門古書店。写真集を始め、美術、ファッション、デザイン、建築、セルフパブリッシングなど多ジャンルの本が並ぶ。バックヤードにも蔵書があるため、店員に尋ねてみるのも良いだろう。

This secondhand bookstore specializing in art books is located near Yoyogi-Hachiman station. Shelves are lined with a variety of art books, with topics including photography, fine art, fashion, design, and architecture. They also carry self-published works. With an extended collection in their backyard, it's worth asking the staff if you are looking for something specific.

住 東京都渋谷区上原 1-47-5　　電 03-6416-8299
Ad 1-47-5 Uehara Shibuya-ku Tokyo　Ph 03-6416-8299

book and sons
book and sons

BOOK
AND
SONS

学芸大学駅から徒歩約3分の場所にあるタイポグラフィを中心にしたデザイン本を扱う古書店。デザイン会社のfull size image（フルサイズイメージ）が運営。ギャラリースペースとコーヒースタンドも併設。

This secondhand bookstore is located about a three-minute walk from Gakugei Daigaku Station and deals in design books, with a focus on typography. Run by the design company "full size image," the store also has a gallery and a coffee stand.

住 東京都目黒区鷹番 2-13-3 キャトル鷹番　電 03-6451-0845
Ad 2-13-3 Takaban, Meguro-ku, Tokyo　Ph 03-6451-0845

表参道・青山
OMOTESANDO / AOYAMA

1. ワタリウム美術館
 WATARI-UM, The Watari Museum of Contemporary Art

2. 根津美術館
 Nezu Museum

3. 岡本太郎記念館
 Taro Okamoto Memorial Museum

4. 青山ブックセンター本店
 Aoyama Book Center Omotesando Main Store

5. ユトレヒト
 UTRECHT

6. 国立代々木競技場
 Yoyogi Stadium

7. ギャラリー 5610
 Gallery 5610

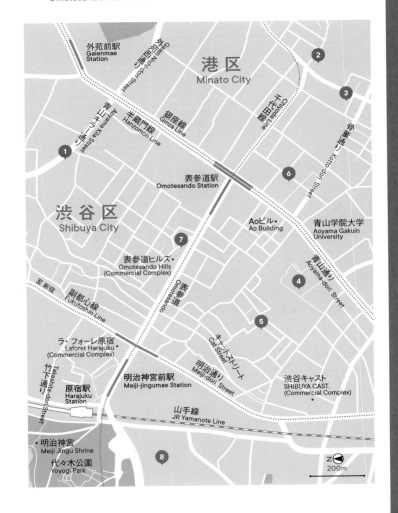

① ワタリウム美術館
WATARI-UM, The Watari Museum of Contemporary Art

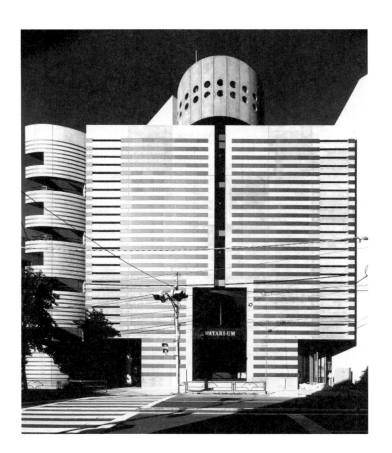

グローバルに開かれた
日本の現代アートの玄関口

1990年、私設美術館として開館。地上5階建て・地下1階建ての建物はスイスの建築家マリオ・ボッタの設計によるもの。国内外を問わず、コンテンポラリーアートの世界で活躍する国際的なアーティストの展覧会を開催することで、グローバルなアートシーンにおける日本の位置の再検討を迫っている。また館内にはミュージアムショップやカフェが設置されているほか、講演会、ワークショップ、パフォーマンス、上映会、ギャラリートーク、教育プログラムなども積極的に開催されている。

**今注目を集める文化を発信する
高感度のショップ**

美術館内には、ミュージアムショップ「オン・サンデーズ」が2フロアにわたって展開。1階では、種類豊富なポストカードやオリジナル商品などが、地階では、展覧会カタログやアーティストグッズのほか、美術・写真・建築関係の和洋書が幅広く揃えられている。さらに、ショップ内の壁面では今注目を集める若手アーティストを招いた展覧会も積極的に開催。上層階で行われているグローバルシーンの展覧会とともに、地階では東京をベースとする最先端の現代アートが発信されている。

A global gateway to Japan's contemporary art

This private art museum, which opened in 1990, was formerly a contemporary art gallery called Galerie Watari. The building was designed by the Swiss architect Mario Botta. Through exhibitions that feature both domestic and international contemporary artists, the museum urges the public to re-examine Japan's position in the global art scene. The museum has a shop and a café and also organizes lectures, workshops, performances, screenings, gallery talks, and educational programs.

🕐 11:00 ─ 19:00 ／（水曜）11:00 ─ 21:00
🈺 月曜（祝日の場合は翌平日）,年末年始
¥ 展覧会により異なる★
🏠 東京都渋谷区神宮前3-7-6　📞 03-3402-3001
🚇 地下鉄銀座線「外苑前駅」より徒歩7分／地下鉄銀座線,千代田線,半蔵門線「表参道駅」より徒歩9分／地下鉄千代田線,副都心線「明治神宮前駅」より徒歩13分／JR「原宿駅」より徒歩14分
🕐 11:00-19:00, Wednesdays 11:00-21:00
🈺 Mondays (or following weekday if Monday is a holiday), New Year holidays
¥ Fees vary by exhibition ★
🏠 3-7-6 Jingumae, Shibuya-ku, Tokyo
📞 03-3402-3001
🚇 7 min walk from Gaienmae Station on the Ginza line, 9 min walk from Omotesando Station on the Ginza, Chiyoda and Hanzomon lines, 13 min walk from Meiji-jingumae Station on the Chiyoda and Fukutoshin lines, 14 min walk from Harajuku Station on the JR line
–
www.watarium.co.jp

永原康史
Yasuhito Nagahara

スイスの建築家マリオ・ボッタの設計で知られる横縞の建物の私設美術館。もともとギャラリーであったことからナムジュン・パイクやヨーゼフ・ボイスといった作家個人との付き合いも深く、現代日本の作家との交流も根強くある。併設のブックショップ「オン・サンデーズ」は老舗のアート系洋書店で、旧店舗時代にキース・ヘリングが壁画を描いたことでも知られている（今は撤去され保管されている）。

This is a private museum inside a striped building, designed by Swiss architect Mario Botta. Originally an art gallery, the museum has connections with artists like Nam June Paik and Joseph Beuys and maintains strong relationships with contemporary Japanese artists. Adjoining the museum is On Sundays, a storied outlet for art books. It is also famous for a mural by Keith Haring that adorned for the shop's previous building. (The work was removed and preserved.)

2 根津美術館
Nezu Museum

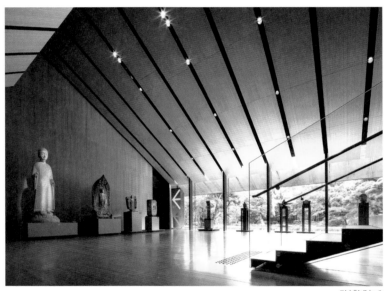

エントランスホール

日本でも有数の古美術コレクション

1941年、東武鉄道の社長などを務めた実業家・根津嘉一郎の日本・東洋美術コレクションをもとにつくられた美術館。尾形光琳の《燕子花図屏風》を筆頭に、数多くの国宝・重要文化財を所蔵している。第二次世界大戦の空襲で建物を失ったが、1954年に再建。その後も断続的な増築を行いながら、2009年に建築家・隈研吾の設計による新本館が開館したことで現在のかたちに至る。建造物やコレクションはもちろん、茶室や薬師堂などが点在する都内有数の日本庭園も見応えあり。

Home to one of the finest collections of classical art in Japan

The museum was built in 1941 for the Japanese and Eastern art collection of Nezu Kaichiro, a businessman who served as president of Tobu Railway. The museum houses many national treasures and important cultural properties, including Ogata Korin's Irises. The museum was rebuilt in 1954, despite suffering a major loss during World War II air raids. Since then, the museum has undergone intermittent expansions. In 2009, the new main building, designed by architect Kengo Kuma, opened in its present form. In addition to its buildings and collections, the museum also has one of the largest Japanese gardens in Tokyo, dotted with tea ceremony rooms and a Yakushido temple, which are worth a visit.

都会の喧騒から離れた和の空間

根津美術館の建物は、明治時代に根津嘉一郎の邸宅として誕生した。17,000㎡におよぶ広大な日本庭園を有し、戦前から長きにわたり愛されてきた。2009年のリニューアルでは、隈研吾の設計による大屋根が特徴的な新本館がオープンするとともに、ドイツ人デザイナー、ペーター・シュミットによる竹をイメージした新ロゴマークが発表された。コレクションから生まれたオリジナルグッズを多数揃えるミュージアムショップや、合計4棟の茶室を含む見事な庭園などにより、都会の喧騒を忘れた充実したひとときを味わうことができる。

🕙 10:00−17:00（入館は閉館30分前まで）
🈺 月曜（祝日の場合は翌平日）,年末年始,展示替期間
💴 特別展：一般1,500円,高校生以上の学生1,200円／企画展：一般1,300円,高校生以上の学生1,000円,小・中学生以下は無料（オンライン日時指定予約制）★
🏠 東京都港区南青山6-5-1　☎ 03-3400-2536
🚇 地下鉄銀座線・千代田線,半蔵門線「表参道駅」より徒歩8分

H 10:00-17:00 (Admission until 30 min before closing)　C Mondays (or following weekday if Monday is a holiday), New Year holidays, and between exhibitions
¥ Special exhibitions: Adults ¥1,500, students (high school and above) ¥1,200 / Collection exhibitions: Adults ¥1,300, students (high school and above) ¥1,000, free for junior high, elementary school students and younger ★ (Online timed-entry reservation reguired)
Ad 6-5-1 Minami-Aoyama, Minato-ku, Tokyo
Ph 03-3400-2536
Ac 8 min walk from Omotesando Station on the Ginza, Chiyoda, and Hanzomon lines

www.nezu-muse.or.jp

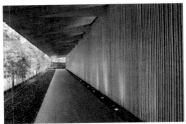
正門からのアプローチ

庭園内の茶室「弘仁亭」

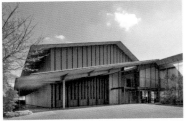
外観

RECOMMENDATION

野見山桜
Sakura Nomiyama

展示と一緒に楽しんでほしいのが庭の散策。竹垣などの日本庭園ならではの造作に加え、バラエティ豊かな石塔や石灯篭がとても面白いです。池の周りに点在する4つの茶室は、時期によって一般公開されることがあるので訪問時にはご確認を。展示と庭を楽しんだ後は、カフェではお茶を楽しんではいかがでしょう。

Along with the exhibition, I would recommend strolling around the garden. It's fascinating to see a variety of stone pagodas and lanterns, besides bamboo fences and other features unique to Japanese gardens. The four teahouses scattered around the pond are open to the public at certain times of the year, so be sure to check them out when you visit. After enjoying the exhibition and the garden, why not enjoy a cup of tea at the cafe?

③ 岡本太郎記念館
Taro Okamoto Memorial Museum

五感を通して岡本太郎の
世界に浸ることができる記念館

1998年に芸術家・岡本太郎のアトリエ兼住居だった建物を改装して設立された記念館。青山にある同館では、1953年から96年までのあいだ、50年近くにわたり岡本太郎が実際に生活していた。それ以前には、太郎が両親（岡本一平・かの子）とともに暮らした旧居が存在しており、現存する建物は戦後に建築家・坂倉準三が設計して建てられたものである。太郎の友人でもあった坂倉は、太郎の求めに応じ、壁の上にレンズ型の屋根を乗せるというユニークな建物をつくり上げたことで話題を集めた。

館内には膨大なスケッチ、彫刻、資料、遺品などが保管されているほか、1階には応接間やアトリエが、2階には展示室が設置され、年間を通して様々な企画展が開催されている。アトリエに隣接する庭園には所狭しと大型の彫刻が並べられており、間近で作品を楽しむことができる。

さらに、カフェ「ア・ピース・オブ・ケーク」は庭園を眺めながらひと息つくことができる憩いのスポット。オーナーで料理研究家の大川雅子によるこだわりのメニューとともに、五感を通して太郎の世界観を堪能することができる。

A memorial museum that immerses you in Taro Okamoto's world

The museum was established in 1998 by renovating Taro Okamoto's studio and residence. The museum houses a vast collection of the artist's sketches, sculptures, documents, and personal items. Visitors can immerse themselves in the space where Taro spent his time and enjoy special exhibitions held in the exhibition space on the second floor. The garden next to his studio is filled with large sculptures that visitors are welcome to touch and experience with their own hands. The museum building was designed by Junzo Sakakura, an architect and a friend of Taro's. Taro came up with the idea for the building to have its unique lens-shaped roof.

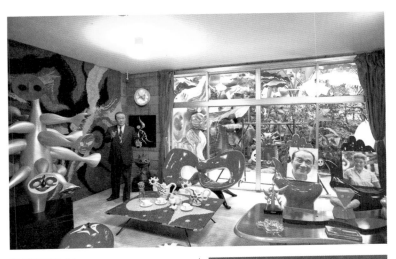

時 10:00−18:00（入館は閉館30分前まで）
休 火曜（祝日の場合は開館）,年末年始および保守点
検日　¥ 一般650円,小学生300円
住 東京都港区南青山6-1-19　電 03-3406-0801
交 地下鉄銀座線,千代田線,半蔵門線「表参道駅」よ
り徒歩8分

H 10:00-18:00 (Admission until 30 min
before closing) C Tuesdays (except for
national holidays), New Year holidays and on
maintenance days
¥ General ¥650, elementary school children
¥300 Ad 6-1-19 Minami-Aoyama, Minato-ku,
Tokyo H 03-3406-0801 Ac 8 min walk from
Omotesando Station on the Ginza, Chiyoda and
Hanzomon lines
-
www.taro-okamoto.or.jp

RECOMMENDATION

佐藤亜沙美
Asami Sato

AD祖父江慎氏のもとデザインを担当した
『岡本太郎 爆発大全』（河出書房新社、2011
年）では、撮影のために同館を訪れ、前から後
ろから作品を観て改めてその異質さに圧倒さ
れた。足を踏み入れた瞬間に太郎の生活の
あとと時間の厚みを感じさせる。時代の空気
に真っ正面から抗っていた太郎作品と、その
一部ともいえる太郎本人が時間を超えて、い
つでも異質で新鮮で圧倒的で居続ける理由
を肌で感じられる場所。

I visited the museum to shoot photographs
for the book Okamoto Taro Bakuhatsu
Taizen (Kawade Shobo Shinsha, 2011),
which I designed under the direction of
Shin Sobue. As I studied his work from
all angles, I was struck by their absolute
uniqueness. You feel transported in time
and can sense traces of Taro's life the
moment you step into the museum. It is a
place where you can personally experience
the elements that continue to make Taro's
work, which stood in defiance to the mood
of the times, and Taro himself, who became
part of his work, transcending time and
remaining unique, fresh, and spectacular.

④ 青山ブックセンター本店
Aoyama Book Center Omotesando Main Store

AOYAMA
BOOK
CENTER

アート・デザインの「本」をめぐる一大文化拠点

1980年に東京・六本木で創業した書店チェーン。東京・青山にある本店は表参道駅から徒歩5分の好立地にあり、アート・デザイン・写真・広告などのクリエイティブ系の和洋書の取り扱いも充実していることから、クリエイターやデザイナーも数多く来訪する。店舗は都心では珍しいワンフロアの構成となっており、見晴らしがきく静かな空間で、約10万冊の在庫から自分にあった本をじっくりと探し出すことができる。

併設のイベント会場では著者を招いたトークショーやワークショップなども開催されており、本をめぐる思考が一層深まる機会が提供されている。さらに、本を通じた学びの場としてのスクールも開校されており、第一線で活躍するデザイナーたちが講師を務める「ミームデザイン学校」からは数多くのデザイナーが輩出。従来の書店という枠組みには留まらない一大文化拠点となっている。

創業40周年目を間近に控えた2020年には、デザイナーのタカヤ・オオタが手がけた新ロゴが発表。新しいロゴのデザインには、出版流通やコミュニティなど、変化の生まれづらい書店のあり方を拡張していきたいという想いが込められている。

A major cultural center for art and design books

Established in 1980 in Roppongi, Tokyo, this store is a favorite among many creators and designers. Its inventory of approximately 100,000 books contains a wide range of Japanese and Western books on art, design, photography, advertising, and other creative subjects. Talks and lectures are held in the event hall, providing opportunities to deepen your experience of books and other topics. In 2020, a new logo designed by Takaya Ota was unveiled. The new design is a representation of the company's desire to shake up the hardened ways of conventional bookstores with respect to publishing, distribution, and community.

この本は、私の処女作。
一番最後を捧げて出来た。
来世も何処かに「私たち」がある証。

「私たちのワンピース」展

🕐 10:00-22:00　🏠 無休　¥ 無料
🏠 東京都渋谷区神宮前5-53-67 コスモス青山ガーデンフロア B2F
🚇 地下鉄銀座線,千代田線,半蔵門線「表参道駅」より徒歩7分／JR,京王線,地下鉄銀座線,半蔵門線,副都心線「渋谷駅」より徒歩13分
H 10:00-22:00　C Open all year round
¥ Free　Ad Cosmos Aoyama Garden Floor B2F, 5-53-67 Jingumae, Shibuya-ku, Tokyo
Ac 7 min walk from Omotesando Station on the Ginza, Chiyoda, and Hanzomon lines, 13 min walk from Shibuya Station on the JR, Keio, Ginza, Hanzomon, and Fukutoshin lines
–
www.aoyamabc.jp

RECOMMENDATION

佐藤亜沙美
Asami Sato

20代の頃は毎日通っていた。常に洗練されたセレクトがされていて信頼している書店。
I used to visit every day during my 20s. It's a bookstore I trust, with a sophisticated selection of books.

5 ユトレヒト
UTRECHT

**本の作り手の顔が
見えてくるような空間**

ユトレヒトは、2002年7月にオンライン
ショップを、同年11月には代官山で実店
舗をオープンさせた。その後は中目黒で
の予約制書店、表参道での書店、そし
て2014年に渋谷区神宮前の現住所へ
と移転している。

書籍の販売や流通にとどまらず、インテ
リア・アパレルショップのブックセレクト、
シェアオフィスなどの各種施設における
ライブラリーのディレクション、「TOKYO
ART BOOK FAIR」の共同開催など、
本にまつわる様々な活動を展開している。
渋谷にあるショップでは、一般書店で目に
する機会の少ない国内外のアート、デザ
イン、ファッション関連の書籍を中心に取
り扱う。さらに、作家自らが制作・発行した
本、凝ったデザインの本、少部数の本など、
作り手の顔が見えてくるような書籍を幅広
く販売するほか、アーティストブックの発行
も行っている。併設するギャラリーNOW
IDeAでは、関連作家の展示も積極的に
開催。本と本の関係性やそれぞれの個性
が見て取れるディスプレイ、関連作家の展
示などを通して、本にまつわる世界観を多
角的に体験することができる。最新情報
はInstagram（utrecht_nowidea）／Twitter
（@UT_IDeA）で日々更新中。

A window into the book creators' world

This bookstore in Shibuya's Jingumae
district specializes in art, design, and
fashion books from Japan and abroad.
The store takes you into the lives of
creators through their wide variety of
books, including books produced and
published by the artists themselves,
books with elaborate designs, and
books printed in limited editions. They
also publish artist books. Exhibitions
exploring fascinating authors are held
at the attached gallery, NOW IDeA.
Through these exhibitions and unique
displays that highlight individual books
while revealing connections among
them, visitors can experience the world
of books from multiple perspectives.

時 12:00 − 20:00
休 月曜日（祝日の場合は翌平日）　Y 無料
住 東京都渋谷区神宮前 5-36-6 ケーリーマンション
2C　電 03-6427-4041
文 地下鉄千代田線,副都心線「明治神宮前駅」より
徒歩10分／地下鉄銀座線,千代田線,半蔵門線「表
参道駅」より徒歩10分

H 12:00-20:00　C Mondays (or following
weekday if Monday is a holiday)　Y Free
Ad 2C Kari Mansion, 5-36-6 Jingumae, Shibuya-
ku, Tokyo　Ph 03-6427-4041
Ac 10 min walk from Meiji-jingumae Station
on the Chiyoda and Fukutoshin lines, 10 min
walk from Omotesando Station on the Ginza,
Chiyoda, and Hanzomon lines

–
utrecht.jp

RECOMMENDATION

渡部千春
Chiharu Watabe

「ちょっと変わった古本、アートブック、雑貨を
売っている場所」から、移転する度にオフィス
兼、うどん屋バー兼、ギャラリー併設、と変容し
続ける書店。小さい展示スペースでも展示
者が思いっきり自由に使っている感じが楽し
い。近年では『山野英之 "がいねんからだて
くせめぢから しゅたいきゃっかんちちんぷいぷ
い URAMI HARASADE STROKES-α 略し
て UHS-α"』に圧倒されました。

Once a shop that sold rare used books,
art books, and miscellaneous goods,
this bookstore continues to grow every
time it changes location. They have
added an office space, an udon noodle
bar, and a gallery. I enjoy how the artists
are maximizing the store's exhibition
space, even if it's small. Recently, I was
blown away by Hideyuki Yamano's
URAMI HARASADE STROKES-α.

6 国立代々木競技場
Yoyogi Stadium

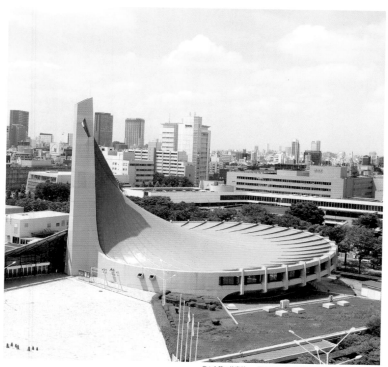

代々木第二体育館　　写真提供：独立行政法人日本スポーツ振興センター

スポーツから音楽イベントまで、人々の集う競技場

1964年の東京オリンピックの開催に伴い、当時新装となった国立競技場で行われる陸上競技と並んで、水泳やバスケットボールの競技会場としてつくられた競技場。1万5千人の観客を動員し、かつ、さまざまな競技に対応できる流動的な空間をめざし、設計者の丹下健三が当時世界的にも珍しかった吊り屋根方式の構造を採用。第一体育館の吊り屋根は、大きな2本の支柱の間に全長280メートルのメインケーブル2本を渡して屋根を支えており、しなやかな曲線を描く屋根の形状はコンクリート造でありながらどこか瓦屋根のような日本的な美しさを感じさせる。一方の第二体育館は、空に向かってのびる支柱から吊りパイプが掛けられており、螺旋形の屋根が特徴的。ともに表参道・原宿エリアを代表する建築物だ。

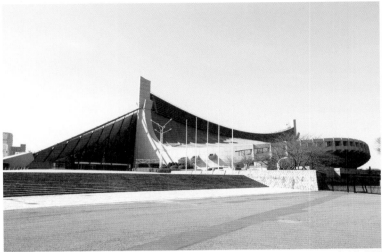

代々木第一体育館

A stadium made for enjoying sports, music, and everything in between

Built to host the 1964 Tokyo Olympics, the indoor stadium seats 15,000 spectators. Designed to be a flexible space used for a variety of sports such as swimming and basketball. Kenzo Tange used a suspended roof structure, which was rare at the time. The building's dynamic appearance has become a symbol of the Omotesando and Harajuku areas. Today, the building is being used as a venue for sporting and music events, serving the city as a cultural center.

🕐 各施設により異なる
🈺 各施設により異なる　💴 各施設により異なる
🏠 東京都渋谷区神南 2-1-1　📞 03-3468-1171
🚃 JR「原宿駅」,地下鉄千代田線,副都心線「明治神宮前駅」より徒歩 5 分

H Hours vary by each facilities
C Closed days vary by each facilities
¥ Fees vary by each facilities
Ad 2-1-1 Jinnan, Shibuya-ku, Tokyo
Ph 03-3468-1171　Ac 5 min walk from Harajuku Station on the JR line and Jingumae Station on the Chiyoda, Fukutoshin lines
–
www.jpnsport.go.jp/yoyogi

RECOMMENDATION

7

アイデア編集部
IDEA

隣接する代々木公園と明治神宮の緑豊かな景色とは対照的なコンクリート造の構造が印象的な建物。イベント時には大勢の人で賑わう競技場内の石畳の広場は、それ以外の時に行けば都会にいながら広々とした空を見渡せる貴重な空間。原宿駅から競技場を通り、渋谷方面を散策するルートがおすすめ。

The impressive concrete structure stands in stark contrast to the lush green landscape of the adjacent Yoyogi Park and Meiji Shrine. The stone-paved plaza in the stadium, which becomes crowded with people during events, is a precious spot where visitors can enjoy a wide, expansive view of the sky when there are no events at the stadium. For a good stroll, start at the Harajuku Station and pass through the stadium towards Shibuya.

⑦ ギャラリー5610
Gallery 5610

Gallery 5610

河野鷹思が設立した
心地良いギャラリー空間

1972年、デザイナーの河野鷹思によって創設されたギャラリー。表参道駅から徒歩3分という好立地ながら、緑豊かなアプローチとテラスに恵まれており、落ち着いた環境で作品を鑑賞することができる。年間を通して様々なデザイナーやアーティストの展覧会を開催している。近年は、オンラインショップに加え、庭に面した心地良い空間で、リアルショップである「SPaTio5610」も展開。こぢんまりとした展示と関連グッズの販売、河野鷹思の作品紹介、デザイン関連書籍の開架、不定期のワークショップや学習会などが行われている。

A comfortable gallery established by Takashi Kono

The gallery was founded in 1972 by Takashi Kono, a graphic designer. The gallery hosts exhibitions of designers and artists throughout the year. In addition to their online store, they recently opened a retail shop, SPaTio5610, in a pleasant space facing the garden.

🕐 展覧会により異なる　🗓 展覧会により異なる
💴 無料　🏠 東京都港区南青山5-6-10 5610番館
📞 03-3407-5610　🚇 地下鉄銀座線, 千代田線, 半蔵門線「表参道駅」より徒歩2分

🕐 Hours vary by exhibition　🅲 Closed days vary by exhibition　🆅 Free　🆔 5610 Ban-kan, 5-6-10 Minami-Aoyama, Minato-ku, Tokyo
📞 03-3407-5610　🆎 2 min walk from Omotesando Station on the Ginza, Chiyoda, and Hanzomon lines
–
www.deska.jp

ロゴデザイン：太田徹也

RECOMMENDATION

イエン・ライナム
Ian Lynam

ギャラリー5610では、世界を代表するアーティスト、デザイナー、職人らの作品を中心に様々な展覧会を開催している。オーストラリアのウォレン・テイラーがキュレーションしたFolkways Recordsのアルバムカバーの展示から、写真作品を中心としたグループ展まで、その内容は多岐にわたる。Gallery 5610では、創業者河野の娘であり、アーティスト兼デザイナーでもある葵・フーバー・河野の作品と、彼女の亡き夫であるスイス人デザイナーのマックス・フーバーの作品が常時展示されている。低い天井と巨大なガラス窓が特徴のこのギャラリーは、もっとシンプルだった時代にタイムマシンで戻ったかのような気分にさせてくれる。

Gallery 5610 hosts a revolving cast of exemplary exhibitions from leading artists, designers and craftspeople from around the world. The gallery's offerings are diverse—from an exhibition of Folkways Records album covers curated by Australia's Warren Taylor to group shows centered on photography. Gallery 5610 perennially shows the work of founder Kono's daughter, artist and designer Aoi Kono Huber alongside the work of her late husband, Swiss designer Max Huber. With its low ceilings and giant glass windows, the gallery feels like a time machine back to simpler modern times.

表参道・青山の行きたいショップ・見たい建築
Shops and architectures in Omotesando / Aoyama

GA gallery
GA gallery

©GA photographers

出版社A.D.A. EDITA Tokyoが運営する建築専門ギャラリー。建築に関連する様々な企画展を開催しているほか、併設するブックショップでは、建築を中心とする専門書籍を数多く取り扱っている。

A gallery focused on architecture, operated by publishing company A.D.A. EDITA Tokyo. In addition to holding a variety of exhibitions centered around the theme of architecture, the attached bookshop carries a wide range of architecture-related books.

住 東京都渋谷区千駄ヶ谷3-12-14　電 03-3403-1581
Ad 3-12-14 Sendagaya, Shibuya-ku, Tokyo
Ph 03-3403-1581

国立能楽堂
National Noh Theatre

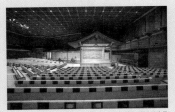

写真提供：国立能楽堂

能楽の保存と普及を目的に設立された能楽堂。建築家・大江宏の設計による敷地内には、樹齢400年の尾州檜を用いた能舞台などが設置されており、627席におよぶ広大な客席でゆったりと能を楽しむことができる。

A performance hall that was established for the purpose of preserving and popularizing Noh theater. Designed by architect Hiroshi Oe, the site includes a Noh stage made of 400-year-old Bishu cypress and a vast 627-seat auditorium, where visitors can enjoy Noh in a relaxed atmosphere.

住 東京都渋谷区千駄ヶ谷4-18-1　電 03-3423-1331
Ad 4-18-1 Sendagaya, Shibuya-ku, Tokyo　Ph 03-3423-1331

ペーターズショップアンドギャラリー
PATER'S Shop and Gallery

1986年、イラストレーター・ペーター佐藤 がオープンしたショップ&ギャラリー。1階はペーター佐藤の画集、ポスター、グッズなどを販売するショップとして、2階は貸しギャラリーとして営業している。

A shop and gallery opened by illustrator Pater Sato in 1986. The first floor is a retail space that sells Pater Sato's art books, posters, and other items, and the second floor is a rental gallery.

住 東京都渋谷区神宮前2-31-18　電 03-3475-4947
Ad 2-31-18 Jingumae, Shibuya-ku, Tokyo
Ph 03-3475-4947

HBギャラリー
HB Gallery

1985年にオープンした、表参道ヒルズの近くに位置するイラストレーションギャラリー。新進気鋭の若手イラストレーターのほか、和田誠や藤枝リュウジといったベテラン作家の展覧会も定期的に開催している。

Opened in 1985, this illustration gallery is located near Omotesando Hills and regularly hosts exhibitions by up-and-coming young illustrators as well as veteran artists such as Makoto Wada and Ryuji Fujieda.

住 東京都渋谷区神宮前4-5-4 原宿エノモトビル1F
電 03-5474-2325
Ad Harajuku Enomoto Building 1F, 4-5-4 Jingumae, Shibuya-ku, Tokyo　Ph 03-5474-2325

表参道ヒルズ
Omotesando Hills

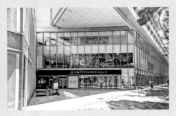

安藤忠雄設計の日本のファッション・カルチャーの中心・表参道の核となる文化商業施設。約700mの長さの「スパイラルスロープ」の周りに、多数のアパレル、ジュエリー、ライフスタイルショップなどが軒を連ねている。

Omotesando Hills is a Tadao Ando designed cultural and commercial facility located at the center of Omotesando, the heart of Japanese fashion and culture. Its 700-meter-long spiral slope leads to numerous apparel, jewelry, and lifestyle stores.

住 東京都渋谷区神宮前4-12-10　電 03-3497-0310
Ad 4-12-10 Jingumae, Shibuya-ku, Tokyo
Ph 03-3497-0310

ジャイル
GYRE

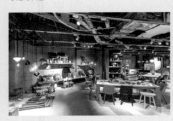

表参道にあるファッション複合ビル。MVRDVの設計による同ビルは、コンセプトストアの集合体として、ファッション、建築、アート、デザイン、フードなど、様々なインスピレーションや文化を発信している。

Designed by MVRDV, this fashion complex in Omotesando is a collection of concept stores that offer cultural inspiration in fashion, architecture, art, design, and food.

住 東京都渋谷区神宮前5-10-1　電 03-3498-6990
Ad 5-10-1, Jingumae, Shibuya-ku, Tokyo
Ph 03-3498-6990

CIBONE
CIBONE

表参道のGYRE B1Fに店を構えるライフスタイルショップ。変容する世界に対して「ユニーク」さを問い続けながら、インテリア、アート、ファッションなどを独自の視点でセレクトし販売している。

A lifestyle store located inside GYRE B1F, Omotesando. The store sells interior design, art, and fashion products, selected by their original perspective with an unwavering focus on determining what is truly unique in our changing world.

住 東京都渋谷区神宮前5-10-1 GYRE B1F　電 03-6712-5301
Ad GYRE B1F 5-10-1 Jingumae, Shibuya-ku, Tokyo
Ph 03-6712-5301

MoMA Design Store 表参道
MoMA Design Store Omotesando

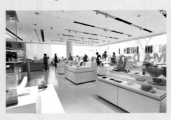

ニューヨーク近代美術館が手がける、世界のグッドデザイングッズを取り揃えたストア。店頭に並ぶ約2,000種類のアイテムは、全て同館のキュレーターがセレクトしたもの。ストア限定アイテムも多数取り揃えている。

A retail store run by New York's Museum of Modern Art, featuring a selection of well-designed items from around the world. All of the approximately 2,000 items in the store have been selected by the museum's curators. The store also carries a large selection of exclusive items.

住 東京都渋谷区神宮前5-10-1 GYRE 3F　電 03-5468-5801
Ad GYRE 3F 5-10-1, Jingumae, Shibuya-ku, Tokyo
Ph 03-5468-5801

エスパス ルイ・ヴィトン東京
ESPACE LOUIS VUITTON TOKYO

ルイ・ヴィトン表参道ビルの7階に位置するアートスペースで、現代美術を中心に紹介し、刺激的なインスピレーションを喚起させられる空間。青木淳の設計よる空に浮かぶガラス張りの空間も一見の価値あり。

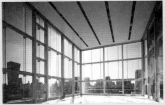
©Louis Vuitton / Daici Ano

Located on the seventh floor of the Louis Vuitton Omotesando building, this art space presents contemporary art in a stimulating and inspiring space. The glass-walled space, which seems to float in the air, was designed by Jun Aoki.

🏠 東京都渋谷区神宮前 5-7-5 ルイ・ヴィトン表参道ビル 7F
☎ 0120-00-1854 (ルイ・ヴィトン クライアントサービス)
🆔 Louis Vuitton Omotesando Building 7F, 5-7-5 Jingumae, Shibuya-ku, Tokyo　📱 0120-00-1854 (Louis Vuitton client service)

BLOCK HOUSE
BLOCK HOUSE

神宮前に位置する複合型スペース。中央アーキの設計による5フロアの建物には、複数のギャラリー、カフェバー、茶室、オフィスなどが入居しており、ジャンルや業界の垣根を超えたカルチャーを発信している。

Exhibition view by Hiro Tanaka / Photo by KABO

A commercial complex located in Jingumae. The five-story building, designed by Chuo Archi, contains several galleries, a café and bar, a tea ceremony room, and offices. This mixed-use cultural center transcends the boundaries of genre and industry.

🏠 東京都渋谷区神宮前 6-12-9
🆔 6-12-9 Jingumae, Shibuya-ku, Toky

スパイラル
SPIRAL

spiral.

アートギャラリーと多目的ホールを中心に、カフェ、レストランバー、ショップなどで構成される複合文化施設。現代美術の展覧会、舞台公演、ファッションショー、シンポジウムなどを開催している。設計は槇文彦。

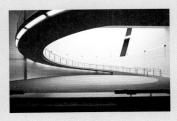

A cultural complex consisting of an art gallery and multi-purpose hall. It also houses a café, restaurant, bar, and retail stores. The facility hosts contemporary art exhibitions, stage performances, fashion shows, and symposiums. The building was designed by Fumihiko Maki.

🏠 東京都港区南青山 5-6-23　☎ 03-3498-1171
🆔 5-6-23 Minami-Aoyama, Minato-ku, Tokyo
📱 03-3498-1171

Found MUJI 青山
Found MUJI Aoyama

無印良品の路面店第一号として1983年にオープンした「無印良品 青山」が2011年にリニューアル。「Found MUJI (見出されたMUJI)」と名づけられた店舗には、世界中で長く愛される手仕事や日用品などを製品化したアイテムに出会える。

This is the store "MUJI Aoyama", which was opened in 1983 and got renewed in 2011 as the first retail store for MUJI. Appropriately named Found MUJI, the store offers handmade items and everyday products that have been found in various corners of the world and brought to the shop.

🏠 東京都渋谷区神宮前 5-50-6 中島ビル 1-2F
☎ 03-3407-4666　🆔 Nakajima Building 1-2F, 5-50-6 Jingumae, Shibuya-ku, Tokyo　📱 03-3407-4666

DIESEL ART GALLERY
DIESEL ART GALLERY

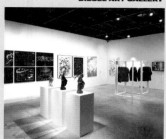

ファッションブランドDIESELが手掛ける明治通り沿いのアートギャラリー。世界中から様々なジャンルのアーティストを招いて年4回の展覧会を開催するほか、アーティスト関連グッズの販売も行っている。

Art gallery curated by the fashion brand DIESEL, located along Meiji Street. In addition to hosting four exhibitions a year with artists of various genres from around the world, the gallery also sells artist-related merchandise.

🏠 東京都渋谷区渋谷1-23-16 cocoti B1F
☎ 03-6427-5955
Ad cocoti B1F, 1-23-16, Shibuya, Shibuya-ku, Tokyo
Ph 03-6427-5955

草月会館
Sogetsu Kaikan

🟠草月

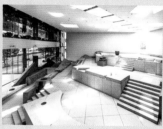

建築家・丹下健三の設計により1977年に竣工した施設。イサム・ノグチによる石庭や多目的ホールなどを備えており、草月流のいけばなはもとより、ジャンルを超えた創造活動の発信地となっている。

A cultural facility built in 1977 and designed by architect Kenzo Tange. Equipped with a stone garden designed by Isamu Noguchi and a multi-purpose hall, the facility contains the Sogetsu-ryu Ikebana, a school of Japanese floral art, as well as a source of creative experiences that goes beyond the field.

🏠 東京都港区赤坂7-2-21　☎ 03-3408-1154
Ad 7-2-21 Akasaka, Minato-ku, Tokyo　Ph 03-3408-1154

Photo by YOSHIKI NAKANO

新宿・四谷
SHINJUKU / YOTSUYA

1 NTTインターコミュニケーション・センター［ICC］
NTT InterCommunication Center [ICC]

2 東京オペラシティ
アートギャラリー
Tokyo Opera City Art Gallery

3 文化学園服飾博物館
Bunka Gakuen Costume Museum

4 印刷博物館
Printing Museum, Tokyo

5 print gallery tokyo
print gallery tokyo

6 早稲田大学坪内博士
記念演劇博物館
The Tsubouchi Memorial Theatre Museum, Waseda University

7 中野ブロードウェイ
Nakano Broadway

8 嘉瑞工房
Kazui Press

7

中野駅
Nakano Station

東中野駅
Higashi-nakano Station

青梅街道
Ome Kaido Avenue

4

8

飯田橋駅
Iidabashi Station

高田馬場駅
Takadanobaba Station

6

東中野駅
Higashi-nakano Station

新宿区
Shinjuku City

大久保駅
Okubo Station

新大久保駅
Shin-okubo Station

青梅街道
Ome Kaido Avenue

東京都庁・
Tokyo Metropolitan
Government

新宿駅
Shinjuku Station

5

3

新宿御苑
Shinjuku Gyoen
National Garden

代々木駅
Yoyogi Station

千駄ヶ谷駅
Sendagaya Station

信濃町駅
Shinanomachi
Station

1

2

N
200m

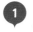

1 NTT インターコミュニケーション・センター [ICC]
NTT InterCommunication Center [ICC]

INTERCOMMUNICATION CENTER

国内におけるメディア・アートの発信拠点

日本の電話事業100周年の記念事業として1997年にオープンした、NTT東日本が運営する文化施設。東京オペラシティタワーの4階に位置し、同じビルの3階には東京オペラシティ アートギャラリーも入居する。

国内におけるメディア・アートのメッカとしても知られており、「コミュニケーション」をテーマに、科学技術と芸術文化の交流を促す展示・企画を数多く行っている。

活動の中核をなすのは、ギャラリー、ミニ・シアター、映像アーカイブ「HIVE」などをフルに活用した長期展示「オープン・スペース」で、年間を通して無料公開されている。さらに、特定のアーティストやテーマに着目した有料の企画展も定期的に開催している。そのほか、トークイベント、シンポジウム、ワークショップ、パフォーマンス、出版などを積極的に行い、オンライン中継・アーカイブにも取り組んでいる。

A hub for media art in Japan

Opened in 1997, this cultural facility is run by NTT East. The institution is known as the epicenter of media art in Japan, and it holds a number of communications-related exhibitions and presentations, with the intention to facilitate interaction between science and technology and art and culture. At the core of its efforts is a long-term exhibition called *Open Space* that uses a gallery, mini-theater, and video archive HIVE. This exhibition is free and open to the public throughout the year. The museum also regularly holds special ticketed exhibitions that focus on specific artists and themes.

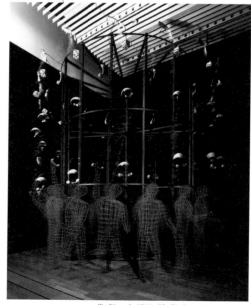

グレゴリー・バーサミアン 《ジャグラー》1997年　ICCコレクション
撮影：大高隆　写真提供：NTT インターコミュニケーション・センター [ICC]

ICC 5F ロビー　写真提供：NTT インターコミュニケーション・センター [ICC]

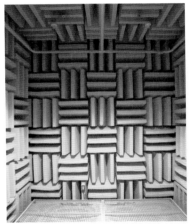

無響室　撮影：木奥恵三
写真提供：NTT インターコミュニケーション・センター [ICC]

RECOMMENDATION

佐藤亜沙美
Asami Sato

同館で行われたワークショップの研究結果を書籍化した『情報環世界─身体とAIの間であそぶガイドブック』（NTT出版）のデザインを担当した。5人の研究者がそれぞれにテクノロジー、人間科学、芸術表現にもとづく、人間・社会の新しい情報のあり方を示したもので、子どもたちに向けて、情報という目に見えない巨大なものを分かりやすく可視化して触れられる内容になっている。情報環世界に身を置くわたしたちにも貴重なギャラリーだ。

I worked on the design of the book *Information Umwelt* (NTT Publishing), which was written based on the research from workshops held at ICC. It features the work of five researchers and their take on new forms of information based on the fields of technology, human science, and artistic expression. The book, which was designed for children, introduces the intangible and gigantic concept of information in a way that is easy to visualize and understand. ICC is an invaluable gallery for those of us who live in the world of information umwelt.

⏰ 11:00 − 18:00　🚫 月曜（祝日の場合は翌平日）, 年末年始, 展示替期間, 保守点検日　💴 オープン・スペースは無料, そのほかの展示・イベントは企画により異なる　🏠 東京都新宿区西新宿 3-20-2 東京オペラシティタワー 4F　☎ 0120-144199（フリーダイヤル）
🚃 京王新線「初台駅」より徒歩 2 分

🕚 11:00-18:00　🅲 Mondays (or following weekday if Monday is a holiday), New Year holidays, between exhibitions, and during maintenance　💴 Free for open space, fees vary by exhibition　🅰 Tokyo Opera City Tower 4F, 3-20-2 Nishishinjuku, Shinjuku-ku, Tokyo
📞 0120-144199 (Toll-free call)　🅰 2 min walk from Hatsudai Station on the Keio New line

–
www.ntticc.or.jp/ja

② 東京オペラシティ アートギャラリー
Tokyo Opera City Art Gallery

西新宿が誇るアートの発信基地

新国立劇場に隣接する、コンサートホールなどが入る東京オペラシティタワーの3階にあるアートギャラリー。「ビジネス」「芸術文化」「商業」の3ゾーンからなる複合施設におけるアートの発信基地として、1999年にオープンした。同じビルの4階にはNTTインターコミュニケーション・センター[ICC]も入居している。

年間4本程度行われる企画展のほか、寺田小太郎寄贈による寺田コレクションを中核としたコレクション展、国内の若手作家を紹介する「project N」などの展覧会を実施。また収蔵品には、抽象画家の難波田龍起・史男父子の作品を始めとする近現代美術の名作およそ3,000点が含まれている。

企画展のテーマは、絵画、彫刻、写真、映像、デザイン、ファッション、建築など多岐にわたっており、空間サイズ、天井高、採光方法などが異なる4つのギャラリーを活かした多彩な展示を実施。同時代のアートが楽しめる。さらに、隣接するショップは「ギャラリー5」と名づけられており、アートギャラリーの「5番目の展示室」として、関連商品、国内外の最新アートブックやグッズなどを展開。観客を飽きさせない体験が提供されている。

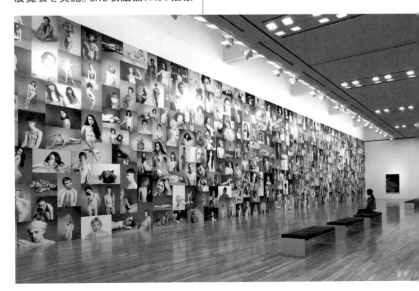

An art center that is the pride of Nishi-Shinjuku

This art gallery is located on the third floor of Tokyo Opera City Tower, which houses several venues, including the New National Theatre, Oumi Gakudo, and a concert hall. It was opened in 1999 as an art hub in a mixed-use complex consisting of three zones: business, art and culture, and commercial. The gallery holds four special exhibitions a year based on a wide variety of themes, such as painting, sculpture, photography, video, design, fashion, and architecture. It also holds exhibitions featuring its own art collection and *project N*, which exhibits the work of young Japanese artists. The institution's collection includes about 3,000 masterpieces of modern and contemporary art.

Photo by Keizo Kioku

🕐 11:00－19:00 (入館は閉館30分前まで)
🈺 月曜 (祝日の場合は翌平日)、年末年始、展示替期間
💴 展覧会により異なる
🏠 東京都新宿区西新宿3-20-2 東京オペラシティタワー－3F ☎ 050-5541-8600 ◎
🚉 京王新線「初台駅」より徒歩2分

🕐 11:00-19:00 (Admission until 30 min before closing) 🅲 Mondays (or following weekday if Monday is a holiday), New Year holidays, between exhibitions
💴 Fees vary by exhibition
🅰 Tokyo Opera City Tower 3F, 3-20-2 Nishishinjuku, Shinjuku-ku, Tokyo
🅟 050-5541-8600 ◎ 🅐 2 min walk from Hatsudai Station on the Keio New line
–

www.operacity.jp/ag

③ 文化学園服飾博物館
Bunka Gakuen Costume Museum

文化学園服飾博物館
BUNKA GAKUEN COSTUME MUSEUM

衣を通して日本と世界の文化を知る、ファッション専門の博物館

学校法人文化学園を母体とする日本では数少ない服飾博物館。1923年に創設された文化学園は、ファッションを専門とする学校、研究所、図書館、出版局などを擁する総合機関として、長きにわたり日本のファッション界をリードしてきた。学園の創設以来コレクションされてきた実物資料を核として1979年に開館。2003年に甲州街道に面する新宿文化クイントビルに移転した。
「衣を通して日本と世界の文化を知る」というテーマのもと、これまでに多数の企画展を開催するとともに、フランス、韓国、ブルガリア、チリなど、世界各地でも展覧会を開催している。コレクションの基礎にあるのは、ヨーロッパのドレス、日本の初期洋装・着物、民族衣装などで、現在も包括的、体系的なコレクションを目指して収集を続けている。
新宿駅からもほど近い好立地を活かし、古今東西の多様なファッション資料・コレクションを世界へ向けて発信している。

Learn about Japanese and world cultures through clothing at this fashion museum

The Bunka Gakuen has long been a leader in the Japanese fashion industry as a comprehensive institution that includes a school, research center, library, and publishing offices specializing in fashion. Opened in 1979, the institution is one of the few fashion museums in Japan, and at its core are tangible resources that have been collected since the founding of the school.
Numerous special exhibitions are held under the theme of "understanding the culture of the world and Japan through clothing." The museum takes advantage of its prime location near Shinjuku Station to present a variety of fashion resources and collections from the past and present and from all over the world.

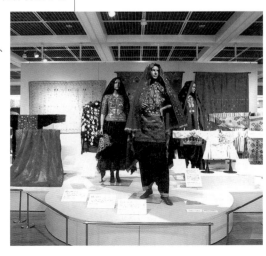

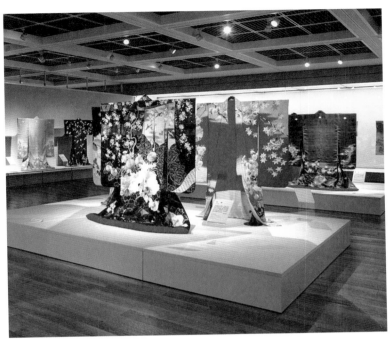

🕐 10:00−16:30（入館は閉館30分前まで）
🈲 日曜・祝日・振替休日, 夏期休暇, 年末年始, 展示替期間　💴 一般500円, 高校・大学・専門学校生300円, 小中学生200円★　🏠 東京都渋谷区代々木3-22-7 新宿文化クイントビル1F
📞 03-3299-2387　🚃 JR「新宿駅」より徒歩7分

🅷 10:00-16:30 (Admission until 30 min before closing)　🅲 Sundays, holidays, substitute public holidays, summer holidays, New Year holidays, and between exhibitions
💴 Adults ¥500, high school, university, and vocational school students ¥300, junior high and elementary school students ¥200★
🆎 Shinjuku Bunka Quint Building 1F, 3-22-7 Yoyogi, Shibuya-ku, Tokyo　📞 03-3299-2387
🆎 7 min walk from Shinjuku Station on the JR line

museum.bunka.ac.jp

RECOMMENDATION

7

アイデア編集部
IDEA

展覧会とあわせて活用したいのが、同館のWEBサイトからアクセスできる所蔵品データベースだ。所蔵品のなかから日本と外国の服飾資料約600件が公開されており、資料名や国名、キーワードなどフリーワード検索ができる。全体や生地のアップなど、豊富な画像と解説付で閲覧することができるのも特徴。The museum's website offers a database, which is a great resource to browse during exhibitions. The database lists approximately 600 items from the museum's collection and can be searched by title and keyword. The database can also be browsed by country, region, and year, and it provides images and descriptions of the artwork.

④ 印刷博物館
Printing Museum, Tokyo

印刷博物館
PRINTING MUSEUM, TOKYO

**印刷を文化として捉え直す、
日本唯一の印刷博物館**

凸版印刷の100周年記念事業の一環として2000年に開館した博物館。地下展示室では、日本を中心に印刷の歴史を時系列で追える常設展のほか、コミュニケーションメディアとしての「印刷」に焦点を当てた企画展などを行っている。また展覧会のみならず、印刷文化に関わる資料の収集、研究活動などを実施。展示室内にある「印刷工房」では、活版印刷の保存と伝承や研究活動を行っており、希望者は活版印刷体験ができる。施設内にはこのほか、VRシアター、ライブラリー、研修室などが備わっている。入口のほど近くには外光が差し込む開放的なミュージアムショップがあり、印刷にまつわる書籍、オリジナルグッズ、展覧会カタログなどを販売している。また、入口奥のP&Pギャラリーでは、現代のブックデザインやグラフィックデザイン、パッケージデザインをテーマにした企画展が開かれている。
印刷を「技術」としてではなく「文化」として包括的に捉え直そうとする印刷博物館は、新しい学問領域としての「印刷文化学」の確立をめざすべく、これまでの研究成果をもとに2020年10月に常設展を一新。外部との積極的なコラボレーションも推進する。

The only printing museum in Japan that redefines printing as a culture

The museum was opened by Toppan Printing in 2000. It holds exhibitions that focus on printing as a communication medium, with the purpose of redefining printing as culture rather than technology. In addition to exhibitions, the museum collects materials related to printing culture, conducts research, and offers letterpress printing workshops. The museum renewed its permanent exhibition in October 2020, based on the results of their past research and it actively promotes external collaborations.

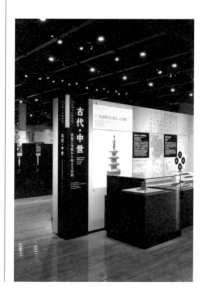

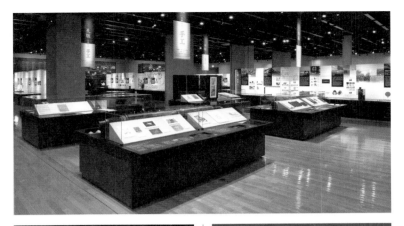

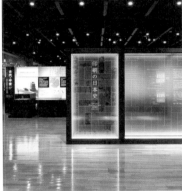

中野豪雄
Takeo Nakano

開館20周年を迎えた2020年のリニューアル事業に携わった。常設展は、日本の印刷史を軸としたクロノロジカルな空間構成をベースに、世界史や印刷技術の原理を関連づけながら、印刷と社会変動の影響関係を資料とともに視覚化する展示形態へと変化を遂げた。東アジア文化圏の博物館や研究者との連携を取り、更なる印刷文化の探究も視野に入れたビジョン「印刷文化学」が構想されているなど、今後の収蔵・研究・公開活動に注目したい。

I was involved in the museum's 20th anniversary renovation project in 2020. The permanent exhibition is presented in a chronological spatial structure based on the history of Japanese printing. It has been transformed into an exhibition that visualizes the relationship between printing and social change, linking it to world history and the principles of printing technology. In collaboration with museums and researchers in East Asian cultures, a vision of "print culture studies" is being conceived with a goal to further investigate the culture of printing, and it will be interesting to see how the museum's collection, research, and public activities will be carried out in the future.

🕐 10:00－18:00（入館は閉館30分前まで）
🈺 月曜（祝日の場合は翌平日）、年末年始、展示替期間
💴 一般400円、大学生200円、中高生100円、小学生以下および70歳以上の方無料★（企画展開催時は金額が変更）
🏠 東京都文京区水道1-3-3トッパン小石川ビル
☎ 03-5840-2300
🚇 地下鉄有楽町線「江戸川橋駅」より徒歩8分

H 10:00-18:00 (Admission until 30 min before closing) C Mondays (or following weekday if Monday is a holiday), New Year holidays, and between exhibitions ¥ General ¥400, university students ¥200, high school and junior high school students ¥100, free for elementary school students and younger children, adults over 70 ★ (fees vary by exhibition)
Ad Toppan Koishikawa Building, 1-3-3 Suido, Bunkyo-ku, Tokyo
Ph 03-5840-2300 Ac 8 min walk from Edogawabashi Station on the Yurakucho line
–

www.printing-museum.org

5 print gallery tokyo
print gallery tokyo

小さいながら国際色あふれるタイポグラフィと印刷に特化したギャラリー

都内でも珍しい、タイポグラフィを中心とした展示を行うスペース。ギャラリーを主宰するデザイナーの阿部宏史はスイス・バーゼルで学んだ経験をもち、その交友関係から欧州のデザイナー・アーティストを紹介する企画や、印刷技法に特色のある作家に焦点をあてた企画展を開催している。再開発計画により白金から四谷三丁目に移転、2021年上旬に再開予定。古くから小規模の印刷会社が点在するエリアでの展開に期待をもって訪れたい空間。

A small gallery with an international flavor and specialization in typography and printing

This is a rare, typography-focused gallery in Tokyo. The designer who runs the space, Hirofumi Abe, studied in Basel, Switzerland. Using his connections, he organizes exhibitions to introduce European designers and artists, with special attention to those with unique printing techniques.

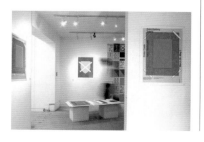

🕙（月曜・金曜）15:00－20:00／（土曜・日曜）13:30－20:00　休 火曜－木曜　¥ 無料
住 東京都新宿区舟町9-2 1F
交 地下鉄丸ノ内線「四谷三丁目駅」より徒歩5分
🕙 Mondays and Fridays 15:00-20:00, Saturdays and Sundays 13:30-20:00　C Tuesdays thru Thursdays　¥ Free　Ad 9-2 1F Funamachi, Shinjuku-ku, Tokyo　Ac 5 min walk from Yotsuya-sanchome Station on the Marunouchi line
–
www.printgallerytokyo.com

RECOMMENDATION

大日本タイポ組合
Dainippon Type Organization

活版／木版／デジタル問わず印刷物中心の展示・作家のセレクションはもちろん、ギャラリーの間取りやたたずまいに漂う余白すら心地良かったのは、主宰の阿部さんのバーゼル仕込みか、あるいは彼がバーゼルで会って以来の仲で、ギャラリーの一番のサポーターだったというヘルムート・シュミットの精神か。その「Design is Attitude」を受け継いで、今後どこでどんな展示が行われるのか、次のフェーズも楽しみ。

Not only is the gallery's selection of artists and the exhibitions of print, woodblock, and digital works are excellent, but we found that even the facility's spatial layout and atmosphere are all very comfortable, probably because the gallery's organizer, Mr. Abe, was trained in Basel. It could also be because the gallery was influenced by the philosophy of Helmut Schmidt, whom Mr. Abe met in Basel and who has been the strongest supporter and friend of the gallery. We're looking forward to the next phase of the gallery and how it will grow and continue the idea of "design is attitude."

 # 早稲田大学坪内博士記念演劇博物館
The Tsubouchi Memorial Theatre Museum, Waseda University

アジア唯一の演劇専門総合博物館

100万点を超える収蔵品のなかには、「総合芸術」としての演劇の幅広さを反映し、戯曲、台本、写真、楽譜、ポスター、衣裳、映像、音源など、様々な資料がコレクションされている。今井兼次らが設計した建物は、16世紀に存在したイギリスの劇場「フォーチュン座」を模したもの。正面の張り出しは舞台、入口はその左右にあり、図書室は楽屋、舞台を囲む両翼は桟敷席、建物前の広場は一般席と、建物自体を「劇場資料」として楽しむこともできる。

Asia's only theater museum

Reflecting on theater as a comprehensive art form, the museum houses various theater-related works and resources, including plays, scripts, photographs, musical scores, posters, costumes, videos, and sound recordings. The building, designed by Kenji Imai's team, is modeled after the 16th-century Fortune Theater in England.

🕐 10:00 − 17:00　　休 不定休　　¥ 無料
住 東京都新宿区西早稲田1-6-1
電 03-5286-1829
交 地下鉄東西線「早稲田駅」より徒歩7分
H 10:00-17:00　　C Irregular holidays　　¥ Free
Ad 1-6-1 Nishi-waseda, Shinjuku-ku, Tokyo
Ph 03-5286-1829　　Ac 7 min walk from Waseda Station on the Tozai line
–
www.waseda.jp/enpaku

RECOMMENDATION

アイデア編集部
IDEA

同館では、2020年にコロナ禍で中止や延期を余儀なくされた演劇公演のチラシを収集しオンラインで公開するなど、公演そのものをモノとして残すことができない演劇作品のアーカイブ活動にも力が注がれている。映画やテレビドラマ、歌舞伎や文楽、落語、ダンスなど、同館ならではの領域横断的な企画展や、現代演劇や劇作家・評論家に焦点をあてた企画展も充実した内容だ。

This museum is devoted to archiving works of theater, an art form that cannot be preserved as physical objects. In 2020, the museum created an online archive of flyers designed for performances that were cancelled or postponed due to the coronavirus pandemic. The museum also hosts several small but substantial exhibitions that focus on contemporary theater, playwrights, and critics.

7 中野ブロードウェイ
Nakano Broadway

カオティックな光景が広がる
サブカルの聖地

1966年に開業した日本初の商業住宅複合ビル。地下3階・地上10階のビルの低層階は商業施設、高層階は集合住宅となっている。当初はファッションビルとして構想されていたものの、1980年に営業を始めた漫画専門店「まんだらけ」を皮切りに、バブル崩壊後にはマニア向けの専門店が集まり始め、「サブカルの聖地」としても知られるように

なった。漫画専門古書店、自費出版専門店、レトログッズ専門店、現代美術ギャラリーなどの店舗が軒を連ねるほか、開業時に由来する地域に根ざした飲食店なども営業を続けており、「サブカル」と「地域密着」という異なるジャンルの店舗が隣り合うカオティックな光景が広がっている。

複雑に入り組んだ内部空間も魅力のひとつで、初めて訪れた者は迷子になってしまうような構造を有するほか、屋上には居住者専用の庭園、プール、

ゴルフ練習場などが完備されており、高級マンションとして建てられた当初の面影を今なお残している。近年ではベンチャービジネスの起点となるなど新たな業態の店舗が増えることで、そのカオスな魅力は益々深められている。また、時計類やプロ向けカメラ機材の専門店なども充実しており、「時計の聖地」として親しまれていることにも注目したい。

🕐 店舗により異なる
🛏 店舗により異なる
🏠 東京都中野区中野 5-52-15
🚃 JR,地下鉄東西線「中野駅」より徒歩5分
H 11:00-19:00
C Closed days vary by store
¥ Fees vary by store
Ad 5-52-15 Nakano, Nakano-ku, Tokyo
Ac 5 min walk from Nakano Station on the JR and Tozai lines
–
nakano-broadway.com

The holy land of subculture with a chaotic landscape

This is Japan's first commercial-residential complex, which opened in 1966. Initially conceived as a fashion building, it gradually became known as the Mecca of subculture as it began to attract specialty stores after the bubble economy burst, starting with the manga specialty store Mandarake, which began operations in 1980. In addition to used comic book stores, self-publishing stores, retro goods stores, and contemporary art galleries, there are also local restaurants that have been in business since the building opened, resulting in a chaotic landscape where stores of different genres stand side by side.

RECOMMENDATION

アイデア編集部
IDEA

ブロードウェイの人気店、まんだらけ。店舗は各フロアに散在しており、1階の「門」に始まり、ソフビやフィギュアの専門店、プラモデル、コスプレ、アニメなど、取り扱い商品のテーマ別に現在30店舗以上まで拡大している。一度訪れたら簡単には抜け出せない空間は訪れる価値あり。

Mandarake has more than 30 stores in the Nakano Broadway shopping complex, with "Mon" on the first floor and others scattered throughout the many floors of the complex. Each Mandarake store specializes in a specific product, such as soft vinyl and figures, plastic models, cosplay, and anime. This black hole of the otaku culture is worth a visit.

⑧ 嘉瑞工房
Kazui Press

高品質な端物印刷物を手がける活版印刷工房

戦前にロンドンで収集した活字や知識を駆使して活躍した井上嘉瑞のプライベートプレスを、唯一の弟子であった先代社長髙岡重蔵が戦後会社組織として創業。二代目の社長の髙岡昌生がそれを受け継ぎ現在まで続いている。海外の活字鋳造会社から直接仕入れた欧文活字を多数保有し、高品質な名刺、招待状、レターヘッド、ディプロマなどの端物（はもの）印刷を中心に制作している。さらに、長年培ってきた欧文組版とタイポグラフィのノウハウを活かして、書籍の執筆、セミナー、講義、企業向けのコンサルティング、ディレクションなども手がけている。

A letterpress studio that specializes in edge-to-edge printing

A letterpress studio that has been in business since before the war. It was founded by an amateur printer, Yoshizui Inoue, based on type collected in London. His apprentice, Juzo Takaoka, revived the studio after the war. The studio was called Friday Salon, and designers and printers interested in typography began to gather there. The studio owns a large number of European types, directly imported from overseas type foundry companies, and mainly produces high quality, single-page prints. Today, the company also offers seminars, consultations, and direction on European typography and typefaces.

時 9:00 − 18:00　休 土曜・日曜・祝日
住 東京都新宿区西五軒町 11-1　電 03-3268-1961
交 地下鉄有楽町線「江戸川橋駅」より徒歩 6 分
H 9:00-18:00　C Saturdays, Sundays, and holidays　Ad 11-1 Nishigokencho, Shinjuku-ku, Tokyo　Ph 03-3268-1961　Ac 6 min walk from Edogawabashi Station on the Yurakucho line

kazuipress.com

RECOMMENDATION

アイデア編集部
IDEA

かつて多くの印刷工場や製本会社など中小規模の出版関連会社が軒を連ねた新宿区にのこる貴重な活版印刷工房。大通りを挟んだ向かい側には印刷博物館もある。欧文活版印刷、タイポグラフィに特化しているので相談も可能（事前連絡が必要）。
This is a type printing studio in Shinjuku, an area once home to rows of small- and medium-sized publishing companies, printing factories, and bookbinders. The studio is staffed with specialists in Western letterpress printing and typography, so please feel free to consult with them (advance notice required).

新宿・四谷の行きたいショップ・見たい建築
Shops and architectures in Shinjuku / Yotsuya

備後屋
Bingoya

全国の民芸品を取り扱うお店。地下1階から4階まである売場では、和紙製品、陶磁器、藍染布、郷土玩具などが豊富に並ぶ。商品のセレクトにおいては、各地の風土や民芸品がもつ意味が重視されているとのこと。

The store sells folk crafts from all over the country. A variety of products, such as washi paper, ceramics, indigo-dyed fabric, and local toys fill the shelves from the basement to the fourth floor. The products are selected based on their regional culture and how folk art has been embraced in the area.

住 東京都新宿区若松町10-6　電 03-3202-8778
Ad 10-6 Wakamatsu-cho, Shinjuku-ku, Tokyo, Japan
Te 03-3202-8778

新宿眼科画廊
Shinjuku Ophthalmologist (Ganka) Gallery

2004年にオープンしたアートギャラリー。5つのギャラリースペースを活かして、写真、映像、演劇など、多様なジャンルの展覧会を行っている。ギャラリー名は、かつて新橋に存在した「内科画廊」に由来している。

Opened in 2004, the art gallery has five separate spaces where exhibitions are held for a variety of fields, including photography, film, and theater. The name of the gallery comes from the former Naiqua Gallery in Shimbashi.

住 東京都新宿区新宿5-18-11　電 03-5285-8822
Ad 5-18-11 Shinjuku, Shinjuku-ku, Tokyo　Te 03-5285-8822

新宿ゴールデン街
Shinjuku Golden Gai

戦後の闇市に由来する飲食店街。2,000坪の区画に約280軒もの飲食店が密集しており、文壇バーなどの個性的なお店が多い。かつてはアングラカルチャーの発信地として、最近では観光地としても高い人気を誇る。

A restaurant district that began as a post-war black market. Approximately 280 restaurants are densely packed into 6,600 square meters, with many unique establishments like the bundan bar (literary bar). The area was a source of underground culture in the past and has recently become a popular tourist destination.

住 東京都新宿区歌舞伎町1-1-6
Ad 1-1-6 Kabukicho, Shinjuku-ku, Tokyo

世界堂新宿本店
Sekaido Shinjuku Main Store

1940年に新宿で創業した画材・文房具専門店。本店の売場は5フロアからなり、文具、画材、額縁などが充実している。また同じビル内には絵画教室やギャラリーなどもあり、ビル全体がアートスポットとなっている。

An art and stationery store founded in 1940 in Shinjuku. The main store has five floors and is well stocked with stationery, art supplies, and picture frames. The building is also home to an art school and gallery, making the entire building a popular art spot.

住 東京都新宿区新宿3-1-1 世界堂ビル1F-5F
電 03-5379-1111　Ad Sekaidou Building 1F-5F, 3-1-1 Shinjuku, Shinjuku-ku, Tokyo　Te 03-5379-1111

新宿末廣亭
Shinjuku Suehirotei

前身は、1897年に創業した寄席（興行小屋）。都内唯一の木造の寄席で、現在の建物は1946年に建造されたもの。地域文化財にも指定される趣ある建築空間の中で、江戸期から続く寄席の伝統を楽しむことができる。

Established in 1897, this facility was the only wooden Yose (entertainment hut) in Tokyo. The current building was constructed in 1946. Visitors can enjoy traditional Yose, a storytelling artform that has been around since the Edo period, in the atmospheric architecture designated as a Regional Cultural Asset.

住 東京都新宿区新宿3-6-12　　電 03-3351-2974
Ad 3-6-12 Shinjuku, Shinjuku-ku, Tokyo　　Ph 03-3351-2974

新宿御苑
Shinjuku Gyoen National Garden

写真提供：環境省新宿御苑管理事務所

1906年に皇室の庭園となり1949年に国民公園として一般に公開される。元は大名屋敷だった広大な敷地には、日本庭園、風景式庭園、整形式庭園のほか、温室や歴史的建造物などが点在している。新宿の一等地において豊かな自然を楽しむことができる。

The site became an imperial garden in 1906, and in 1949, it was opened to the public as a national garden. The expansive site is a former feudal lord residence and includes a Japanese-style, landscape-style, and formal-style garden as well as a greenhouse and a historical building. Visitors can immerse themselves in nature within the city's busiest neighborhood of Shinjuku.

住 東京都新宿区内藤町11番地　　電 03-3350-0151
Ad 11 Naito-machi, Shinjuku-ku, Tokyo　　Ph 03-3350-0151
酒類持込禁止、遊具類使用禁止（こども広場除く）　Drinking alcohol, using sports equipment and musical instrument in the garden are prohibited.

国立競技場
Japan National Stadium

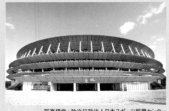

写真提供：独立行政法人日本スポーツ振興センター

2019年に完成した国立競技場。建築家・隈研吾を含む、大成建設・梓設計・隈研吾建築都市設計事務所共同企業体が設計を担当し、「杜のスタジアム」をコンセプトに、木材をふんだんに使用した造りが特徴的な東京の新名所。

This national gymnasium was built in 2019. It was designed by a Joint venture of KENGO KUMA AND ASSOCIATES, Taisei Corporation, Azusa Sekkei Corporation, including Kengo Kuma, an architect. The building was constructed with a lot of wood using the concept of a "forest stadium," and it has become a new landmark in Tokyo.

住 東京都新宿区霞ヶ丘町10-1
Ad 10-1 Kasumigaokamachi, Shinjuku-ku, Tokyo

迎賓館赤坂離宮
State Guest House Akasaka Palace

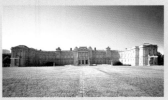

1909年に東宮御所として建設された、日本唯一のネオ・バロック様式による宮殿。現在は国の迎賓施設として利用されており、通年で一般公開されている。建設100年目である2009年に国宝に指定された。

This is Japan's only neo-baroque palace, built in 1909 as the Togu Palace. The building is now being used as a state guest house and is open to the public throughout the year. It was designated as a National Treasure on its 100th anniversary in 2009.

住 東京都港区元赤坂2-1-1　　電 03-5728-7788
Ad 2-1-1, Moto-Akasaka, Minato-ku, Tokyo　　Ph 03-5728-7788

神田・秋葉原

KANDA / AKIHABARA

1 東京国立近代美術館
The National Museum of Modern Art, Tokyo

2 アーツ千代田 3331
3331 Arts Chiyoda

3 米沢嘉博記念図書館
Yoshihiro Yonezawa Memorial Library of Manga and Subcultures

4 株式会社竹尾 見本帖本店
Takeo Mihoncho Honten

5 神保町古書店街
Jimbocho secondhand bookstore street

6 美学校
Bigakko

7 The White
The White

8 アキハバラ@BEEP
Akihabara@BEEP

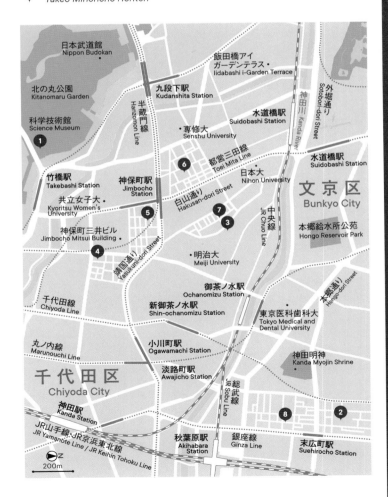

❶ 東京国立近代美術館

The National Museum of Modern Art, Tokyo

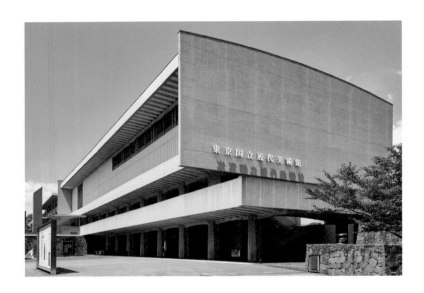

日本初の国立美術館で楽しむ 近現代美術の名作

1952年に開館した日本初の国立美術館。皇居のほど近くに建ち、四季の移ろいを感じられる環境の中で、日本最大級の近代美術コレクションを楽しむことができる。萬鉄五郎の《裸体美人》や岸田劉生の《道路と土手と塀（切通之写生）》など、重要文化財に指定された名作を筆頭に、コレクションの数は13,000点にも及ぶ。それらの中から選りすぐりの収蔵品で展開される「MOMATコレクション」展や、特定のテーマに基づいて国内外の作品を紹介する企画展が人気を博している。4階には皇居の緑と丸の内のビル郡を一望できる「眺めのよい部屋」も。

Enjoying modern and contemporary art masterpieces at Japan's first national art museum

Opened in 1952, the museum is Japan's first national art museum and houses one of the largest collection of modern art in the country. Its vast collection of modern art spans 13,000 works, including masterpieces such as Tetsugoro Yorozu's *Naked Beauty* and Ryusei Kishida's *Sketch of Road Cut through a Hill*, both of which have been designated as Important Cultural Properties. The museum features a variety of popular exhibitions, including the MOMAT Collection, themed exhibitions that introduce works from Japan and abroad, and daily guided tours of the museum's permanent collection.

**皇居の四季を感じながら
過ごすことのできるアートな空間**

世界的建築家・谷口吉郎が設計した本館内部には、美術館オリジナルグッズや展覧会カタログ、和洋のアートブックなどを幅広く揃えるミュージアムショップ、三國清三がプロデュースしたレストラン「ラー・エ・ミクニ」、国内外の近現代美術図書を閲覧できるアートライブラリが完備している。とくに、美術館60周年を記念して新設された「ラー・エ・ミクニ」では、眼前に広がる皇居の四季を感じられるテラス席で、「芸術と料理」をテーマにしたフレンチとイタリアンの融合を楽しむことができる。

🕐 10:00−17:00／(金曜・土曜)10:00−20:00(入館は閉館30分前まで)
🏠 月曜(祝日の場合は翌平日),年末年始,展示替期間
¥ 展覧会により異なる
🏠 東京都千代田区北の丸公園3-1
☎ 050-5541-8600 ◎
🚇 地下鉄東西線「竹橋駅」より徒歩3分
H 10:00-17:00, Fridays and Saturdays 10:00-20:00 (Admission until 30 min before closing)
C Mondays (or following weekday if Monday is a holiday), New Year holidays, and between exhibitions
¥ Fees vary by exhibition
Ad 3-1 Kitanomaru-koen, Chiyoda-ku, Tokyo
Ph 050-5541-8600 ◎
Ac 3 min walk from Takebashi Station on the Tozai line
–
www.momat.go.jp/am

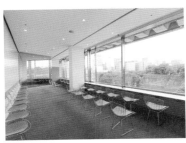

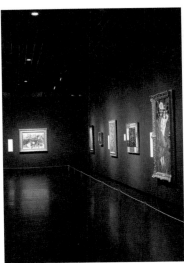

RECOMMENDATION

野見山桜
Sakura Nomiyama

MOMATコレクションでは、日本独自の近代美術の展開をゆるやかな時系列で追うことができます。定期的に展示替えが行われるため、毎回違う作品とそれらにまつわるストーリーを楽しめるのも嬉しいポイント。剣持勇、渡辺力、ハリー・ベルトイア、マリオ・ベリーニといった面々がデザインした椅子が館内各所に置かれているので、楽しく休憩を取りつつ、じっくり鑑賞ができます。

In the MOMAT Collection, visitors can explore the displays of important pieces from the museum's collection all in one place and observe the development of modern Japa-nese art in chronological order. The exhibition changes regularly, allowing visitors to enjoy different works of art and the stories behind them. Chairs are placed in each hall, designed by various designers, including Isamu Kenmochi, Riki Watanabe, Harry Bertoia, Mario Bellini, allowing the visitors to appreciate art comfortably.

❷ アーツ千代田 3331
3331 Arts Chiyoda

3331 ARTS CYD

旧中学校を改修した
21世紀型のアートセンター

2010年に旧千代田区立練成中学校を改修して誕生したアートセンター。現代アートの展覧会を中心に、建築、デザイン、身体表現など、多彩なジャンルの表現を発信している。地下1階から地上3階まである館内には、アートギャラリー、スタジオ、クリエイティブオフィスなどが入居。さらに、練成公園とつながるウッドデッキや開放的なコミュニティスペースは、近隣住民の憩いの場としても機能している。

代表的なスペースとしては、期間ごとに特別展を行う「メインギャラリー」、多摩美術大学が運営するオルタナティブ・スペース「アキバタマビ21」、東京と奈良を拠点に活動する「Gallery OUT of PLACE TOKIO」などがあるほか、旧中学校時代の面影を残す体育館、そしてレンタル可能な屋上菜園も備わっている。公園を臨む1階には、マイクロベーカリー＆カフェ「3331 Cafe Ubuntu」、クリエイターのオリジナルグッズなどを扱う「3331 CUBE shop&gallery」、写真に関する実験的なアイテムを展開する「Lomography+（ロモグラフィープラス）」など、個性豊かなカフェ・ショップでショッピングを楽しむこともできる。

A junior high school converted into a 21st-century art center

The arts center, housed in the renovated former Chiyoda Kanda Hitotsubashi Junior High School, was established in 2010. Focusing on special exhibitions, it offers art from a variety of genres, including architecture, design, and performing arts. The facility includes the Main Gallery, which regularly holds special exhibitions, and the alternative gallery Akibatamabi 21, operated by Tama Art University. In addition to the studios and creative offices, a wood deck, which is linked to Rensei Park, and the open community space serve as relaxation areas for local residents, and visitors can also enjoy the unique cafes and shops inside the center.

Photo : 3331 Arts Chiyoda

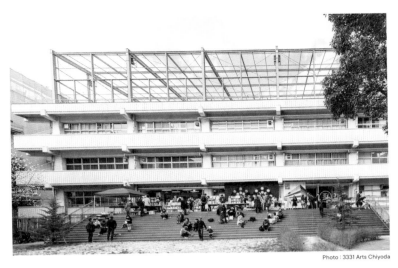

Photo : 3331 Arts Chiyoda

Photo : 3331 Arts Chiyoda

時 10:00 − 21:00（最終入館は閉館の30分前）
休 夏季休業,年末年始　V 展覧会により異なる
住 東京都千代田区外神田 6-11-14
電 03-6803-2441
交 地下鉄銀座線「末広町駅」より徒歩1分／千代田線
「湯島駅」より徒歩3分

H 10:00-21:00 (Admission until 30 min before
closing)　C Summer holidays, New Year
holidays　V Fees vary by exhibition
Ad 6-11-14 Sotokanda, Chiyoda-ku, Tokyo
Ph 03-6803-2441
Ac 1 min walk from Suehirocho Station on the
Ginza line, 3 min walk from Yushima Station on
the Chiyoda line

–
www.3331.jp

RECOMMENDATION

7

アイデア編集部
IDEA

「3331（さんさんさんいち）」の由来は、施設が位置する江戸・東京の庶民文化の中心地である神田にちなみ、江戸時代から受け継がれてきた手締めのリズムを表している。ロゴデザインは同施設のデザインディレクター・佐藤直樹によるもの。コロナ禍に10周年をむかえ「寛容性と批評性」をキーワードにアップデートし、これまで以上にバラエティに富んだ展開が期待できそうな空間。

The name "3331" is a reference to Kanda, where the facility is located. Kanda is at the center of Edo (now Tokyo), the heart of the old city's popular culture, and 3-3-3-1 represents the hand-clapping rhythm that has been passed down through history. The logo was designed by Naoki Sato, who is also involved in the design direction of the facility. The facility celebrated its 10th anniversary during the coronavirus pandemic and relaunched with a focus on "tolerance and criticism." As the space develops, it is expected that it will host an even wider variety of activities in the future.

③ 米沢嘉博記念図書館
Yoshihiro Yonezawa Memorial Library of Manga and Subcultures

コミックマーケットの創設者が育んだ専門図書館

2009年に開館したマンガとサブカルチャーの専門図書館。米沢嘉博はコミックマーケットの創設者のひとりとして知られるマンガ評論家で、米沢が所有していた14万冊以上の蔵書をもとに設立された。明治大学附属の図書館であるため、2階の開架閲覧室と3〜5階の書庫資料の利用は大学関係者と有料会員のみに限られるが、1階の展示室は誰でも無料で観覧することができる。

主要な蔵書はマンガ雑誌・単行本、同人誌、サブカル雑誌、カストリ雑誌など。1階の展示室では、豊富なアーカイブを活用したマンガ・サブカル関連の資料や原画展示のほか、図書館が位置する大学構内で専門家を招いたトークイベントも開催している。

日本でも数少ないマンガとサブカルチャー専門の図書館として、マニアやファンのみならず、研究者も利用する施設として幅広いニーズに応えている。マンガの専門家でなくとも、昔なつかしのマンガや雑誌を求めて、ネットでは手に入らない情報を探しに訪れるのも、敢えてテーマを決めずに散策するのも楽しいディープスポットだ。

A library specializing in Manga and cultivated by the founder of Comic Market

The library at Meiji University was established to house manga critic Yoshihiro Yonezawa's collection of more than 140,000 volumes of manga magazines, books, doujinshi magazines, subculture magazines, kasutori magazines, and other related items. Access to the open reading room on the second floor and the stacks on the third to fifth floors is limited to university personnel and paying members only, but the exhibition room on the 1st floor is open to the public for free. Even if you're not a manga expert, it's a fun place to visit in search of nostalgic manga and magazines that you can't find on the Internet, or to wander around without a specific goal.

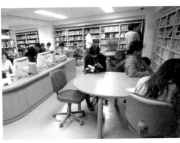

🕐 （月曜・金曜）14:00 − 20:00 ／（土曜・日曜・祝日）
12:00 − 18:00　🈺 火曜・水曜・木曜、年末年始、特
別整理期間　💴 無料（2階閲覧室は有料）
🏠 東京都千代田区神田猿楽町1-7-1
📞 03-3296-4554
🚃 JR「御茶ノ水駅」より徒歩7分

H Mondays and Fridays 14:00-20:00, Saturdays,
Sundays and holidays 12:00-18:00
C Tuesdays, Wednesdays, Thursdays, New Year
holidays, and during maintenance
¥ Free (there is an additional fee for entering
the reading room on the 2nd floor)
Ad 1-7-1 Kanda-Sarugakucho, Chiyoda-ku,
Tokyo Ph 03-3296-4554 Ac 7 min walk from
Ochanomizu Station on the JR line

-
www.meiji.ac.jp/manga/yonezawa_lib

RECOMMENDATION

アイデア編集部
IDEA

蔵書のなかには、米沢嘉博が個人で集めたお
よそ17,000冊の同人誌が保管されており、名
も無い同人誌ひとつひとつにも資料としての
価値を見出した米沢の思想が継承されている。
また、近年ではコミックマーケットで頒布される
見本誌も同館にて期間限定で公開されており、
同人誌ファンには嬉しいサービスだ。

The library contains a total of 2 million
volumes, including sample copies
of doujinshi magazines that were
distributed at Comic Market throughout
the years, since its inception in 1975.
The facility maintains the philosophy of
Yonezawa, who found value even in a
nameless doujinshi magazine because it
is a resource that preserves the manga
culture.

④ 株式会社竹尾 見本帖本店
Takeo Mihoncho Honten

見本帖
本店

300銘柄・2,700種類もの紙を提供する紙の専門スペース

1899年に創業した紙の専門商社「竹尾」のショップ兼ショールーム。神田錦町に位置する見本帖本店は2000年にオープンした。

見本帖本店では、高級特殊印刷用紙「ファインペーパー」を中心に、1階のショップスペースでグラデーション別に並んだ約300銘柄（2,700種類）の紙を1枚から購入することができる。また2階スペースでは、専門のスタッフから紙や印刷加工についてのアドバイスが受けられるほか、紙とデザインをテーマにした企画展やセミナーも開催されている。

また、ファインペーパーを用いた封筒や、オリジナルステーショナリーブランド「Dressco」などの高品質な紙製品も提供しており、本店ではそれらの製品も実際に手に取って購入することができる。また事前に注文することによって、最大全判サイズの用紙（指定の寸法で断裁可能）を倉庫から取り寄せることも可能だ。デザイナーでなくとも、見たこともないような多彩なファインペーパーに触れることによって、紙の奥深い世界を垣間見られる。また、紙とデザインの世界を一層深堀りした企画展とあわせて見ることで、様々な角度から紙の魅力を楽しむことができる。

A paper specialist offering 2,700 paper types from 300 brands

This is the sample room of Takeo, a paper trading company founded in 1899. Located in Kanda-Nishikicho, the main store opened in 2000. The retail space on the first floor features 300 brands (2,700 types) of paper, including the company's own fine paper, which are arranged in a colorful gradation and can be purchased from a single sheet. On the second floor, expert staff members can be consulted for advice on paper and printing. The floor is also used to hold special exhibitions and seminars focused on paper and design. The space is dedicated to appreciating the joys of paper from various perspectives.

時 (1F)10:00－19:00（最終オーダーは18:30まで）／
(2F)11:00－19:00　**休** 土曜・日曜・祝日
¥ 無料　**住** 東京都千代田区神田錦町3-18-3
電 03-3292-3669
交 地下鉄東西線「竹橋駅」より徒歩8分
H First floor 10:00-19:00 (orders accepted until
18:30), second floor 11:00-19:00
C Saturdays, Sundays, and holidays　**¥** Free
Ad 3-18-3 Kanda Nishiki-cho, Chiyoda-ku, Tokyo
Ph 03-3292-3669
Ac 8 min walk from Takebashi Station on the
Tozai line
–
www.takeo.co.jp/finder/mihoncho

RECOMMENDATION

永原康史
Yasuhito Nagahara

神田神保町の古書店街を抜けたところにあり、紙を知るにはとても良いロケーション。1階はファインペーパーの検索や購入ができる、まさに「見本帖」と言っていいスペース。2階では、紙・デザイン・テクノロジーをテーマに様々な展示が行われている。青山見本帖や銀座伊東屋7階の見本帖も合わせて覗いてみるのも良いだろう。

Located just past the used bookstore district in Kanda Jimbocho, this is a great place to learn about paper. The first floor is great for sampling paper and offers visitors a place to search for and purchase fine paper. The second floor is used to host exhibitions related to paper, design, and technology. They also have other sample stores in Aoyama and on the seventh floor of Ginza Ito-ya.

⑤ 神保町古書店街
Jimbocho Secondhand Bookstore Street

1日をたっぷり過ごすことが
できる文化の街

神田神保町にある日本最大の古本屋街。200軒弱もの古書店のほか、岩波書店や小学館などの大手出版社、大学などが密集している。

なかでもアート・デザイン系の古書店としては、美術書や肉筆を取り揃える「ボヘミアンズ・ギルド」、和洋の展覧会カタログが充実した「源喜堂書店」、デザイン本や古い挿画本などを取り扱う「かげろう文庫」、50年以上の歴史を誇る建築専門書店の「南洋堂」、そしてアートブック・写真集・美術作品などを幅広く扱う「小宮山書店」などがよく知られている。

また書店のみならず、1974年に開館し、世界の埋もれた名作映画を上映しているミニシアターの「岩波ホール」、歩き疲れたら立ち寄りたい老舗喫茶店の「さぼうる」、1日の締め括りにお腹を満たせるカレーの名店「エチオピア」など、個性豊かな施設・名店が軒を連ねている。

興味の赴くままに古本を物色し、ミニシアターで埋もれた映画を見て、喫茶店で一休みし、お腹を満たして帰るという、徒歩圏内で1日をたっぷりと過ごすことができる文化の街だ。

A town bursting with culture where you can easily spend an entire day

This is the largest secondhand bookstore district in Japan, located in Kanda Jimbocho. Nearly 200 secondhand bookstores and restaurants line the streets, making the area a cultural district where you can spend a day browsing through old books.
For the art and design category, we recommend Bohemian's Guild for art books and original paintings; Genkido Books for a wide range of Japanese and Western exhibition catalogs; Kagerou Bunko for design books and old illustrations; Nanyodo Books for architecture books; and Komiyama Book Store for art books, photography books, and artwork.

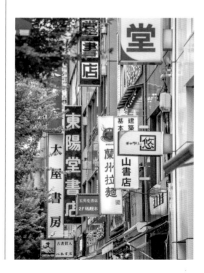

時 各店舗により異なる　休 各店舗により異なる
¥ 無料　住 東京都千代田区神田神保町
交 地下鉄半蔵門線,三田線,都営新宿線「神保町駅」
周辺

H Hours vary by store
C Closed days vary by store　¥ Free
Ad Kanda-Jinbocho, Chiyoda-ku, Tokyo
Ac Areas surrounding Jinbocho Station on the
Hanzomon, Toei Mita and Toei Shinjuku lines

室賀清徳
Kiyonori Muroga

日本でもっともなくなって困る街。神田神保町はワクワクするワンダーランドであり、インスピレーション
の源であり、たましいのオアシスでもあります。和洋漢をとわず書物が集まるこの街では、本がもつ時
間と空間を越えて人々をつなぐ力を体感できます。それは、インターネットや情報資本主義が押し進め
る非人間的な世界に対抗する力でもあります。ただ、神保町のお店は夜は閉まるのが早く、多くは週
末に開いていないので訪問予定には注意。店内を勝手に撮影するのもやめましょう。

Jimbocho is one of the most irreplaceable places in Japan. Located in Kanda, it is a
wonderland, a wellspring of inspiration, a spiritual oasis! In Jimbocho, home to publications
of all kinds (Japanese, Western, and Chinese among them), you can experience the
transcendent power of books, which have the ability to connect people beyond time and
space. This is also a power that counteracts the inhuman world that is constantly being
promoted by the Internet and information capitalism. However, the booksellers in Jimbocho
close early at night, and many of them are also closed on the weekend, so it's important to
plan your visit accordingly. Also, please refrain from taking pictures in the shops.

6 美学校
Bigakko

第一線のクリエイターが教壇に立つ、個性豊かな教育機関

1969年に新宿区若葉町で設立され、翌年神保町へ移転した美術／音楽／メディア表現の学校。年齢・性別・国籍不問をモットーに、技術や資格の有無を問わず誰でも入学することができる。ロゴデザインは赤瀬川原平。

歴代講師には、著名なアーティストやクリエイターが名を連ねており、設立から間もない頃には赤瀬川のほかに粟津則雄、唐十郎、小杉武久、澁澤龍彦、瀧口修造、土方巽、松澤宥らが教壇に立ち、2000年以降は会田誠、小沢剛、中ザワヒデキ、佐藤直樹、都築潤らが講座を開講。現在は佐藤直樹による絵画講座、松蔭浩之による現代アート講座、根本敬によるマンガ講座、菊地成孔による作曲講座、そして大原大次郎によるデザイン講座など、第一線のクリエイターによる幅広いジャンルの授業が実施されている。

また校舎は不定期で一般にも開放されており、生徒の卒業作品展のほか、特定のテーマを設けた企画展やトークイベントなども開催されている。日本の前衛芸術の歴史の生き証人として、50年にわたり文化の

街・神保町で開校し、これまでに4,000人以上が美学校を卒業している。私塾でありながら、美大・芸大に負けない存在感を放つ異色の教育機関だ。

A unique educational institution with classes taught by leading creators

This school of art, music, and media expression was established in Shinjuku Wakaba-cho in 1969 and relocated to Jimbocho the following year. Its motto is to be open to all students regardless of age, gender, or nationality, and anyone can enroll irrespective of skills or qualifications.
Past instructors include famous artists and creators such as Norio Awazu, Juro Kara, Tatsuhiko Shibusawa, and Genpei Akasegawa, who was in charge of the school logo design. At present, the school offers classes in a wide range of genres such as painting taught by Naoki Sato, composition taught by Naruyoshi Kikuchi, and design taught by Daijiro Ohara.

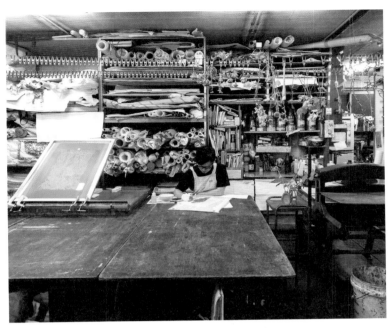

アイデア編集部
IDEA

開校50周年を機にまとめられた書籍『美学校1969-2019: 自由と実験のアカデメイア』〈晶文社〉には、美学校の歴史に加え、これまでその活動に携わった様々なアーティストや関係者による寄稿やインタビューが集められている。日本の美術界への同校の多大な貢献が理解できる内容。

The book *Bigakko 1969–2019: Academia of Freedom and Experimentation* (Shobunsha), published in the year of the school's 50th anniversary, not only covers the school's history but also contains contributions and interviews with various artists and people involved in the school over the years. This insightful book is useful for understanding the school's tremendous contribution to the Japanese art world.

🕐 見学の可否と時間についてはウェブサイトをご確認ください 🏠 東京都千代田区神田神保町2-20第2富士ビル3F ☎ 03-3262-2529
🚃 地下鉄半蔵門線,都営新宿線,三田線「神保町駅」より徒歩3分

🅷 See website for details on tour times and availability
🆎 Dai-ni Fuji Building 3F, 2-20 Kanda Jinbocho, Chiyoda-ku, Tokyo 📞 03-3262-2529
🆎 3 min walk from Jimbocho Station on the Hanzomon, Toei Shinjuku and Mita lines

bigakko.jp

7 The White
The White

表現者が自身の作品と
向き合うアート／デザインの実験場

2014年に写真家・澤田育久がオープン
したオルタナティブスペース。写真、映像、
ペインティング、インスタレーション、デザ
イン、出版物などジャンルに囚われない
展覧会を行っている。発表の場として
のみならず、アーティストが自身の表現
に向き合うための実験の場としても機
能しており、3つの部屋それぞれ異なる
展示空間を作品に合わせて活用してい
る。2019年には、開催中止が発表され
た「ブルノ国際グラフィックデザイン・ビエ
ンナーレ」をテーマにした架空のポスター
作品展も行われるなど、国内外の枠を
越えて、意欲的な表現を発信している。

A place for artists to experiment with their art and design

This alternative space was opened in
2014 by photographer Ikuhisa Sawada. It
hosts exhibitions of a variety of art forms,
including video, installation, design,
and published work, but with a focus on
photography. In 2019, the gallery hosted
an exhibition of posters in collaboration
with *IDEA* magazine.

🕐 13:00-19:00　🏠 展覧会による　¥ 無料
🏢 東京都千代田区神田猿楽町 2-2-1 #202 #205 #
303　🚇 地下鉄半蔵門線・三田線・都営新宿線「神
保町駅」より徒歩5分

🕐 13:00-19:00　🅲 Closed days vary by
exhibition　¥ Free　🆎 #202 #205 #303, 2-2-1
Kanda-Sarugakucho, Chiyoda-ku, Tokyo
🆎 5 min walk from Jimbocho Station on the
Hanzomon, Mita and Toei Shijuku lines
–
www.the-white-jp.com

RECOMMENDATION

7

アイデア編集部
IDEA

ギャラリーでは出版レーベルRondadeによ
る定期イベントも開催されており、各国のアー
トブックの紹介や、Rondadeの新刊やプロ
ダクトの販売、作品の発表の場としても機能
している。通りを挟んだ一角には写真集の
専門出版社スーパーラボのコンセプトストア
もあり、コレクター心をくすぐる写真集やオリ
ジナルプリント、グッズなどにも出会える。
This gallery hosts regular events by the
publishing label Rondade. These events
serve as a venue to introduce their art
books from around the world and sell
new Rondade books and products.
Across the street is a concept store
by Superlabo, a publishing company
specializing in photography books. The
store offers photography books, original
prints, and merchandise that will tickle
the fancy of collectors.

8 アキハバラ@BEEP
Akihabara@BEEP

マニアでさえ驚く品揃えの
レトロPC・ゲーム空間

2015年に秋葉原でオープンしたレトロPC・ゲーム専門店。80年代のレトロPC・ゲームに関連するアーケード基板、PC筐体、家庭用ゲーム機、ゲーム雑誌・書籍、同人誌、ゲームグッズなどの販売・買取を行っている。レトロゲームファンにとってはもちろん、たとえレトロゲームの知識がなくとも、個性豊かなPC筐体、インスト、ポスター、ポップなどに代表されるレトロな販促印刷物、時代の空気をたっぷり反映したアーケード雑誌などは眺めているだけでも楽しい。80年代のPC・ゲームの世界を存分に味わうことのできる空間だ。

A retro computer and game store

This retro computer and game store, opened in Akihabara in 2015, buys and sells arcade circuit boards, computer chassis, home gaming consoles, game magazines and books, doujinshi magazines, and other items related to retro computers and games from the 1980s.

時 11:00 – 20:00　休 水曜　¥ 無料
住 東京都千代田区外神田3-9-8 中栄ビル 地下1階
電 03-6206-9116
交 地下鉄銀座線「末広町駅」より徒歩3分
H 11:00-20:00　C Wednesdays　¥ Free
Ad Nakae Building B1F, 3-9-8 Sotokanda, Chiyoda-ku, Tokyo　Ph 03-6206-9116　Ac 3 min walk from Suehirocho Station on the Ginza line
–
www.deska.jp

看板

RECOMMENDATION

室賀清徳
Kiyonori Muroga

戦後、電子機器や家電の専門店街として発展してきた秋葉原は、ビデオゲームブームを経由してアニメや同人誌を始めとするホビーショップが集まるオタク文化の発信地へと変容していった。近年の観光地化、再開発によるオフィス街化によって、かつての風景は失われつつあるが、表通りから一歩入ればかつての磁場が感じられるマニアックなスポットも数多く集まり、日本の土着的な視覚文化に出会う格好の機会を提供している。

After World War II, Akihabara became a district specializing in electronic devices and home electronics. With the video game boom, it evolved into a center of otaku culture, attracting hobby shops carrying anime and doujinshi magazines. In recent years, this atmosphere has faded as the area has become a tourist attraction and an office district. If you step off the main street, however, you can still feel the culture of the past with many specialty stores and locations, offering a great opportunity to encounter the indigenous visual culture of Japan.

神田・秋葉原の行きたいショップ・見たい建築
Shops and architectures in Kanda / Akihabara

マーチエキュート神田万世橋
mAAch ecute
KANDA MANSEIBASHI

mAAch
ecute
KANDA MANSEIBASHI

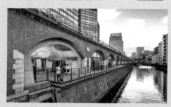

中央線神田〜御茶ノ水間にあった旧万世橋駅を、みかんぐみの設計により商業施設としてリノベーション。嗜好性の高いショップやカフェが並ぶなか、旧駅舎のジオラマ模型の展示やオープンデッキなどが無料で楽しめる。

The former Manseibashi Station, part of which used to be located between the Kanda and Ochanomizu stations on the Chuo Line, has been renovated into a commercial facility designed by Mikangumi. While the facility houses mostly luxury stores and cafes, the old station diorama and the open deck can be enjoyed for free.

🏠 東京都千代田区神田須田町1-25-4　☎ 03-3257-8910
Ad 1-25-4 Kanda Sudacho, Chiyoda-ku, Tokyo
Ph 03-3257-8910

PARCEL
PARCEL

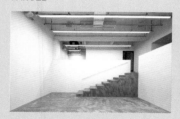

2019年にデザインホテル「DDD HOTEL」の一角に開廊。元は立体駐車場だった空間は、プロジェクトスペースとギャラリーの両方を兼ねており、展示のみならずアーティストの滞在制作やリサーチ活動なども展開している。

The gallery opened in 2019 in a corner of the DDD Hotel. The former multi-story parking garage now serves as both a gallery and a multipurpose space used for exhibitions, artist residencies, and research activities.

🏠 東京都中央区日本橋馬喰町2-2-1 DDDHOTEL 1F
Ad DDD HOTEL 1F, 2-2-1 Nihonbashibakurocho, Chuo-ku, Tokyo

minä perhonen elävä Ⅰ・Ⅱ
minä perhonen elävä Ⅰ・Ⅱ

minä perhonen
elävä

Photo by Norio Kidera

フィンランド語で「暮らし」を意味する名前の「elävä」は、ブランド、minä perhonenによるふたつのショップ。オーガニックの食材やビンテージ家具など、丁寧なものづくりや暮らしを豊かにする品々に出会える空間。

These two shops, run by Minä Perhonen, are devoted to the fashion brand elävä, a Finnish word meaning "lifestyle." They offer organic food, vintage furniture, and other carefully crafted items that enrich our lives.

[Ⅰ] 🏠 東京都千代田区東神田1-3-9　☎ 03-6825-3037
[Ⅱ] 🏠 東京都千代田区東神田1-2-11 201号室
☎ 03-6825-8037　[Ⅰ] Ad 1-3-9 Higashi-Kanda, Chiyoda-ku, Tokyo　Ph 03-6825-3037　[Ⅱ] Ad Agata Takezawa Building#201, 1-2-11 Higashi-Kanda, Chiyoda-ku, Tokyo
Ph 03-6825-8037

パピエ ティグル
PAPIER TIGRE

PAPIER TIGRE

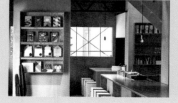

2012年にパリで生まれたステーショナリーを中心としたプロダクトブランドの日本1号店。遊び心のあるグラフィックと実用性を兼ね備えたアイテムを展開しているほか、国内外のセレクトアイテムを展開している。

The first retail store in Japan of this stationery brand, which was founded in Paris in 2012. In addition to offering items with playful graphics and practicality, the store offers a selection of both domestic and imported products.

🏠 東京都中央区日本橋浜町3-10-4　☎ 03-6875-0431
Ad 3-10-4 Nihonbashihamacho, Chuo City, Tokyo
Ph 03-6875-0431

上野・日暮里
UENO / NIPPORI

1 東京国立博物館
Tokyo National Museum

2 国立西洋美術館
The National Museum of Western Art

3 東京都美術館
Tokyo Metropolitan Art Museum

4 上野の森美術館
The Ueno Royal Museum

5 国立科学博物館
*National Museum of
Nature and Science*

6 文化庁国立
近現代建築資料館
*National Archives of Modern
Architecture*

7 台東区立書道博物館
Calligraphy Museum

8 弥生美術館・竹久夢二美術館
*Yayoi Museum / TakehisaYumeji
Museum*

① 東京国立博物館
Tokyo National Museum

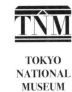

**TOKYO
NATIONAL
MUSEUM**

1872年に開館した
日本で最も歴史の長い博物館

1872年に湯島聖堂で開催した、日本初の博覧会をきっかけに創設された日本最古級の博物館。1882年からは上野公園にある現在地に移転した。東京ドーム2.2個分もの敷地には、本館を始めとする6つの展示館や重要文化財に指定された門と校倉、庭園、茶室が点在している。展示館の建築も見どころのひとつで、明治の洋風建築の代表作とされる表慶館、戦後日本のモダニズム建築を代表する谷口吉郎が設計した東洋館、谷口吉郎の息子・吉生が設計した法隆寺宝物館、今上陛下のご成婚を記念し1999年に開館した平成館、イオニア式列柱のスクラッチタイルが印象的な黒田記念館など、建築のバリエーションを眺めるだけでも楽しむことができる。

それに加えて、国宝・重要文化財を含む約12万件もの日本・東洋美術コレクションは国内屈指の質と量を誇るもので、総合文化展では、常時約3,000件の作品が展示されている。さらに館内には、美術工芸品から食品まで博物館ならではのグッズを扱うミュージアムショップ、ホテルオークラレストラン「ゆりの木」などが営業しており、1日を通して博物館を楽しむことができる。

Japan's oldest museum opened in 1872

This is Japan's oldest museum of its kind, which was founded in 1872 as a result of Japan's first exposition held at the Yushima Seido Temple. It moved to its present location in Ueno Park in 1882. The site, which is more than twice the size of the Tokyo Dome, is dotted with six exhibition buildings and a number of facilities that have been designated as Important Cultural Properties, such as a gate, Azekura Repository, garden, and tea houses. The museum's collection of about 120,000 Japanese and Asian artifacts, including National Treasures and Important Cultural Properties, is one of the largest in Japan and requires more than one visit to fully appreciate the collection. The museum offers permanent and special exhibitions throughout the year.

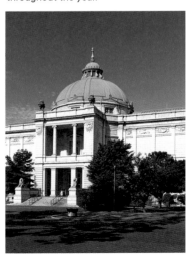

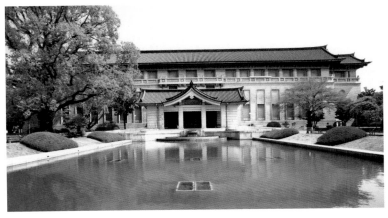

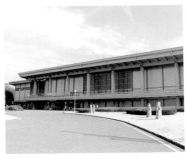

時 9:30－17:00／（金曜・土曜）9:30－21:00（入館は閉館30分前まで）　休 月曜（祝日の場合は翌平日）、年末年始　V 展覧会により異なる ★

住 東京都台東区上野公園13-9

電 050-5541-8600 ◎

交 JR「上野駅」、「鶯谷駅」より徒歩10分

H 9:30-17:00, Fridays and Saturdays 9:30-21:00 (Admission until 30 min before closing)

C Mondays (or following weekday if Monday is a holiday), New Year holidays

V Fees vary by exhibition ★

Ad 13-9 Ueno Koen, Taito-ku, Tokyo

Ph 050-5541-8600 ◎　Ac 10 min walk from Ueno or Uguisudani Station on the JR line

–

www.tnm.jp

RECOMMENDATION

大日本タイポ組合
Dainippon Type Organization

総合文化展で「文字」三昧。まずは東洋館で荷物をロッカーに入れ、4階で唐や宋など「中国の書」を堪能。展示ケースが低反射ガラスだから、ガン見するのにうってつけ。本館に移動したら2階3室で「平安古筆」を、そして8室の「近世の書」で〆、が基本コース。とはいえ途中の茶の湯コーナーに掛かる軸、刀・鎧コーナーの消息文、歴史の記録コーナーの刷り物も見逃せない、あっ、東洋館に戻ったら、楔形文字や甲骨文字も忘れずに!

Immerse yourself in calligraphy at the regular exhibition. First, put your belongings in a locker in the Toyokan, and go up to the fourth floor to explore the calligraphy of the Tang and Song dynasties. The low-reflective glass display cases make it easy to spend a long time studying the exhibits. Inside the Honkan main building, the usual route is to visit the second floor, stopping first in Room 3 to explore the ancient calligraphy of Heian Era and closing with Room 8, where modern calligraphy is examined. Between these rooms, don't miss the scrolls displayed in the tea ceremony section, personal letters in the swords and armor section, and the prints in the historical record section. When you return to the Toyokan, don't forget to check out the cuneiform and the oracle bone script!

2 国立西洋美術館
The National Museum of Western Art

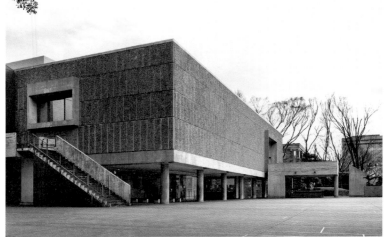

写真提供：国立西洋美術館

建物自体が世界遺産、西洋美術の真髄に触れる美術館

印象派絵画とロダンの彫刻を中心とする「松方コレクション」を基礎に、1959年に開館した国立西洋美術館。西洋美術全般を対象とする唯一の国立美術館として、年間を通して展覧会を開催している。その核となるのは、開館以来収集されてきたルネサンス以降の西洋美術作品と松方コレクションが組み合わされた常設展、そして海外の美術館からの借用作品を中心に据えた企画展。フランスの建築家ル・コルビュジエにより設計された美術館自体も近代建築の名だたる作品として高い評価を受けており、2016年には世界遺産に登録された。

A museum that touches the essence of Western art in a building recognized as a World Heritage Site

The museum, opened in 1959, is based on the Matsukata Collection of impressionist paintings and Rodin's sculptures. As the only national art museum dedicated to Western art, the museum holds exhibitions throughout the year. At its core is the permanent exhibition, which includes the Matsukata Collection as well as pieces from its collection of from the Renaissance to the early 20th century, and special exhibitions that feature works loaned from overseas museums. The museum's architecture is highly regarded, and the building, which was designed by architect Le Corbusier, became a World Heritage Site in 2016.

波乱の遍歴をたどった
松方コレクション

松方コレクションは、実業家・松方幸次郎が戦前に収集した約1万点もの絵画、彫刻、家具、タペストリーなどのコレクションに端を発する。しかし1939年、ロンドンで作品を預けていた倉庫が火災に襲われ、大多数の作品が消失してしまう。パリには約400点の作品が残されていたものの、第二次世界大戦末期に「敵国人財産」としてフランス政府に接収されるという憂き目にあう。そのような波乱の遍歴を経て、ようやく1959年に作品の大部分が日本政府に寄贈返還されることになり、同館が誕生することになった。

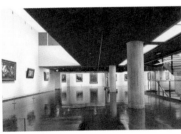

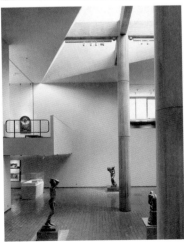

🕘 9:30－17:30／（金曜・土曜）9:30－20:00
（館内施設整備のため、2022年春［予定］まで全館休館中）
🚫 月曜（祝日の場合は翌平日）、年末年始
💴 展覧会により異なる
🏠 東京都台東区上野公園7-7
☎ 050-5541-8600 ◎
🚃 JR「上野駅」より徒歩1分
H 9:30-17:30, Fridays and Saturdays 9:30-20:00 The entire museum will be closed until spring 2022 for facilities maintenance work (schedule subject to change).
C Mondays (or following weekday if Monday is a holiday), New Year holidays
¥ Fees vary by exhibition
Ad 7-7 Ueno Koen, Taito-ku, Tokyo
Ph 050-5541-8600 ◎
Ac 1 min walk from Ueno Station on the JR line

www.nmwa.go.jp

RECOMMENDATION

7

アイデア編集部
IDEA

同館はコルビュジエの「無限成長美術館」構想のもとに設計された建物で、将来的なコレクションの拡大に備え、あえて特定のファサード（正面部分）をもたず、内部の螺旋状の回廊を軸に展示室が卍型に増築可能な平面計画に基づいて設計されている。水平にのびる長方体の建物の側面には、現在エントランスとして使用されている入り口以外にも2階には大きな開口部が設置されているが、実はこれは増築の際の連結部分を想定したもの。

The building was designed in accordance with Le Corbusier's idea of a museum of unlimited growth. To prepare for the future expansion of the museum collection, the building was designed without a facade and is based on a plan that allows for the exhibition rooms to be extended around an internal spiral corridor. In addition to the current entrance, there is another large opening that stretches horizontally across the side of the rectangular building. This feature was designed with future expansion in mind.

③ 東京都美術館
Tokyo Metropolitan Art Museum

**アートをより広く・深く知り、新たな
つながりをつくる「アートへの入口」**

1926年に日本初の公立美術館として開
館した美術館。国内外の名品による特別
展、多彩な企画展、美術団体による公募
展などを開催しているほか、一般公募の
市民（アート・コミュニケータ）と東京藝術大
学と連携し、美術館を拠点にアートを介し
てコミュニティを育む「とびらプロジェクト」や
「建築ツアー」、障害のある方のためのプ
ログラム、すべての子どものミュージアム・
デビューを応援する「Museum Startあい
うえの」など、「アートへの入口」を継続的
に創出するプログラムが充実している。
現在の建物は建築家・前川國男の設計
により1975年に建て替えられたもので、
広場・ロビー・レストランといったコミュニ
ティスペースが重視された都市的な空間
が広がっている。2012年のリニューアル
ではユニバーサルデザインの整備もされ、
さらにひらかれた美術館として生まれ変
わったほか、吉岡徳仁によるシンボルマー
ク・ロゴも誕生した。
美術館のエスプラナード（広場）や上野
公園の四季を感じることができるレスト
ラン・ミューズ、本格フレンチを味わえるレス
トラン・サロン、「＋CRETION」をコンセプ
トに、日々の暮らしを彩るアイテムを取り
扱うミュージアムショップなど、見どころが
数多く点在している。

A "Doorway to Art" with unique communicational opportunities

The museum, which opened in 1926 as
Japan's first public art museum, holds
special exhibitions that bring together
masterpieces from Japan and abroad,
and it also holds public exhibitions
by domestic art organizations. In
addition to exhibitions, the museum
offers a variety of unique programs.
The Tobira Project is a social design
project based in museums which fosters
communities through art, co-organized
by the museum and Tokyo University
of the Arts. The project comprises art
communicators from all walks of life,
curators and university educators, and
experts working on the front line. Art
communicators are widely selected from
the general public each year. "Museum
Start iUeno" is a learning design project
that encourages every child to make
their "museum debuts". Architecture
Tour provides a walking tour of the
museum with art communicators.

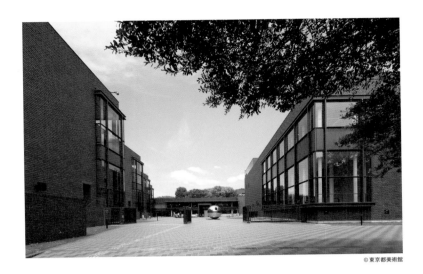

© 東京都美術館

渡部千春
Chiharu Watabe

1987年の『ボロフスキー展』は私の生涯で一番ショッキングだった展覧会です。博物館、特に公立の施設ではホワイトキューブに秩序立って作品が並んでいるもの、と思っていたのに、作品が外にはみ出しているわ、順番もあるようでないわ、終いには、どれが作品だか分からなくなってしまいました。今もそうですが、超ハイエンドな展示と、無料でやっている地域のサークル発表のような展示のギャップがすごく、これもある種の醍醐味です。

The Borovsky Exhibition in 1987 was the most shocking exhibitions of my life. I thought that in a museum, especially a public institution, the artwork would be arranged inside white cubes in an orderly fashion. But in this exhibition, they overflowed to the outside without an apparent order, and by the end, I couldn't tell the difference between what was art and what was not. The museum is still the same today, hosting both extremely high-end exhibits and free presentations of local clubs, and I find this dichotomy to be part of its charm.

時 9:30－17:30（入館は閉館30分前まで）
休 第1・第3月曜日（祝日・振替休日の場合は翌日）、特別展・企画展は月曜日休室,年末年始,整備休館
¥ 展覧会により異なる
住 東京都台東区上野公園8-36
電 03-3823-6921
交 JR「上野駅」より徒歩7分

H 9:30-17:30 (Admission until 30 min before closing)
C First and third Mondays (or following weekday if Monday is a holiday), Mondays (Special exhibitions and thematic exhibitions), New Year holidays, and during maintenance
¥ Fees vary by exhibition
Ad 8-36 Ueno Koen, Taito-ku, Tokyo
Ph 03-3823-6921
Ac 7 min walk from Ueno Station on the JR line

–
www.tobikan.jp

4 上野の森美術館
The Ueno Royal Museum

若手作家の登竜門的展覧会を多数開催する私立美術館

A private art museum that hosts many exhibitions showcases upcoming artists

上野恩賜公園内の一角で1972年に開館した私立美術館。開館以降、重要文化財の公開を始めとする多彩なジャンルの特別展を開催している。年に1度開催される「VOCA展」は、若手現代美術作家の登竜門として毎年大きな注目を集めている。さらに「上野の森美術館大賞展」や「日本の自然を描く展」などの公募展も開催し、様々な顕彰を行っている。本館横の別館では、小企画展を開催できる「上野の森美術館ギャラリー」や、初心者から熟練者までを対象にした「上野の森アートスクール」が設置されており、従来的な鑑賞の場としてだけでなく、実際にアートの創作に親しむことのできる教育の場としても機能している。
美術館のエントランスを入ってすぐ正面にある「Café MORI」では、注文後に一杯ずつドリップされるこだわりのコーヒーを味わうことができるほか、オリジナルグッズやデザイン文具、美術関連書籍などを幅広く取り扱うミュージアムショップが充実している。Café MORIは新型コロナウイルス対策のため休店中。

This is a private art museum that opened in 1972 in a corner of Ueno Onshi Park. The museum hosts various special exhibitions that include Important Cultural Properties. They also hosts the annual VOCA exhibition, which draws a lot of attention every year for displaying the work of upcoming artists in Japan. On the annexed building right next to the museum, you can find the Ueno Forest Art School, which is for beginners and experts alike. It functions not only as a traditional place to view art but also as a school where visitors can become familiar with creating art.

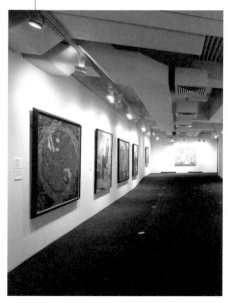

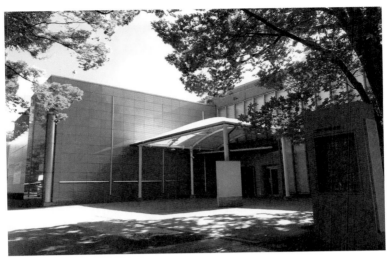

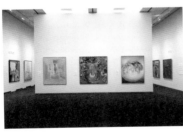

7

アイデア編集部
IDEA

「ヴォーカ」あるいは「ボカ」として親しまれる VOCA展の正式名称は「VOCA　現代美術 の展望—新しい平面の作家たち（The Vision Of Contemporary Art）」。全国の学芸員や 美術記者、美術評論家などによって推薦され た40歳以下の若手作家に出品を依頼し、そ のなかから選考委員会がVOCA賞を始めと した各賞を選出する。近年では、写真や映 像など多様なメディアと独自の技法を用いた 平面表現が展開されることも多くなり、常に時 代を映す表現に出会える展覧会だ。

The official name of the *VOCA* exhibition is *VOCA: The Vision Of Contemporary Art*. Young artists under 40 years old who are recommended by curators, reporters, and critics from around the country are invited to exhibit their work, with the selection committee awarding the winners with the VOCA Prize and other honors. The exhibition is great for discovering art that reflects the times and includes a wide range of two-dimensional media types, such as photography and video.

時 10:00 — 17:00（入館は閉館30分前まで）
休 展覧会により異なる
¥ 展覧会により異なる
住 東京都台東区上野公園1-2
電 03-3833-4191
交 JR「上野駅」より徒歩3分
H 10:00-17:00 (Admission until 30 min before closing)
C Closed days vary by exhibition
¥ Fees vary by exhibition
Ad 1-2 Ueno Koen, Taito-ku, Tokyo
Ph 03-3833-4191
Ac 3 min walk from Ueno Station on the JR line
–
www.ueno-mori.org

⑤ 国立科学博物館
National Museum of Nature and Science

**ダイナミックな展示が広がる
日本最大級の総合科学博物館**

上野の森を泳ぐような実物大のシロナガスクジラの模型がランドマークの日本最大級の総合科学博物館。創立は1877年で、アジアにおける科学系博物館の中核施設として、調査・収集・展示活動に力を入れている。

1931年に竣工した「日本館」はネオ・ルネサンス様式を基調とした重厚な建築物で、建物自体が重要文化財に指定されている。クラシックな空間のなかでは、「日本列島の自然と私たち」をテーマに数々の剥製、標本、化石などが常設展示されているほか、シアター36○ではオリジナルプログラムを鑑賞することもできる。

2004年には新しく「地球館」がオープンし、日本に留まらず地球全体の生き物や自然をテーマにした展示が行われている。3階の「大地を駆ける生命」では、大型の哺乳類や鳥類の剥製が圧巻のスケールで展示されているほか、宇宙史・生命史・人間史にまつわる物語をテーマにした「地球史ナビゲーター」など、館全体を通して壮大な展示を楽しむことができる。屋外には、人工衛星「おおすみ」が打ち上げられた発射台や、D51形蒸気機関車なども設置されており、館内から館外まで余すことなくダイナミックな展示が行われている。

One of Japan's largest science museums hosting dynamic exhibitions

The museum is one of the largest science museums in Japan, with a blue whale model as its landmark. Established in 1877, the museum focuses on research, collection, and exhibition as the core science museum in Asia. The exhibition space is divided into the Japan Gallery, which was completed in 1931, and the Global Gallery, which opened in 2004 and features exhibits of living creatures and nature from around the world. Programs such as the Navigators on the History of Earth, which tells stories about the history of space, life, and mankind, offer visitors opportunities to enjoy spectacular exhibitions throughout the museum.

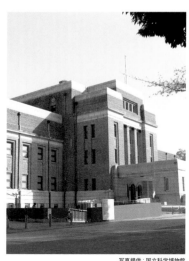

写真提供：国立科学博物館

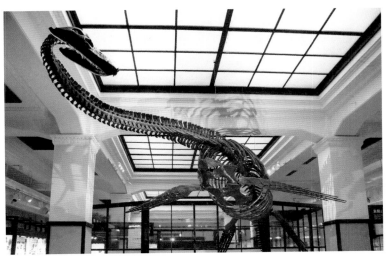

RECOMMENDATION

三澤遥
Haruka Misawa

常設エリアは、日本館と地球館に分かれていて、地球館の一部には、地上のマングローブなどの景観を再現した展示があります（2021年3月まで改修中）。どこかの土地の一部をごっそりそのままもってきて展示したような見せ方や、まるで生きているかのようにリアルな剥製や緻密な模型には目を見張ります。ひとつの生き物に焦点を当てて解説するだけでなく、生き物同士のつながり周辺環境とともに伝えてくれる展示です。

The permanent exhibition area is divided into the Japan Gallery and the Global Gallery. In the Global Gallery, there is an exhibit that replicates the mangroves and other landscapes. The display looks as if a part of the land was secretly transported into the museum, and the taxidermy and detailed models are astonishingly realistic, as if they are still alive. The exhibition not only focuses on a single species but conveys the connections that exist between the creatures and their surrounding environment.

時 9:00－17:00／（金曜・土曜）9:00－18:00
休 月曜（祝日の場合は翌平日）,年末年始,臨時休館
¥ 展覧会により異なる
住 東京都台東区上野公園7-20
電 03-5777-8600◎
交 JR「上野駅」より徒歩5分
H 9:00-17:00, Fridays and Saturdays 9:00-18:00
C Mondays (or following weekday if Monday is a holiday), New Year holidays, other temporary closures
¥ Fees vary by exhibition
Ad 7-20 Ueno Koen, Taito-ku, Tokyo
Ph 03-5777-8600◎
Ac 5 min walk from Ueno Station on the JR line

www.kahaku.go.jp

⑥ 文化庁国立近現代建築資料館
National Archives of Modern Architecture

日本の近現代建築の歩みを感じる
アーカイブズ施設

2013年に開館した建築資料のアーカイブズ施設。日本の近現代建築に関する資料の劣化、散逸、流出を防ぐため、緊急に保護が必要な資料の収集・保管を行っており、これまでに坂倉準三、前川國男、吉阪隆正、大髙正人、菊竹清訓といった世界的に著名な建築家による設計図面などの収集・整理を進めてきた。館内では、収蔵資料の閲覧などができる（事前申請が必要）ほか、建築資料に関する展示（常設展はなし）や講演会、ギャラリートークなども開催しており、これまでに坂倉準三、菊竹清訓、吉阪隆正、大髙正人、安藤忠雄、吉田鉄郎などの展覧会を開催してきた。また、展示に際してはカタログの発行も積極的に行っており、研究者のみならず、建築ファンにとっても貴重な資料として数多く発行されている。

資料館の建物自体は旧岩崎邸庭園に隣接した湯島地方合同庁舎の構内にあり、建築家ジョサイア・コンドルが設計した旧岩崎邸とセットで鑑賞することによって、日本の近現代建築の歩みを肌で感じることができる。

An archival facility that offers a glimpse into the history of modern Japanese architecture

This archival facility opened in 2013 for storing architectural documents. The facility collects and preserves documents related to modern and contemporary Japanese architecture that requires immediate preservation to prevent documents from deterioration, loss, and misuse. It has collected and organized design drawings by world-renowned architects, such as Junzo Sakakura, Kunio Maekawa, Takamasa Yoshizaka, and Masato Otaka, and Kiyonori Kikutake. Although they have no permanent exhibitions, the facility also hosts exhibitions, lectures, and gallery talks on architectural materials. It has published catalogues and other written works that are valuable not only to researchers but also to architecture fans.

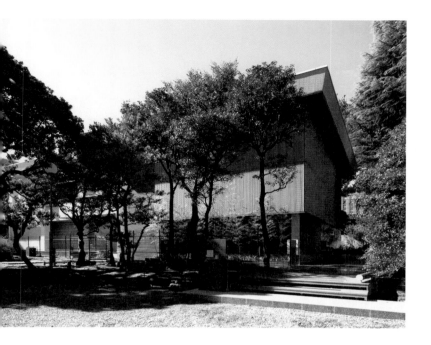

時 10:00－16:30　休 展覧会により異なる
¥ 入館無料（都立旧岩崎邸庭園と同時観覧する場
合は400円）
住 東京都文京区湯島4-6-15 湯島地方合同庁舎内
電 03-3812-3401
交 地下鉄千代田線「湯島駅」より徒歩8分
H 10:00-16:30　C Closed days vary by

exhibition　¥ Free (or ¥400 if visiting Kyu-
Iwasaki-tei Garden)
Ad 4-6-15 Yushima, Bunkyo-ku, Tokyo
Ph 03-3812-3401
Ac 8 min walk from Yushima Station on the
Chiyoda line
–
nama.bunka.go.jp

RECOMMENDATION

野見山桜
Sakura Nomiyama

企画展示では、図面だけでなく手紙や写真といった資料が多く展示されます。コルビュジエのもとで修
行を積み、神奈川県立近代美術館（現鎌倉文華館）を設計した坂倉準三や、メタボリズムの代表物であ
る菊竹清訓関連の資料などを所蔵しており、事前に申し込みをすれば閲覧可能なものも!
隣接する旧岩崎邸もおすすめの場所。洋館の方では、部屋ごとに異なる創意工夫を凝らした壁紙にも
注目を!

The special exhibitions often feature not only drawings but also letters, photographs, and
other important materials. The archive holds many documents related to notable masters,
such as Junzo Sakakura, who was trained by Le Corbusier and Kiyonori Kikurtake, one of
the founders of the Metabolism movement. Some of these documents can be available for
inspection if visitors apply in advance. The adjoining former Iwasaki residence is also a good
place to visit. Well-crafted wall papers decorate the rooms in the western style building!

7 台東区立書道博物館
Calligraphy Museum

書道博物館
CALLIGRAPHY MUSEUM

古代からの漢字の歴史を辿ることができる博物館

日本の近代芸術におおきな足跡を残した洋画家、中村不折（1866-1943）は、書家としても知られ、画業の傍ら書の研究にも取り組んだ人だ。書道博物館では、その半生40年あまりにわたり独力で蒐集した、重要文化財12点、重要美術品5点を含む中国および日本の書道史、東洋美術史上重要なコレクションを所蔵し、保管・公開している。

もともとは1936年に開館したが、当初の博物館建設に伴う一切の費用は全て不折自身により捻出された。開館以来約60年にわたって中村家の手により維持・保存されたのち、1995年に台東区に寄贈され、中村不折記念館の増設を経て2000年に現在のかたちで再開館した。本館では文字の刻まれた、あるいは書き込まれた収蔵品を常設展示しており、漢字の書法や文字の歴史をたどる上で非常に重要な資料を目にすることができる。中村不折記念館では、碑拓法帖、経巻文書、文人法書等を、テーマに基づいた年4回の企画展・特別展で紹介している。中村不折自身の作品やその関係資料が展示される記念室も見どころのひとつ。

A museum that traces the history of Chinese characters since ancient times

Western-style painter Fusetsu Nakamura (1866–1943) also studied calligraphy. The Calligraphy Museum houses, preserves, and exhibits valuable pieces of historical Chinese and Japanese calligraphy and oriental art, including twelve Important Cultural Properties and five Art Treasures that were collected by Fusetsu.

The exhibition areas are divided into the Main Building and the Nakamura Fusetsu Memorial Hall. The Main Building houses documents and materials related to calligraphy and the history of kanji and Chinese characters, while the Nakamura Fusetsu Memorial Hall displays items such as rubbed copies of stone inscriptions, Buddhist sutras, and calligraphy textbooks during special exhibitions held four times a year.

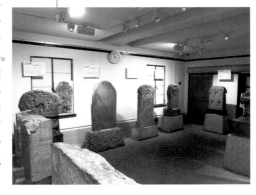

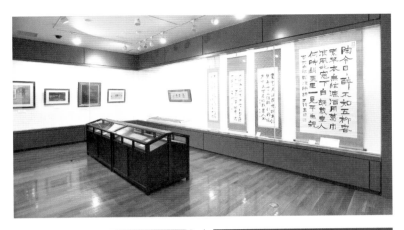

大日本タイポ組合
Dainippon Type Organization

中村不折が愛し蒐集した北魏・六朝の書を始め所蔵作品の企画展が行われるから、いわゆる「書道」の博物館だろう、と思うなかれ。じつは本館に所狭しと並ぶ石碑や青銅器などが圧巻で、不折の傑作『龍眠帖』のルーツが一望できると同時に、みんぱく（国立民俗学博物館）っぽさ・れきはく（国立歴史民俗博物館）っぽさすらあって、文字の成立から変遷も体験できる。館内各所にある、不折の書風に似せて書かれた注意書きもみどころ。

Don't assume this museum only focuses on calligraphy because of the featured pieces from the Northern Wei and Six Dynasties that Fusetsu Nakamura loved and collected. The stone monuments and bronze vessels that fill the museum's galleries are quite impressive, and they offer a panoramic view of the origins of Fusetsu's masterpiece, Ryuminjo. Similar to the National Museum of Ethnology and the National Museum of Japanese History, this museum allows you to experience the evolution of the written language from its origins to the present day. Signs throughout the museum that imitate Fusetsu's style of calligraphy are enjoyable as well.

時 9:30－16:30（入館は閉館30分前まで）
休 月曜（祝日の場合は翌平日）,年末年始,特別整理期間　¥ 一般500円,小中高校生250円,障害者手帳または特定疾患医療受給者証をお持ちの方およびその付添の方は無料　住 東京都台東区根岸2-10-4
電 03-3872-2645　交 JR「鶯谷駅」より徒歩5分

H 9:30-16:30 (Admission until 30 min before closing)　C Mondays (or following weekday if Monday is a holiday), New Year holidays, and during maintenance　¥ General ¥500, high school, junior high school, and elementary school students ¥250, free for those with a physical disability certificate or with a recipient certificate issued for specific disease treatment, and their attendant　Ad 2-10-4 Negishi, Taito-ku, Tokyo　Ph 03-3872-2645
Ac 5 min walk from Uguisudani Station on the JR line
–
www.taitocity.net/zaidan/shodou

8 弥生美術館・竹久夢二美術館
Yayoi Museum / TakehisaYumeji Museum

ひっそりと佇むふたつの美術館

弥生美術館は、1984年にこの地で活躍する鹿野琢見氏によって設立された美術館。それに対して竹久夢二美術館は、1990年に弥生美術館から独立する形で開館した美術館で、夢二作品の常設展示のほか、年4回の企画展を開催している。同じ敷地内に建つ、ふたつの美術館の展示を併せて見ることで、明治・大正・昭和の出版・挿絵の世界を堪能することができる。

🕐 10:30－16:30（入館は閉館30分前まで、オンラインによる予約制）　🚫 月曜・火曜、年末年始、展示替期間　💴 一般1,000円,高校・大学生900円,小中学生500円　🏢 東京都文京区弥生2-4-3【弥】／2-4-2【竹】　☎【弥】03-3812-0012　【竹】03-5689-0462　🚇 地下鉄千代田線「根津駅」,南北線「東大前駅」より徒歩7分
H 10:30-16:30 (Admission until 30 min before closing, Online Reservation System)　C Mondays, Tuesdays, New Year holidays, and between exhibitions　V General ¥1,000, university and high school students ¥900, junior high school and elementary school students ¥500　Ad 2-4-3[Y] / 2-4-2[T] Yayoi, Bunkyo-ku, Tokyo　Ph [Y]03-3812-0012　[T]03-5689-0462　Ac 7 min walk from Nezu Station on the Chiyoda line, 7 min walk from Todaimae Station on the Namboku line

–
www.yayoi-yumeji-museum.jp

Two museums Waiting Quietly

The Yayoi Museum of Art was founded in 1984 by Takumi Kano, who worked and lived in the area. In contrast, the Yumeji Takehisa Museum of Art was opened in 1990 as a facility independent from the Yayoi Museum of Art, and it holds four special exhibitions each year in addition to the permanent exhibition of Yumeji's works. The two museums, built on a single property, allow visitors a chance to immerse themselves in the world of historical illustrations and publishing.

RECOMMENDATION

室賀清徳
Kiyonori Muroga

日本の近代ポップカルチャーの源流を知るうえでは欠かせない美術館。東京大学の裏手の落ち着いたエリアにあり、建物や内装も含めて、今どきの現代的な美術館にはない「愁い」みたいなものがあります。アールヌーヴォーやユーゲントシュティルといった欧州からの潮流と江戸の大衆文化のあいだから生まれた作品群を、当時の空気を残した上野周辺の町歩きとともに楽しむと良いかもしれません。
The Yayoi Museum is an indispensable part of understanding the inspirations for modern Japanese pop culture. Located in a tranquil neighborhood behind the University of Tokyo, the museum is pervaded by a sense of melancholy, both in and outside the building, that distinguishes it from a present-day contemporary art museum. The works on display, emanating from European styles such as Art Nouveau and Jugendstil, and Tokyo's own popular culture, might best be enjoyed with a stroll around the surrounding Ueno area, which retains the atmosphere of that age.

上野・日暮里の行きたいショップ・見たい建築
Shops and architectures in Ueno / Nippori

東京文化会館
Tokyo Bunka Kaikan

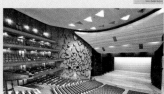

提供：東京文化会館

オペラやバレエもできる本格的な音楽ホールとして1961年にオープンした。建物は、建築家・前川國男の代表作としても知られており、2,303人収容の大ホールを擁するなど、「音楽の殿堂」とも呼ばれている。

The facility opened in 1961 as a formal music hall equipped to host opera and ballet performances. The building is also known as the hall of fame for music and has a capacity to seat 2,303 people. It is known as a masterpiece of the architect Kunio Maekawa.

住 東京都台東区上野公園5-45　電 03-3828-2111
Ad 5-45, Ueno Koen, Taito-ku, Tokyo　Ph 03-3828-2111

国立国会図書館 国際子ども図書館
International Library of Children's Literature, National Diet Library

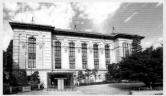

写真提供：国際子ども図書館

2000年にオープンした、日本初の児童書専門の国立図書館。明治39年に帝国図書館として建てられた「レンガ棟」と、ガラス張りでコンテンポラリーな「アーチ棟」という新旧対象的なふたつの建物からなる。

Opened in 2000, this is Japan's first national library dedicated to children's books. The library consists of two buildings that contrast new and old: the Brick Building, built in 1906 as the Imperial Library, and the glass-walled, contemporary Arch Building.

住 東京都台東区上野公園12-49　電 03-3827-2053
Ad 12-49 Ueno Koen, Taito-ku, Tokyo　Ph 03-3827-2053

東京藝術大学大学美術館
The University Art Museum, Tokyo University of the Art

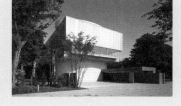

1999年に開館した、芸術・美術資料に特化した大学美術館。1887年の東京美術学校設立に先立つ時期から130年以上にわたり、教育に資する「参考品」として収集されたコレクションを基盤に設立された。

A university art museum that opened in 1999 and specializes in art and artifacts. It was originally founded to house a collection of educational reference materials collected over 130 years, predating the establishment of the Tokyo School of Art and Design in 1887.

住 東京都台東区上野公園12-8　電 050-5541-8600◎
Ad 12-8 Ueno Koen, Taito-ku, Tokyo,　Ph 050-5541-8600◎

台東区立朝倉彫塑館
ASAKURA Museum of Sculpture, Taito

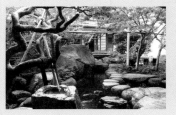

彫刻家・朝倉文夫のアトリエ兼住居を公開する美術館。現在の建物は朝倉自らが設計して1935年に完成したもの。館内では朝倉の彫刻も展示されている。2008年に国指定名勝に登録された中庭や屋上庭園も見応えがある。

The museum displays the sculptures and the former studio and residence of sculptor Asakura Fumio. The current building structure was designed by Asakura himself and completed in 1935. The courtyard and rooftop garden, which were designated as National Site of Scenic Beauty 2008 is worth seeing.

住 東京都台東区谷中7-18-10　電 03-3821-4549
Ad 7-18-10 Yanaka, Taito-ku, Tokyo　Ph 03-3821-4549

HIGURE 17-15 cas
HIGURE 17-15 cas

HIGURE 17-15 cas
contemporary art studio

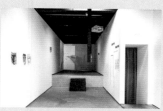

冨井大裕「素描、彫刻」Photo by Masaru Yanagiba

2002年にオープンしたコンテンポラリーアートスタジオ。元々は工場だった建物を改装し、展覧会やパフォーマンスライブなどで利用されるほか、美術設営事務所／現代アート作品の修復記録ラボとして機能している。

A contemporary art studio that opened in 2002. This renovated factory is used for exhibitions and live performances as well as serving as an art-construction office, and a restoration and documentation facility for contemporary art.

住 東京都荒川区西日暮里3-17-15　電 03-3823-6216
Ad 3-17-15 Nishinippori, Arakawa-ku, Tokyo
Ph 03-3823-6216

トーキョーバイク 谷中
Tokyobike Yanaka

tokyobike

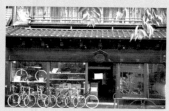

東京、谷中生まれの自転車ブランド。店舗では自転車の販売はもちろんサイクルグッズやセレクト雑貨類の販売もある。

A bicycle brand based in Yanaka, Tokyo. The store carries bicycles, bike-related items, and other select items.

住 東京都台東区谷中4-2-39　電 03-5809-0980
Ad 4-2-39 Yanaka, Taito-ku, Tokyo　Ph 03-5809-0980

東洋文庫ミュージアム
Toyo Bunko
(The Oriental Library)

2011年に開館した東洋学に特化したミュージアム。1924年に設立された東洋文庫を広く普及するべく、日本一美しい本棚とも言われる「モリソン書庫」や「ムセイオンの泉」など、親しみやすい展示を行っている。

Opened in 2011, this museum is dedicated to Asian, Eastern studies. To promote the Toyo Bunko that was founded in 1924, the museum hosts a series of exhibitions, including the Morrison Stacks, said to be the most beautiful book stacks in Japan, and the Fountains of the Museum.

住 東京都文京区本駒込2-28-21　電 03-3942-0280
Ad 2-28-21 Honkomagome, Bunkyo-ku, Tokyo
Ph 03-3942-0280

お茶の水おりがみ会館
Ochanomizu Origami Kaikan

お茶の水
おりがみ会館

1858年に創業した染め紙屋「小林染紙店」を前身に、1972年に設立された折り紙専門の施設。折り紙・千代紙の製造販売、講習会の開催、折り紙の実演や展示などを通して、折り紙の魅力を世界に発信している。

Formerly the location of Kobayashi Somegamiten, a dyed paper store founded in 1858, this facility was established in 1972 as an institution that specializes in origami. In addition to manufacturing and selling origami and chiyogami, the facility also hosts workshops, demonstrations, and exhibitions to promote the appeal of origami to audiences around the world.

住 東京都文京区湯島1-7-14　電 03-3811-4025
Ad 1-7-14, Yushima, Bunkyo-ku, Tokyo　Ph 03-3811-4025

東京その他エリア
Other Areas

墨田・江東・台東
SUMIDA / KOTO / TAITO

1 東京都現代美術館
Museum of Contemporary Art Tokyo

2 たばこと塩の博物館
Tobacco & Salt Museum

3 花王ミュージアム
Kao Museum

豊島
TOSHIMA

1 東京芸術劇場
Tokyo Metropolitan Theatre

2 自由学園明日館
Jiyugakuen Myonichikan

世田谷
SETAGAYA

1 世田谷文学館
Setagaya Literary Museum

2 公益財団法人せたがや
文化財団　生活工房
Setagaya Lifestyle Design Center

3 大宅壮一文庫
Oya Soichi Library

4 BONUS TRACK
BONUS TRACK

5 ノストスブックス
nostos books

品川・大田
SHINAGAWA / OTA

1 WHAT
WHAT

2 All Right Printing
All Right Printing

武蔵野・多摩
MUSASHINO / TAMA

1 多摩美術大学
アートテークギャラリー
Tama Art University Art-Theque Gallery

2 武蔵野美術大学
美術館・図書館
Musashino Art University Museum & Library (MAU M&L)

3 町田市民文学館ことばらんど
Machida city public museum of literature

① 東京都現代美術館
Museum of Contemporary Art Tokyo

**日本の現代美術を未来に
つなげる一大拠点**

変化の激しい現代の美術動向を体系的に研究、収集、保存、展示するための機関として1995年に開館。領域横断的な国内外の創造活動を取り上げる意欲的な企画展に加え、日本の戦後美術を中心としたコレクション展示、教育普及活動、美術図書室の運営などを行う。2019年のリニューアルでは、建築家の長坂常とアート・ディレクターの色部義昭が館内の什器とサイン計画を手がけ、よりパブリックな空間へと生まれ変わった。

A major center for the future of Japanese contemporary art

This museum opened in 1995 as an institution for systematic research, collection, preservation, and exhibition of contemporary art and its rapidly shifting trends. In addition to holding ambitious exhibitions that feature cross-disciplinary creative works from Japan and abroad, the museum also exhibits collections of post-war Japanese art, conducts educational activities, and runs an art library.

時 10:00－18:00（展示室入場は閉館30分前まで）
休 月曜（祝日の場合は翌平日）、年末年始、展示替期間　料 展覧会により異なる
住 東京都江東区三好4-1-1　電 03-5777-8600◎
交 地下鉄半蔵門線「清澄白河駅」より徒歩9分

10:00-18:00 (Tickets available until 30 min before closing)　**C** Mondays (or following weekday if Monday is a holiday), New year holidays, between exhiitions
Fees vary by exhibition　**Ad** 4-1-1 Miyoshi, Koto-ku, Tokyo　**Ph** 03-5777-8600◎　**Ac** 9 min walk from Kiyosumi-shirakawa Station on the Hanzomon line
–
www.mot-art-museum.jp

RECOMMENDATION

7

アイデア編集部
IDEA

美術館の位置する江東区木場周辺は、江戸から昭和にかけて、江戸・東京へ材木を供給し「材木のまち」として栄えてきた場所。大部分は新木場に移転し跡地に木場公園がつくられたが、現在も町のところどころにその面影を残す建物が発見できる。近年では木材倉庫を再利用し、大型の焙煎機を設置する本格的なカフェが急増。ブルーボトルコーヒーの旗艦店などもオープンし、「コーヒーの街」としてもにぎわっている。

The area around Kiba, Koto-ku, where the museum is located, prospered as a town that supplied lumber to Edo-Tokyo from the Edo period to the Showa period. Most of the industry that moved to Shin-Kiba and Kiba Park was built in this area, but remnants of the old town still remain. In recent years, there has been a surge in the number of cafes and coffee roasters that have repurposed the old wood warehouses to house large roasting machines. The Blue Bottle Coffee flagship store has also opened, and the town has become a popular coffee town.

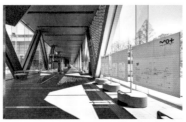

Photo: Kenta Hasegawa

❷ たばこと塩の博物館
Tobacco & Salt Museum

専売品であったたばこと塩の歴史から文化に出会う博物館

1978年に日本専売公社（現・日本たばこ産業株式会社）により設立された「たばこ」と「塩」の歴史と文化をテーマとする博物館で、2015年に渋谷から移転し、現在地にリニューアルオープンした。16世紀末に日本に伝来し、庶民文化にとけこみ独自の文化をつくってきたたばこと、縄文時代以来、生活必需品としてつくられてきた塩に関する資料収集、調査・研究を行い、それぞれに関連した幅広いテーマの特別展を開催している。

Understanding culture from the history of salt and tobacco

Founded in 1978, this museum is dedicated to the history and culture of tobacco and salt. In 2015, the museum relocated from Shibuya to its current address. The museum collects data and conducts their own surveys and research on tobacco and salt, two historical commodities that were once protected by a government monopoly in Japan. The museum also hosts special exhibitions related to a variety of topics related to tobacco and salt.

🕐 11:00−17:00（入館は閉館30分前まで）
🈺 月曜（祝日の場合は翌平日）,年末年始
💴 大人・大学生100円,小中高生・満65歳以上（要証明書）★
🏠 東京都墨田区横川1-16-3　☎ 03-3622-8801
🚉 東武スカイツリーライン「とうきょうスカイツリー駅」より徒歩8分

🕐 11:00-17:00 (Admission until 30 min before closing)　🄲 Mondays(or following weekday if Monday is a holiday), New Year holidays
💴 Adults and university students ¥100, Children and pupils of primary, juniorhigh, and high schools and Visitors over 65 years old with age certificate ¥50 ★
Ad 1-16-3 Yokogawa, Sumida-ku, Tokyo
Ph 03-3622-8801
Ac 8 min walk from Tokyo Skytree Station on the Tobu Skytree line

–
www.tabashio.jp

RECOMMENDATION

渡部千春
Chiharu Watabe

2017年『和田誠と日本のイラストレーション』や2019年『マッチ 〜魔法の着火具・モダンなラベル〜』など特別展に「おおっ」と思うものがあります。優秀な学芸員さん達と豊富なアーカイヴ資料が揃っている博物館ならでは。常設展について学生に聞いてみたら、沢山自撮りしてきちゃいましたー、だそうです。
Their special exhibitions, such as *History of Japanese Illustration* in 2017 and *Match: A Magical Fire-Starting Tool and a Modern Label* in 2019 were impressive. These shows could only be achieved by a museum that has excellent curators and a wealth of archival materials. When I asked my students how they felt about the museum's permanent exhibit, they told me it was good for taking lots of selfies.

③ 花王ミュージアム
Kao Museum

花王ミュージアム
Kao Museum

企業が育んだ文化史を
一望できるスポット

1887年の創業以来、花王石鹸をはじめ、入浴、洗濯、掃除、化粧などの清浄文化の発展に深く関わってきた花王が、これまでに収集した関連史料を一般に展示・公開し、清浄文化の移り変わりを紹介する施設。館内は3つの展示ゾーンに分かれており、パネル解説、映像や模型資料、美術史料やプロダクト製品など、立体的な展示が構成されている。歴代商品パッケージのアーカイブ展示も必見。

A place to study the history of Japan's cleanliness culture

Since its establishment in 1887, Kao has been closely involved in the development of the country's culture of cleanliness through items used in bathing, laundry, cleaning, and makeup. This museum exhibits its historical materials to the public and explores how the culture of cleanliness has evolved over the years. The museum is divided into three exhibition zones, each of which is composed of three-dimensional shows that include explanatory panel boards, videos, models, art history documents, and products like household appliances.

🕐 事前予約制　🏠 土曜・日曜・祝日・会社休日
💴 無料　🏢 東京都墨田区文花2-1-3 花王株式会社 すみだ事業場内　📞 03-5630-9004
🚃 東武亀戸線「小村井駅」より徒歩8分

🅗 Advance reservation system　🅒 Saturdays, Sundays, Holidays, Company Holidays　🅥 Free
🅐 Kao Corporation Sumida Plant, 2-1-3 Bunka, Sumida-ku, Tokyo　🅟 03-5630-9004
🅐🅒 8 min walk from Omurai Station on the Tobu Kameido line

–
www.kao.com/jp/corporate/about/tour/museum-tour/kao-museum

RECOMMENDATION

渡部千春
Chiharu Watabe

原弘の新装花王石鹸パッケージの現物など、パッケージ好きにはたまらない場所。団地を模した昭和コーナーや過去の商品紹介コーナーには、使われていた道具と一緒に製品が並べてあり、当時の家庭や流行に合わせてパッケージが出来ていた、とか、確かに昔は洗剤を買うのが一苦労だった、とか、なにかしみじみしてしまう。浅生ハルミンさん描く家族のパネルが展示を案内してくれるところも愛らしい。

With pieces like the original packaging of the new Kao Sekken by graphic designer Hiromu Hara, this place is a must-see for package design lovers. The company's products, along with utensils and everyday items used in the old days, are exhibited in sections that are modeled to resemble the old Showa-era housing complexes. Seeing them in context makes me feel nostalgic—it helps me understand how the packaging was designed to reflect the household needs and trends of the time, and it makes me remember how buying detergent was a big deal. The information panels, with illustrations of a family drawn by Harumin Asao, are another delightful feature.

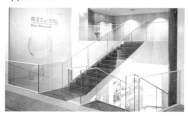

墨田・江東・台東の行きたいショップ・見たい建築
Shops and architecture in Sumida / Koto / Taito

東京都江戸東京博物館
Tokyo Metropolitan Edo-Tokyo Museum

江戸東京の歴史と文化をふりかえり、未来の都市と生活を考える場として1993年に開館。菊竹清訓による高床式の倉をイメージしたユニークな建物が特徴。特別展のほか、常設展内の様々な復元模型は一見の価値あり。

This museum opened in 1993 as a place to reflect on the history and culture of Edo-Tokyo and consider the future of the city and the lifestyles of those who live in it. The unique building, designed by Kikutake Kiyonori, was built like a warehouse on stilts. In addition to the special exhibitions, the variety of reconstructed models in the permanent exhibition are worth a visit.

住 東京都墨田区横網1-4-1　電 03-3626-9974
Ad 1-4-1 Yokoami, Sumida-ku, Tokyo　Ph 03-3626-9974

東京都江戸東京博物館

すみだ北斎美術館
The Sumida Hokusai Museum

浮世絵師、葛飾北斎の作品を展示する美術館として、北斎が90年の生涯のほとんどを過ごした墨田区に誕生。インパクトのある外観は、妹島和世による建築。浮世絵作品の保存を考慮しながらも、公園や地域と一体になったデザインだ。

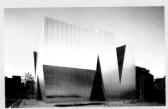

This art museum was born in Sumida city, where Katsushika Hokusai, an Ukiyo-e artist who spent most of his ninety years of his life here. His work is showcased in this art museum. This impactful exterior was architectured by Sejima Kazuyo. The building's architecture is designed to preserve the precious Ukiyo-e while blending in with the park and the locality.

住 東京都墨田区亀沢2-7-2　電 03-6658-8936
Ad 2-7-2 Kamezawa, Sumida-ku, Tokyo　Ph 03-6658-8936

© Forward Stroke

ギャラリーエークワッド
GALLERY A⁴

「建築・愉しむ」をコンセプトに、建築の周辺の事象をめぐる企画展を数々行っている。原寸大で空間を再現したり、最先端の映像技術などを駆使して建築の魅力を紹介する。子どもから大人まで幅広く楽しめるギャラリー。

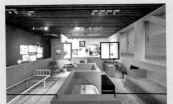

Based on the concept of "architecture and enjoyment," the gallery has organized numerous exhibitions related to buildings in the local area. These shows convey the allure of architecture through reproductions of full-scale spaces and cutting-edge imaging techniques. The gallery is sure to delight visitors of all ages.

住 東京都江東区新砂1-1-1 竹中工務店東京本店1F
電 03-6660-6011
Ad 1-1-1 Shinsuna, Koto-ku, Tokyo　Ph 03-6660-6011

過去の展覧会風景　撮影：光齋昇馬

トーキョーピクセル ショップアンドギャラリー
TOKYO PiXEL. shop & gallery

近年飲食店などの出店が増える蔵前エリアのショップ＆ギャラリー。ギャラリーでは6日単位でクリエイターの展示が行われるほか、ショップではオリジナルアイテムのほか、陶器やクリエイター雑貨にも出会える。

A store and gallery in Kuramae, an area with an increasing amount of new stores and restaurants. The gallery hosts 6-day artist exhibitions and sells unique items designed by artists, ceramic works, and their own branded products.

住 東京都台東区寿3-14-13-1F　電 03-6802-8219
Ad 3-14-13-1F Kotobuki, Taito-ku, Tokyo　Ph 03-6802-8219

① 東京芸術劇場
Tokyo Metropolitan Theatre

東京芸術劇場
Tokyo Metropolitan Theatre

開放的なガラス屋根が
ランドマークの池袋の文化拠点

演劇・舞踊等の公演を行う3つの劇場と
コンサートホール、展示ギャラリーや、会
議室などを有する複合文化施設。2009
年、芸術監督に野田秀樹が就任。2012
年には大規模改修を終え、リニューアル
オープンした。東京の音楽・舞台芸術を
代表する「顔」として、多岐に渡る活動
を行っている。芦原義信の設計によるダ
イナミックな建築も必見。

時 9:00－22:00　**休** 公式WEBサイトをご確認く
ださい　**¥** 公演により異なる　**住** 東京都豊島区西
池袋1-8-1　**電** 03-5391-2111　**交** JR、地下鉄丸ノ
内線、有楽町線、副都心線、東武東上線、西武池袋線
「池袋駅」より徒歩2分

H 9:00-22:00　**C** See website for details
¥ Fees vary by performance
Ad 1-8-1 Nishi-Ikebukuro, Toshima-ku, Tokyo
Ph 03-5391-2111　**Ac** 2 min walk from Ikebukuro
Station on the JR, Marunouchi, Yurakucho,
Fukutoshin, Tobu Tojo and Seibu Ikebukuro lines
–
www.geigeki.jp

A cultural center and a
landmark of Ikebukuro with an
iconic glass roof

This cultural complex houses three
theaters for drama and dance
performances, a concert hall, an
exhibition gallery, and conference rooms.
Hideki Noda has served as the facility's
artistic director since 2009. The complex
reopened in 2012 following a large-scale
renovation. It currently stands at the
forefront of Tokyo's music and performing
arts scene, and is engaged in a diverse
range of activities. The building's
dynamic architecture, designed by
Yoshinobu Ashihara, is also a must-see.

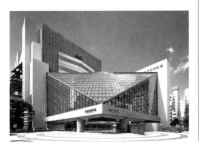

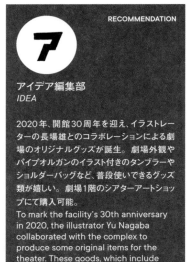

RECOMMENDATION

7

アイデア編集部
IDEA

2020年、開館30周年を迎え、イラストレー
ターの長場雄とのコラボレーションによる劇
場のオリジナルグッズが誕生。劇場外観や
パイプオルガンのイラスト付きのタンブラーや
ショルダーバッグなど、普段使いできるグッズ
類が嬉しい。劇場1階のシアターアートショッ
プにて購入可能。

To mark the facility's 30th anniversary
in 2020, the illustrator Yu Nagaba
collaborated with the complex to
produce some original items for the
theater. These goods, which include
tumblers and shot glasses decorated
with pictures of the building's exterior
and pipe organ, are especially delightful
because they can be used on a daily
basis. They are available in the Theater
Art Shop on the first floor of the
building.

② 自由学園明日館
Jiyugakuen Myonichikan

F・L・ライトのプレイリースタイル建築

大正時代に創立した自由学園の旧校舎。幾何学模様の窓枠が印象的なホールを中心に、食堂と教室が配置された建物は、近代建築の巨匠フランク・ロイド・ライトによるもの。設計には弟子の遠藤新も携わり、敷地南側に建つ講堂とともに重要文化財に指定されている。近隣の東京カテドラル（丹下健三設計）などと合わせて巡りたい近代建築遺産。

F. L. Wright's prairie-style architecture

This is the old school building of the Jiyu Gakuen, originally constructed during the Taisho era. The building, with its cafeteria and classrooms arranged around a series of impressive geometric-patterned window frames, was designed by one of the masters of modern architecture, Frank Lloyd Wright. His pupil, Arata Endo, was involved in its design, and the building has been designated an Important Cultural Asset along with the auditorium on the south side of the site. It is one of the city's modern architectural treasures and should be visited along with the nearby Tokyo Cathedral, which was designed by Kenzo Tange.

⏰ 10:00－16:00（入館は閉館30分前まで）、夜間見学日・休日見学日あり 休 月曜（祝日の場合は翌平日）、年末年始 ¥ 喫茶付見学600円、見学のみ400円、夜間見学1,000円、中学生以下無料 住 東京都豊島区西池袋2-31-3 ☎ 03-3971-7535 交 JR、私鉄、地下鉄「池袋駅」より徒歩5分

⏰ 10:00-16:00 (Admission until 30 min before closing). Have Night-time tour days and Holiday tour days 🅲 Please check the official website ¥ Tour with coffee shop ¥600, tour only ¥400, night tour ¥1,000, free of charge for Junior high school students and Younger 🅰 2-31-3 Nishi-Ikebukuro, Toshima-ku, Tokyo 🅿 03-3971-7535 🅰 2 min walk from Ikebukuro Station.

jiyu.jp

RECOMMENDATION

野見山桜
Sakura Nomiyama

ユニークな教育で知られる学校で美術教育に力を入れていた一面も。例えば、工芸研究所（現：生活工芸研究所）は、バウハウスで教鞭をとったヨハネス・イッテン主宰の美術学校に留学した学園卒業生が創設に携わりました。今もその活動は継続しており、研究所で制作されたオリジナル製品は併設のショップで購入可能。壁画や机・椅子などから当時の学校生活を振り返る事ができます。The school was known for its unique education with an emphasis on life and art. For example, the Kogei Laboratory (now Seikatsu Kougei Laboratory) was founded by one of the school's students, who studied at an art school founded by Johannes Itten, who was associated with the Bauhaus school. The institute is still active today, and some of the products designed there are available for purchase in the store. From a wall painting to furniture, you can get a glimpse as school life back then.

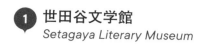

世田谷文学館
Setagaya Literary Museum

多彩なテーマの展示イベントを楽しめる総合文学館

1995年に開館した都内初の地域総合文学館。数多くの文学者・芸術家が居を構えた世田谷の文化的な風土を現代に継承していくため、文学を軸に、マンガ、映画、美術、デザイン、音楽など、幅広いジャンルに交差する企画展を開催。世田谷ゆかりの文学や文学者に関する資料をもとにしたコレクション展も充実しており、企画展と連動したイベントや地域にむけた講座の開催、文学賞の主催など、地域に根付いた活動を展開する。

Variety of themed exhibitions and events

Opened in 1995, this is the first regional literature museum in Tokyo. In order to preserve the cultural climate of Setagaya, home to numerous literary figures and artists, the museum holds exhibitions that focus primarily on literature but also include manga, film, art, design, and music. The museum also hosts exhibits based on their extensive collection of resources related to the literature and literary figures associated with Setagaya.

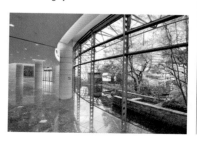

時 10:00－18:00（入館は閉館30分前まで）
休 月曜（祝日の場合は翌平日）,年末年始
¥ 展覧会により異なる
住 東京都世田谷区南烏山1-10-10
電 03-5374-9111
交 京王線「芦花公園駅」より徒歩5分
H 10:00-18:00 (Admission until 30 min before closing)
C Mondays (or following weekday if Monday is a holiday), New Year holidays
¥ Fees vary by exhibition
Ad 1-10-10 Minami Karasuyama, Setagaya-ku, Tokyo　Ph 03-5374-9111
Ac 5 min walk from Roka-koen Station on the Keio line
–
www.setabun.or.jp

RECOMMENDATION

室賀清徳
Kiyonori Muroga

近年は岡崎京子、原田治、ヒグチユウコ、信藤三雄など、近現代の漫画家、イラストレーター、デザイナーを掘り下げる展示も精力的に行っておじゃまする機会が多かった文学館です。展示ではたいてい関連グッズや書籍もあわせて売っているのでうっかり散財するのに注意。あと、人気の展示はすごく混むときもあります。

I've been inspired to visit the Setagaya Literary Museum on many occasions recently to see shows that explore the work of modern and contemporary manga artists, illustrators, and designers like Kyoko Okazaki, Osamu Harada, Yuko Higuchi, and Mitsuo Shindo. Be careful not to spend too much money on the goods and books that are often on sale at the exhibitions. Also, don't forget that the popular shows can sometimes be very crowded.

② 公益財団法人せたがや文化財団 生活工房
Setagaya Lifestyle Design Center

世田谷文化生活情報センター
生活工房
Lifestyle Design Center

子どもから大人まで楽しめる、多彩な企画が目白押し

世田谷文学館や世田谷美術館などを運営するせたがや文化財団の管理施設。三軒茶屋駅直結のビル内に展示スペースを構え、暮らしに身近なデザイン、文化、環境などをテーマとした展示やワークショップの開催など、地域にひらかれた活動を展開。物や情報があふれる時代に、観る、触る、感じるという体験を通じ「豊かさ」や「文化」の意味を問うユニークな企画が多数。キッチン完備のワークショップルームなどは貸出利用も可能。

Offering a variety of programs for children and adults

Inside a building directly connected to Sangenjaya Station, there is an exhibition space where they hold a variety of events that are easily accessible and open to the public, such as exhibitions and workshops on design, culture, and the environment. In this age when our lives are overflowing with information and material possessions, the center offers many unique programs that are designed to question the meaning of richness and culture through hands-on experiences.

時 9:00～22:00（企画展により異なる）
休 平日月曜、年末年始
¥ 無料（一部有料） 住 東京都世田谷区太子堂
4-1-1 キャロットタワー3～5F 電 03-5432-1543
交 東急田園都市線、世田谷線「三軒茶屋」駅直結
H 9:00-22:00 (Hours vary by exhibition)
C Mondays, New Year holidays
¥ Free (Fees vary by project)
Ad Carrot Tower3-5F, 4-1-1 Taishido, Setagaya-ku,
Tokyo Ph 03-5432-1543
Ac Direct access from Sangenjaya Station on
the Tokyu Denentoshi and Setagaya Lines
–
www.setagaya-ldc.net

RECOMMENDATION

7

アイデア編集部
IDEA

多彩な展覧会とともに楽しみなのが、チラシなど告知物の印刷デザイン。コンセプトにそって毎回さまざまなデザイナーが起用され、2020年にはそれまでのポスター・チラシのデザインを振り返るアーカイブ展も開催された。なお、同館で2007年に開催された「活版再生展」で展示された印刷機や活字を引き継ぎはじまったのが髙田唯が主宰するAll Right Printingだ。

Along with the venue's diverse array of exhibitions, we look forward to seeing the flyer and other promotional designs. Designers are chosen to work on the project based on the exhibition concept, and in 2020, the venue held an archival show that featured posters and flyers from past shows. By the way, All Right Printing, headed by Yui Takada, began by taking over the printing presses and typesetters exhibited at *the Letterpress Revival Exhibition* held here in 2007.

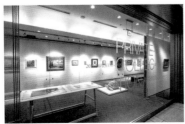

©撮影：松尾宇人

3 大宅壮一文庫
Oya Soichi Library

日本ではじめての雑誌図書館

独特な社会評論や人物評論で長くマスコミ界で活躍した評論家・大宅壮一（1900−1970）の雑誌コレクションを引き継ぎ、明治以降の雑誌資料を所蔵・一般公開する私設図書館。評論活動のかたわら、執筆のために資料収集と整理に力を尽くした大宅は、生前から自らの蔵書を広く公開することを望んでいたことから、同館では所蔵される雑誌の記事索引データベースの利用のほか、雑誌原本の閲覧や複写サービスも行っている。

The first magazine library in Japan

This private library houses a collection of magazine archives that date back to the Meiji era. The collection was inherited from Soichi Oya (1900–1970), a journalist with a long career in mass media and known for his unique social and personal critiques. Oya, who devoted himself to collecting and organizing materials for his writing during his career, wanted to make his collection widely available to the public even before his death. The museum provides access to the database index for the articles in the journals and magazine in its collection, and visitors can browse original copies and use the museum's copying services.

🕐 11:00 − 18:00
🚫 日曜・祝日・年末年始
¥ 500円
🏠 東京都世田谷区八幡山3-10-20
☎ 03-3303-2000
🚃 京王線「八幡山駅」より徒歩8分
🕐 11:00-18:00
🚫 Sundays, Holidays and New Year holidays
¥ ¥500
📍 3-10-20, Hachimanyama, Setagaya-ku, Tokyo
📞 03-3303-2000
🚶 8 min walk from Hachimanyama Station on the Keio line

–
www.oya-bunko.or.jp

RECOMMENDATION

7

アイデア編集部
IDEA

2020年で開館50年をむかえた同館だが、近年はスマホやインターネットの普及により利用者数が減少し経営危機に立たされている。支援組織「パトロネージュ」が発足し、かつて大宅壮一による取材により窮地を救われた経験をもつタレントのデヴィ夫人が代表を務め、運営継続とジャーナリズムの重要性が唱えられている。

The museum celebrates its 50th anniversary in 2020. In recent years, the venue has faced financial difficulties due to a decrease in the number of visitors, caused by the widespread use of smartphones and the Internet. A supportive organization called "Patronage" has been established and is headed by TV personality Dewi Sukarno, who was once saved from a difficult situation by an interview with Soichi Oyake. The organization is advocating the importance of journalism and the venue's continued operation.

4 BONUS TRACK
BONUS TRACK

線路跡地に生まれた
新しいカルチャースポット

小田急線線路跡地の再開発エリア
に生まれた商業施設。ウェブマガジン
「greenz.jp」を運営する小野裕之氏
と、下北沢で本屋B&Bを営んできた内沼
晋太郎氏のふたりによるプロデュースで、
B&Bの新店舗やショップ、飲食店に加え、
コワーキングスペースやシェアキッチン、広
場といった、一般利用も可能なコミュニ
ティスペースを提供している。近隣の温
泉宿「由縁別邸 代田」とあわせて丸一日
楽しめるエリアだ。

A new culture spot on a former railroad track

This commercial facility emerged in
the redevelopment area of the former
Odakyu railway. Developed by Hiroyuki
Ono, who runs the web magazine
"greenz.jp," and Shintaro Uchinuma,
who operates a bookstore B&B in
Shimokitazawa, this facility provides a
new community space that includes the
new B&B store, restaurants, a co-working
space, a shared kitchen, and a plaza.
With the hot-spring bath hotel Yuen
Bettei Daita nearby, visitors can easily
spend an entire day in this area.

🕐 店舗により異なる　🅿 店舗により異なる
¥ 無料　🏠 東京都世田谷区代田 2-36-12 〜 15
🚇 小田急線「世田谷代田駅」「下北沢駅」より徒歩5分

🅷 Hours vary by shop　🅲 Closed vary by shop
¥ Free　🄰 2-36-12 to 15, Daita, Setagaya-ku,
Tokyo　🄰🄲 5 min walk from Setagayadaita and
Shimokitazawa Station on the Odakyu line
—
bonus-track.net

RECOMMENDATION

7

アイデア編集部
IDEA

設計を担当したのはツバメアーキテクツ。近
年駅周辺の店舗賃料が高騰したことで、大手
チェーンのテナントが増え、以前の個性ある
商店街の風景が消えつつある下北沢。この
状況を鑑み、大きく街の景色を変える再開発
ではなく、近隣地区と調和し下北沢らしさを維
持しつつ相乗効果を生むような空間づくりが
なされている。 設計だけでなく、完成後の使
い方を考慮し研究を行う「Lab」部門をもつ
設計事務所ならではの視点に出会える場所。
The project was designed by
Tsubame Architects. In recent years,
Shimokitazawa's landscape, where
streets are lined with small, unique
stores, is disappearing because of
increased rent in areas surrounding
the station, which has caused an influx
of major chain stores. The project was
not intended to drastically change
the scenery of the city but to create a
synergistic effect by harmonizing with
the neighborhood while maintaining
its distinctiveness. The project is full
of new ideas that are implemented by
an architecture office with a unique
department called "Lab," where they
research and explore the ways a project
could be used after its completion.

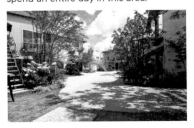

ノストスブックス
nostos books

nostos books

松陰神社前の穴場デザイン系古書店

路面に開けたガラス張りの空間が目を引く、デザイン会社の事務所と古書店を併設する店舗。もとはオンラインストアからスタートし、2013年に現在の場所で実店舗を始動して以来、「新しい過去を発見できる」書店を目指し、デザイン、タイポグラフィ、アート関連を中心に古書や雑貨を扱っている。店内にはギャラリースペースもあり、刊行記念展やワークショップも開催。人気の飲食店も多い近辺を散策しながら訪れたい。

A little-known place to find used design books in front of the Shoin Shrine

With an eye-catching, glass-walled room facing the street, this building houses a design company office, a used bookstore, and a gallery. The brand started as an online store and opened a retail store at the current location in 2013. It has since operated with the goal of creating a place where visitors can "discover a new past" by offering old books and various items related to design, typography, and art. In the gallery, they hold workshops and exhibitions to commemorate new publications. This is a great place to stop by while strolling through the neighborhood, which is known for its many popular restaurants.

時 13:00 — 18:00
休 平日
¥ 無料
住 東京都世田谷区世田谷4-2-12
電 03-5799-7982
交 東急世田谷線「松陰神社前駅」より徒歩1分
H 13:00-18:00
C Weekdays
¥ Free
Ad 4-2-12, Setagaya, Setagaya-ku, Tokyo
Ph 03-5799-7982
Ac 1 min walk from Shoin-jinja-mae Station on Tokyu Setagaya line
–
nostos.jp

RECOMMENDATION

7

アイデア編集部
IDEA

店舗が軒を連ねる松陰神社通り商店街は、吉田松陰を祀る松陰神社と、東急世田谷線の松陰神社前駅をつなぐ小さな商店街。2016年に線路沿いにできた商業施設「松陰PLAT」をはじめ、ベーカリーやカフェの出店が続いている。一方で、昔からの商店にも活気が残っており、老舗パン屋のニコラス精養堂やメンチカツが人気の肉の染谷など、なつかしさを残す雰囲気も魅力。
Shoun-jinja-dori Sho-tengai is a small street full of shops that connects the Shoin Shrine, dedicated to Yoshida Shoin, and Shoin-jinja Station on the Tokyu Setagaya Line. Several bakeries and cafes have been popping up, starting with Shoin PLAT, a commercial facility that opened along the railway tracks in 2016. The old stores still retain their vitality, preserving the nostalgic atmosphere with stores like Nicholas Seiyodo, a bakery store with a long history, and Someya, with its popular menchi-katsu (deep fried ground meat cakes).

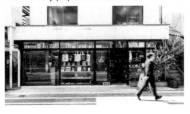

WHAT
WHAT

寺田倉庫による新しいミュージアム

現代アートのコレクターズミュージアム「WHAT」は、寺田倉庫の美術品保管サービスを利用するコレクターの貴重なアート作品を公開し、その文化的価値と魅力を広く開花させることを目的とした芸術文化発信施設。コレクターの視点を通じて現代アートの魅力に迫る展覧会と、模型の価値発信を軸とする建築にまつわる展覧会を会期毎に開催。アート作品から建築模型まで常時100点以上の作品を展示する。

The new museum opened by Warehouse Terrada

"WHAT" is a museum of modern art from collectors, and is a destination of art and culture, that aims to promote the artistic value of modern arts by displaying valuable art properties belonging to collectors who use Warehouse Terrada's artwork storage services. The museum hosts exhibition that approaches the beauty of modern art through collector's perspective, and architecture related exhibition based on the value of the models every session. The museum exhibits more than 100 properties such as artworks and building models.

🕐 11:00 − 19:00（入館は閉館1時間前まで）
🚫 月曜（祝日の場合は翌平日）
💴 一般:1,200円,大学生・専門学生:700円,中高生:500円,小学生以下:無料
🏠 東京都品川区東品川2-6-10 G号
📞 非公開
🚉 東京モノレール「天王洲アイル駅」より徒歩5分
🕐 11:00-19:00 (Admission until one hour before closing)
🅲 Mondays (or following weekday if Monday is a holiday)
💴 Adults ¥1,200, university students ¥700, high school and junior high school students ¥500, free for elementary school students and younger children
🅰 2-6-10 G, Higashi-Shinagawa, Shinagawa-ku, Tokyo
🅿 Disclosed
🅰 5 min walk from Tennozu Isle Station on Tokyo Monorail
–
what.warehouseofart.org

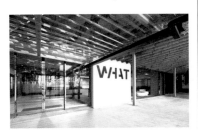

RECOMMENDATION

7

アイデア編集部
IDEA

同施設のウェブサイト「ARCHI-DEPOT ONLINE」〈online.archi-depot.com/ja/about〉では、保管されている建築模型のウェブアーカイブも閲覧できる。世界的な建築家たちの作品から、中小規模のプロジェクトまで、幅広い作品を一堂に見られる貴重な情報源。The facility's website, ARCHI-DEPOT ONLINE 〈online.archi-depot.com/en/about〉, features a web archive of their stored architectural models. It is a valuable resource for viewing a broad range of works, from small- and medium-sized projects to those by world-class architects.

② All Right Printing
All Right Printing

活版印刷をより身近に
体験する印刷工房

グラフィックデザイナーの髙田唯率いるAllrightが運営する活版印刷工房。活版印刷の技術を継承していくことを目的に設立され、名刺やショップカードなどの印刷受注を行うほか、用紙や加工の相談や、デザイン依頼にも対応している。貴重な活版印刷機を目にできる印刷立会や見学も人気。また、Allrightの事務所では、オープンデーに限りオリジナルグッズや作品、関連商品の販売も行なっており、あわせて訪れたい。

A printing studio offering an intimate letterpress experience

This letterpress studio is run by Allright and headed by graphic designer Yui Takada. It was established for the purpose of passing down techniques involved in letterpress printing, and besides taking orders for business cards and store cards, the studio provides consultation services for paper selection, print processing, and other design requests. On-site witness and tour held in front of the precious letterpress are also popular. Also, the nearby Allright office sells items and products designed by the studio.

時 10:00 — 18:00
休 土曜・日曜・祝日　￥ 無料
住 東京都大田区田園調布 1-52-14
電 03-5755-5322
交 東横線「多摩川駅」より徒歩 2 分

H 10:00-18:00
C Saturdays, Sundays and holidays　￥ Free
Ad 1-52-14 Denenchofu, Ota-ku, Tokyo
Ph 03-5755-5322
Ac 2 min walk from Tamagawa Station on the Tokyu Toyoko line
–
allrightprinting.jp

RECOMMENDATION

渡部千春
Chiharu Watabe

印刷屋もやるデザイン会社なのか、デザイン会社もやる印刷屋なのか、はたまた音楽事業もあり、ますます「特定されない会社」になっていくAllright。Allright Printing（All right Printingと綴る時もあり。どっちでもいいそうだ）はその中の印刷部門。やっぱり圧倒されるのは活版機で、自分が発注したものが印刷される工程を見るのはトキメキを感じる。今もあるのか分からないけれど、すり減って使えなくなった活字が一斗缶に山盛りで入っていたのも素敵でした。
I don't know if they are a design company that also runs a print shop or a print shop that also runs a design company. With a music business also on the side, Allright is becoming increasingly hard to pin down. Allright Printing is their printing division. The letterpress always leaves me speechless, and it is thrilling to see the pieces of my order being printed in the machine. I don't know if they still have it, but it was neat to see a pile of worn-out type being stored in a large can.

① 多摩美術大学アートテークギャラリー
Tama Art University Art-Theque Gallery

知と創造のネットワークを
形成する発信拠点

2015年に新設された複合施設アートテークにあるギャラリー。学生用のアトリエなどにあわせて、1、2階はアート、デザイン、映像、デジタルやインスタレーションの展示・発信の場として一般公開されている。グラフィックデザイン学科と紙の専門商社、竹尾によるポスターコレクションを収蔵・展示するギャラリーもあり、アートやデザインの多面性を体験できる。キャンパス内の図書館、近隣の大学美術館とあわせて訪れるのも◎。

A communications hub
that nourishes a network of
knowledge and creativity

This gallery is held in Art-Theque, a complex which was newly constructed in 2015. The first and second floors feature fine art, design, videos, digital works, and installations. The complex also includes a special gallery that houses and displays a poster collection by the graphic design department and the paper-trading company Takeo, allowing visitors to experience the multifaceted nature of art and design. The complex is a great place to stop by while visiting the campus library and other university museums in the area.

🕐 10:00-17:00
🏠 日曜、祝日、年末年始、8月、2月、展示替期間
¥ 無料
🏠 東京都八王子市鑓水2-1723 アートテーク
📞 042-679-5727
🚌 JR横浜線・京王相模原線橋本駅北口から神奈川中央交通バス「多摩美術大学行」で8分。または、JR八王子駅南口から京王バスで20分

🕐 10:00-17:00
🅲 Sundays, Holidays, New Year holidays, August, February, between exhibitions　🅐🅳 2-1723 Yarimizu Hachioji, Tokyo
¥ Free
📞 042-679-5727
🅐🅲 Take a bus for "Tama Art University (Tama Bijutsu Daigaku)" from bus stop at Hashimoto Station North Exit (8 min), or take a bus from Hachioji Station South Exit(20 min).

–

aac.tamabi.ac.jp/

RECOMMENDATION

永原康史
Yasuhito Nagahara

多摩美術大学八王子キャンパスにあるギャラリー。アートとデザインを横断するさまざまな展示が行なわれている。棟内にはアートアーカイヴセンターが併設されており、もの派アーカイヴ、安齊重男フォトアーカイヴ、三上晴子アーカイヴ、和田誠アーカイヴ、瀧口修造文庫、北園克衛文庫など、多くの資料が収蔵されている。

This is the gallery at Tama Art University's Hachioji campus, where a wide range of art and design exhibitions are held. The building includes the Art Archive Center, which houses numerous resources, including the Mono-ha Archive, Shigeo Anzai Photo Archive, Seiko Mikami Archive, Makoto Wada Archive, Shuzo Takiguchi Collection, and Katsue Kitazono Collection.

写真提供：石黒写真研究所

2 武蔵野美術大学 美術館・図書館
Musashino Art University Museum & Library (MAU M&L)

MAU M&L
武蔵野美術大学 美術館・図書館

美術館・博物館・図書館の機能を併せ持つ、知の複合施設

1967年に「美術資料図書館」として開館し、2011年にリニューアル。美術館はポスターと近代椅子を中心に、4万点を超えるデザイン資料や美術作品のコレクションをもち、年間を通じて多くの企画展を開催。図書館では約32万冊の図書や学術雑誌・専門誌約5,000タイトルを所蔵しているほか、国内有数のコレクションをもつ民俗資料室や、映像資料を視聴できるイメージライブラリーも併設されている。

A knowledge center that functions as a museum and a library

Opened in 1967 as an Art Library and was renewed in 2011. The museum owns a collection of over 40,000 design resources and art pieces, centered on posters and modern chairs, and holds special exhibitions throughout the year. The library holds approximately 320,000 books and 5,000 academic journals and magazines. It is also equipped with a folk-art archive room, which houses one of the largest archives in the country, and an image library where visitors have access to video archives.

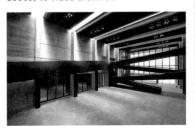

🕐 10:00－18:00／（土曜・特別開館日）
10:00－17:00　🏠 日曜、祝日　💰 無料
🏢 東京都小平市小川町1-736　📞 042-342-6003
🚃 西武国分寺線「鷹の台」駅より徒歩18分

🅗 10:00-18:00, Saturdays and special opening hours 10:00-17:00　🅒 Sundays, Holidays
🆅 Free　🆔 1-736 Ogawa-cho, Kodaira-shi, Tokyo
🅟 042-342-6003　🆎 18 min walk from Takanodai Station on the Seibu Kokubunji line

mauml.musabi.ac.jp

RECOMMENDATION

中野豪雄
Takeo Nakano

国内有数の貴重書を所有する図書館が併設されていることを活かし、学内では収蔵資料を歴史的に位置づけ直す研究プロジェクトと、その成果報告としての展覧会が開催されている。コレクションをその物理的なスケールや存在感、質感と共に実物として見ることができる特徴を生かした特別授業も開催されるなど、造形教育に資する環境としての活動も精力的に行う。教育アーカイブとしての教授退任記念展の開催なども美術大学ならでは。

Taking advantage of their access to a library that holds some of the rarest books in the country, the university is conducting a research project to re-evaluate the historical relevance of its collection and organizing an exhibition to report its results. The university is also engaged in activities that contribute to the education of young artists, offering special classes where students can appreciate items in the collection as tangible objects that have physical scale, presence, and texture. The university holds additional exhibitions to commemorate professors' retirements as events that also become part of the school's educational archives.

③ 町田市民文学館ことばらんど
Machida city public museum of literature

文学をより身近に感じる場所

地域に根ざした文学館として2006年にオープン。文字やことば、文学の魅力に気軽に出会う機会を提供するとともに、市民の文学活動の拠点を目指す。町田に関連する作家の資料を所蔵し、作家の展覧会のほか文学作品の映像化とタイアップした展覧会、写真、装幀、文字の造形まで多様化する表現形態や、ことば・文学を取り巻く事象について横断的な企画に取り組んでいる。

The place that make literature more accessible

Opened in 2006 as a community literary museum, this facility aims to be a hub for literary activities and provide opportunities to experience the magic of literature and language in a casual manner. The museum collects materials relating to writers with connections to the town of Machida. It also holds exhibitions related to film and video adaptations and organizes events related to various forms of expression surrounding literature, including karuta card games, picture-storytelling, photography, illustrations, and bookbinding.

⏰ 10:00－17:00　🚫 月曜日（祝休日は開館）、第2木曜日（祝日の場合は翌平日）、年末年始、特別整理日　¥ 無料　🏠 東京都町田市原町田4-16-17　☎ 042-739-3420　🚃 JR「町田駅」より徒歩8分

🕙 10:00-17:00　🄲 Mondays, 2nd Thursday (Except Holidays), New Year holidays, Special Arrangement Days　¥ Free　🄰 4-6-17, Haramachida, Machida city, Tokyo　📞 042-739-3420　🄰 8 min from Machida Station on JR Line

–
www.city.machida.tokyo.jp/bunka/bunka_geijutsu/cul/cul08Literature

RECOMMENDATION

大日本タイポ組合
Dainippon Type Organization

町田といえば版画美術館が有名ですが、実はその道中に建つ「ことばらんど」。ファンシーな名前ゆえにスルーしがちだけどあなどれない。町田在住だった赤瀬川原平の展覧会も行うなど、企画展はその名のとおり「文学」「ことば」をテーマとしながら、解釈は広範囲に「文字デザイン」にも拡がって、2019年には大日本タイポ組合展『文ッ字』も開催。同展期間内に催した「文ッ字フリマ」は大盛況で、毎年やろう！と意気込んでます。
This facility is located along the way to Machida's famous graphic art museum. Its fancy name makes it easy to overlook, but this place is not to be underestimated. While its special exhibitions, such as the exhibition on Genpei Akasegawa of Machida, are themed on literature and language, the facility's interpretation of this theme has widely expanded to include typography. In 2019, it hosted the *Mojji* exhibition by us. The Mojji Flea Market held during the exhibition was a huge success, and we are enthusiastic about repeating the exhibition every year.

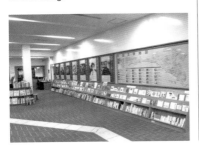

武蔵野・多摩の行きたいショップ・見たい建築
Shops and architecture in Musashino / Tama

三鷹天命反転住宅
イン メモリー オブ ヘレン・ケラー
Reversible Destiny Lofts Mitaka
(In Memory of Helen Keller)

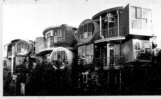

芸術家／建築家の荒川修作とマドリン・ギンズによる「死なないための住宅」。9戸から成る集合住宅の内外装には14色の鮮やかな色が施され、身体を揺さぶり感覚を呼び起こす仕掛けが施されている。見学や宿泊も可能。（見学は事前予約制）

Artists and architects Shusaku Arakawa and Madeline Gins created these "reversible destiny lots," nine units in an apartment complex with 14 vibrant colors splashed across the interior and exterior. The complex is designed to shake up the body and evoke the senses. Tours and lodgings are available. (Advance reservation system)

🏠 東京都三鷹市大沢2-2-8　📍 2-2-8 Osawa Mitaka-shi Tokyo

Photo by Masataka Nakano, courtesy of Arakawa+Gins Tokyo Office © 2005 *Estate of Madeline Gins.* Reproduced with permission of the Estate of Madeline Gins.

江戸東京たてもの園
Edo-Tokyo Open Air Architectural Museum

災害や戦災により多くの歴史的建造物が失われてきた東京の歴史を踏まえ、都内に存在した江戸前期から戦後までの建造物を移築し、復元・保存・展示する野外博物館。夏の夕涼みなど、懐かしい街並みを楽しむ催しも充実。

This open-air museum relocates, restores, preserves, and exhibits buildings from the early Edo period to the post-war period that existed in Tokyo, where many historical buildings have been lost due to disasters and warfare. A variety of events are offered for visitors to enjoy the nostalgic cityscape, including cool-down festivities during summer evenings.

🏠 東京都小金井市桜町3-7-1　📞 042-388-3300
📍 3-7-1 Sakuracho, Koganei-shi, Tokyo　📱 042-388-3300

PLAY!
PLAY!

PLAY!

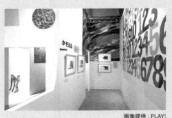

画像提供：PLAY!

立川駅北口の複合文化施設。絵とことばがテーマの美術館「PLAY! MUSEUM」と子どものための屋内広場「PLAY! PARK」では、それぞれ体感型の展示企画やワークショップが楽しめる。アートディレクションとロゴマークは菊地敦己が担当。

This cultural complex is located at the north exit of Tachikawa Station. Interactive exhibitions and other fun activities are offered at the PLAY! MUSEUM, a museum using a theme of pictures and words, and PLAY! PARK, an indoor plaza for children. Atsuki Kikuchi is in charge of the art direction and logo.

🏠 東京都立川市緑町3-1 GREEN SPRINGS W3
📞 [MUSEUM]042-518-9625, [PARK]042-518-9627
📍 GREEN SPRINGS, W3, Midoricho 3-1, Tachikawa-shi, Tokyo　📱 [MUSEUM]042-518-9625, [PARK]042-518-9627

国立本店
Kunitachi Honten

国立本店

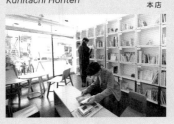

公募による運営メンバーが選書する「ほんの団地」や読書スペースなど、本や街、編集やデザインにより国立をおもしろくする企画が行われる本のあるコミュニケーションスペース。近隣のショップなどとあわせて楽しめる。

Communications spot where a variety of projects are organized to bring delight to the city of Kunitachi through books, community, and editorial and design work. Some of its projects include a "book apartment," where the elected managing members curate the book selection, and a communal reading space. This is a location to be enjoyed along with its neighboring stores.

🏠 東京都国立市中1-7-62
📍 1-7-62, Naka, Kunitachi-shi, Tokyo

阿佐ヶ谷 VOID
Asagaya VOID

VOID

JR中央線・阿佐ヶ谷駅の北口から徒歩5分、中杉通り沿いにあるアート・ギャラリー。絵画・イラストレーション・写真などの表現を問わず、年間を通じて様々なアーティストによる展示を開催している。

An art gallery located along Nakasugi-dori, a five-minute walk from the north exit of Asagaya Station, Chuo Line. The gallery exhibits various artist's arts throughout the year, such as paintings, illustrations, and photographs.

住 東京都杉並区阿佐谷北1-28-8 芙蓉コーポ102
電 03-5364-9758
Ad #102 1-28-8 Asagaya Suginami-ku Tokyo
Ph 03-5364-9758

本屋 Title
Title books

本屋 **Title**

衣・食・住はもちろん、よりよく生きていくために役立つ文学や哲学、芸術、社会に関連した書籍、雑誌、絵本などを扱う書店。店内にはカフェも併設されており、2階のギャラリーではイベントや企画展示も楽しめる。

The bookstore carries books, magazines, and picture books related to basic life necessities, such as clothing, food, and housing, but also on topics that enrich our lives, such as literature, philosophy, art, and society. The store also has a cafe and holds events and exhibitions on the second-floor gallery.

住 東京都杉並区桃井1-5-2 電 03 - 6884 - 2894
Ad 1-5-2 Momoi, Suginami-ku, Tokyo 167-0034
Ph 03 - 6884 - 2894

撮影：齋藤陽道

百年
Hyakunen

百年

古本をメインに、アートブック、デザイン書、思想関連、国内外文学などを取り扱う書店。コミュニケーションする本屋をコンセプトに展示やトークイベントも行っている。zineやリトルプレスを扱うコーナーも面白い。

This bookstore carries used books and publications on art, design, philosophy, and Japanese and foreign literature. Using the concept of "a communicating bookstore," it also holds exhibitions and talk events. Its zine section is also fascinating.

住 東京都武蔵野市吉祥寺本町2-2-10 村田ビル2F
電 0422-27-6885 Ad Murata Bld.2F, 2-2-10, Kichijoji Honcho, Musashino-shi, Tokyo Ph 0422-27-6885

珍屋
MEZURASHIYA RECORD

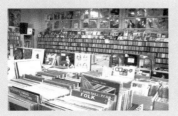

1982年に東京都国分寺に創業以来、オールジャンルのセレクトと中古CD・LP・EP・DVD・音楽書籍等を取り揃えるレコード店。国分寺と立川に計4店舗あり、中央線沿線の音楽好きたちがハシゴして集う場所。

This is a record store established in 1982 in Kokubunji, Tokyo, selling a wide selection of music as well as used CDs, LPs, EPs, DVDs, and music books. With four stores in Kokubunji and Tachikawa, it's a place where music lovers who live along the Chuo Line come to hang out.

住 東京都国分寺市南町2-17-10（国分寺南口店）
電 042-326-0359
Ad 2-17-10, Minami-cho, Kokubunji city, Tokyo
Ph 042-326-0359

原研哉（はら・けんや）
1958年生まれ。グラフィックデザイナー。日本デザインセンター代表。武蔵野美術大学教授。2002年より無印良品アートディレクター。蔦屋書店など多数のブランドデザインのほか、「RE-DESIGN」「HAPTIC」「SENSEWARE」「Ex-formation」など、既存の視点を更新する着想による展覧会や教育活動も展開。近年は日本を見つめ直すプロジェクト「低空飛行」を進行中。

Kenya Hara
Born in 1958. Graphic designer. Representative of the Nippon Design Center Inc. Professor at Musashino Art University. Art director for MUJI since 2002. In addition to designing for numerous brands, such as Tsutaya Books, Hara has also been involved in exhibitions and educational activities that explore existing perspectives in new ways, including "RE-DESIGN,""HAPTIC,""SENSEWARE," and "Ex-formation." In recent years, he has been working on "HIGH RESOLUTION," a project that re-evaluates Japan.

渡部千春（わたべ・ちはる）
1969年新潟県生まれ。デザインジャーナリスト。東京造形大学准教授。1993年東京造形大学卒業。『これ、誰がデザインしたの?』（美術出版社、2004年）、『北欧デザイン 1-3』（プチグラパブリッシング、2003-04年）、『日本ブランドが世界を巡る』（日経BP、2010年）、『スーパー!』（飛鳥新社、2013年）などの著書がある。

Chiharu Watabe
Born in 1969 in Niigata Prefecture. Design journalist. Associate professor at Tokyo Zokei University. Graduated from Tokyo Zokei University in 1993. Works include *Who Designed This?* (Bijutsu Shuppansha, 2004), *Scandinavian Design 1–3* (Petit Grand Publishing, 2003–2004), *Japanese Brands Go Around the World* (Nikkei BP, 2010), and *Super!* (Asuka Shinsha Publishing, 2013).

イエン・ライナム
グラフィックデザイン、デザイン教育、デザイン研究の領域で活動。テンプル大学日本校、Vermont College of Fine Arts のグラフィックデザイン修士課程、ミームデザイン学校で教鞭を執り、California Institute of the Arts の客員評論家を務める。また、デザインスタジオ Ian Lynam Design を運営し、アイデンティティ、タイポグラフィ、インテリアデザインを手がけている。『Slanted』への寄稿はじめ、デザインに関する書籍を多数出版。
ianlynam.com

Ian Lynam
Ian Lynam works at the intersection of graphic design, design education and design research. He is faculty at Temple University Japan, as well as at Vermont College of Fine Arts in the MFA in Graphic Design Program, Meme Design School in Tokyo and is Visiting Critic at CalArts. He operates the design studio Ian Lynam Design, working across identity, typography, and interior design. Ian writes for *Slanted* (DE) and has published a number of books about design.
ianlynam.com

佐藤亜沙美 (さとう・あさみ)
1982年福島県生まれ。2006年から2014年までコズフィッシュに在籍。2014年に独立し、サトウサンカイ設立。数多くの書籍を手がけるとともに、『Quick Japan』(太田出版) のアートディレクター&デザイナーを経て、2019年より『文藝』(河出書房新社) のアートディレクター&デザイナーを務める。

Asami Sato
Born in 1982 in Fukushima Prefecture. Member of cozfish from 2006 to 2014. Founded Satosankai in 2014. In addition to working on a number of titles, Sato has worked as art director and designer for *Quick Japan* (Ota Publishing). She has worked as art director and designer for *Bungei* (Kawade Shobo Shinsha) since 2019.

中島佑介 (なかじま・ゆうすけ)
1981年生まれ。2002年にlimArtをスタート。2011年には出版社という括りで定期的に扱っている本が全て入れ代わるブックショップ「POST」をオープン。ブックセレクトや展覧会の企画なども手がける。2015年からはTOKYO ART BOOK FAIRのディレクターを務める。

Yusuke Nakajima
Born in 1981. Started limArt in 2002. In 2011, he opened POST, a bookstore that carries titles by a one publishing company at a time and completely replaces its entire collection on a regular basis. Nakajima is also involved in projects involving book selection and exhibition planning. Since 2015, he has been the director of TOKYO ART BOOK FAIR.

野見山桜 (のみやま・さくら)
ニューヨークのパーソンズ・スクール・オブ・デザインにてデザイン史の修士号を取得。デザインの研究者として展覧会の企画や書籍・雑誌への寄稿を行う。東京国立近代美術館工芸課客員研究員、女子美術大学、東北芸術工科大学非常勤講師。

Sakura Nomiyama
Graduated with a master's degree in design history from Parsons School of Design in New York City. As a design researcher, Nomiyama organizes exhibitions and is a contributing writer for books and magazines. She is also a visiting researcher in the Crafts Division of the National Museum of Modern Art, Tokyo, and a part-time lecturer at Joshibi University of Art and Design and Tohoku University of Art and Design.

中野豪雄（なかの・たけお）
1977年東京都生まれ。グラフィックデザイナー。武蔵野美術大学卒業。勝井デザイン事務所を経て、中野デザイン事務所代表。情報の構造化と文脈の可視化を主題に、さまざまな領域でグラフィックデザインの可能性を探る。武蔵野美術大学教授

Takeo Nakano
Born in Tokyo in 1977. Graphic designer. Graduated from Musashino Art University. Established Nakano Design Office after working at Katsui Design Office. He explores the potential of graphic design following the themes of organizing information and visualizing context. Professor at Musashino Art University.

三澤遥（みさわ・はるか）
1982年群馬県生まれ。武蔵野美術大学工芸工業デザイン学科卒業後、デザインオフィスnendoを経て、2009年より日本デザインセンター原デザイン研究所に所属。2014年より三澤デザイン研究室として活動開始。著書に『waterscape』（X-Knowledge、2018年）がある。

Haruka Misawa
Misawa was born in Gunma Prefecture in 1982. After graduating from the Interior Design Course of Musashino Art University and working at the design office nendo, she joined Hara Design Institute at Nippon Design Center in 2009. She founded Misawa Design Institute in 2014. She is the author of *waterscape*, published by X-Knowledge in 2018.

大日本タイポ組合（だいにっぽん・たいぼくみあい）
1993年に秀親と塚田哲也により結成。日本語やアルファベットなどの文字を解体し、組合せ、再構築することによって、新しい文字の概念を探る実験的タイポグラフィ集団。ロンドン、バルセロナ、東京にて個展を開催。著書に『大日本字』（誠文堂新光社、2008年）、『もじかけえほんかな?』（偕成社、2020年）など。

Dainippon Type Organization
Founded in 1993 by Hidechika and Tetsuya Tsukada. As an experimental typographic group, they explore the concept of new characters by dismantling, combining, and reconstructing letters of the Japanese language and alphabet. The organization has held exhibitions in London, Barcelona, and Tokyo. Published titles include *Dainipponji* (Seibundo Shinkosha, 2008), *Mojikake ehon Kana?* (Kaiseisha, 2020).

室賀清徳（むろが・きよのり）
1975年新潟県長岡市生まれ。前『アイデア』編集長。グラフィックデザイン、タイポグラフィ関連書を中心に編集するほか評論、教育活動にも携わる。オンラインデザイン評論誌「The Graphic Design Review」〈gdr.jagda.or.jp〉編集長。

Kiyonori Muroga
Born in Nagaoka City, Niigata Prefecture in 1975. Former editor-in-chief of *IDEA*. While working as editor on graphic design and typography books, Muroga is also involved in reviews and educational activities. He is currently the editor-in-chief of an online design review magazine, "The Graphic Design Review" (gdr.jagda.or.jp).

永原康史（ながはら・やすひと）
グラフィックデザイナー。多摩美術大学教授、メディアセンター所長。電子メディアや展覧会のプロジェクトを手がけ、メディア横断的なデザインを推進している。『インフォグラフィックスの潮流』（誠文堂新光社、2016年）など著書多数。監訳にカール・ゲルストナー『デザイニング・プログラム』（ビー・エヌ・エヌ、2020年）など。

Yasuhito Nagahara
Graphic designer. Professor at Tama Art University, and director of the school's Media Cen-ter. Nagahara has worked on electronic media projects and exhibitions that promote cross-media design. His countless published works include *The Stream of Information Graphics* (Seibundo Shinkosha, 2016); and *Karl Gerstner: Designing Programmes* (BNN, 2020), which he supervised and translated.

加藤賢策（かとう・けんさく）
1975年埼玉県生まれ。株式会社ラボラトリーズ代表。グラフィックデザイン、ブックデザイン、WEBデザイン、サインデザインなどを手がける。おもな領域はアートや建築、思想、ファッションなど。

Kensaku Kato
Born in Saitama in 1975. Representative of Laboratories Co. Involved in graphic design, book design, web design, sign design, and more. His main areas include art and architecture, ideology, and fashion.

デザイン｜LABORATORIES（加藤賢策、岸田紘之）
イラスト｜コグレチエコ
翻訳｜Nuance Translation（坂井絵理加）
翻訳協力｜チョン・ソンラン、クリストファー・スティヴンズ、ダンカン・ブラザトン
編集協力｜藤生新、野口真弥、今雪成実、古田悠

TRIP TO JAPAN GRAPHICS

トーキョーデザイン探訪

マストビジット デザイン デスティネーション イン トーキョー
Must-Visit Design Destinations in TOKYO
デザインがよくわかる美術館・ギャラリー・ショップガイド（東京版）

2021年1月25日　発　行　　　　　　　　　　　　　　　　　　　　　　NDC 703

編　者　　アイデア編集部
発行者　　小川雄一
発行所　　株式会社 誠文堂新光社
　　　　　〒113-0033　東京都文京区本郷3-3-11
　　　　　（編集）電話 03-5805-7763
　　　　　（販売）電話 03-5800-5780
　　　　　https://www.seibundo-shinkosha.net/
印刷所　　株式会社 大熊整美堂
製本所　　和光堂 株式会社